Secrets of Oscar-winning Animation

Olivier Cotte

Secrets of Oscar-winning Animation

Behind the scenes of 13 classic short animations

Focal Press
Taylor & Francis Group

NEW YORK AND LONDON

First published 2006 by Focal Press
This edition published 2013
by Focal Press
70 Blanchard Road, Suite 402, Burlington, MA 01803

Simultaneously published in the UK
By Focal Press
2 Park Square, Milton Park, Abingdon, Oxon OX14 4RN

Focal Press is an imprint of the Taylor & Francis Group, an informa business

Neighbours, production Office national du film/National Filmboard of Canada
Frank Film, production Caroline Mouris
Le Château de Sable (The Sand Castle), production Office national du film/National Filmboard of Canada
A Légy (The Fly), production Pannonia Films
Anna & Bella, production Cilia Van Dijk
L'homme qui plantait des arbres (The Man who Planted Trees) production Radio Canada
Balance, production Christoph and Wolfgang Lauenstein
Manipulation, production Tandem Film Ltd
Mona Lisa Descending a Staircase, production Joan C. Gratz
Quest, production Thomas Stellmach
The Old Man and the Sea, production Pascal Blais/Imagina Corp./Animation Film Studio of Yaroslal
Father and Daughter, production Cloudrunner Ltd/CineTe Filmproductie bv
Harvie Krumpet, production Melodrama Pictures Pty Ltd

Translation from the French language edition of:
Les Oscars du film d'animation
By Olivier Cotte

Copyright © 2006 Editions Eyrolles, Paris, France

Notices

Practitioners and researchers must always rely on their own experience and knowledge in evaluating and using any information, methods, compounds, or experiments described herein. In using such information or methods they should be mindful of their own safety and the safety of others, including parties for whom they have a professional responsibility.

To the fullest extent of the law, neither the Publisher nor the authors, contributors, or editors, assume any liability for any injury and/or damage to persons or property as a matter of products liability, negligence or otherwise, or from any use or operation of any methods, products, instructions, or ideas contained in the material herein.

Library of Congress Cataloging-in-Publication Data
Application submitted

British Library Cataloguing-in-Publication Data
A catalogue record for this book is available from the British Library.

ISBN: 978-0-240-52070-4 (pbk)

Typeset by Charon Tec Ltd (A Macmillan Company), Chennai, India

Acknowledgements

My thanks, of course, primarily to the film-makers/directors who so amazed me with their work, who inspired me to write this book and who generously gave their time to answer my questions:

Frédéric Back
Michael Dudok de Wit
Adam Elliot
Joan C. Gratz
Daniel Greaves
Co Hoedeman
Christoph and Wolfgang Lauenstein
Tyron Montgomery
Frank Mouris
Alexandre Petrov
Børge Ring
Ferenc Rófusz

with particular mention to Norman McLaren, without whom I would never have fallen in love with animation, as well as to the producers who made this book possible: Pascal Blais, Melanie Coombs, Claire Jennings, Caroline Mouris, Willem Thijssen, Hubert Tison, Tatsuo Shimamura, Thomas Stellmach, Nigel Pay, Cilia Van Dijk, Gaston Sarrault, and to the colleagues and managers in the studios: Suzel Back, Maurice Corbet, Martine Chartrand, Erica Darby, Colette Forest, Morgan Francis, Lynn Hollowell, James Roberts, Laurie Jones, Bernard Lajoie, Claude Lord, Grant Munro, Christine Noël, Marcy Page, Russel Pay, Normand Roger, Hélène Tanguay, and also: Tess Földes-Cotte for her patience, as well as Joseph Altairac for his proofreading.

I would equally like to thank Stéphanie Poisson, my editor, whose professionalism and constant enthusiasm for the project has enabled this book to come to fruition.

Acknowledgements

My thanks, of course, primarily to the film-makers/directors who so inspired me with their work, who inspired me to write this book, and who generously gave their time to answer my questions:

Hégane Paul
Michael Dudok de Wit
Adam Elliot
Joan C. Gratz
Daniel Greaves
Co Hoedeman
Christoph and Wolfgang Lauenstein
Yuri Norstein
Frank Morris
Alexander Petrov
Bretislav Pojar
Helene Rosner

with particular mention to Norman McLaren, without whom I would never have fallen in love with animation, as well as to the producers who made this book possible: Pascal Blais, Melanie Coombs, Claus Clausen, Caroline Moore, Willem Thijssen, Robert Rea, Nicole Salomon, Thomas Stellmach, Nigel Pay, Gilda Van Dijk, Gaston Sarault, and to the colleagues and managers in the studios: Suzel Back, Marilyn Bonet, Martine Chartrand, Sara Darby, Camille Fauble, Joanne Ferris, Lynn Holloway, James Roberts, Linda Jones, Bob Last, Claude Lord, Marie Morel, Christine Noll, Mary Pays, David Fox, Norman Roger, Hélène Tanguay, and last, Jess Folley, Colin for her patience, as well as to wife Al after for his proofreading.

I would equally like to thank Stephanie Poisson, my editor, whose professionalism and constant enthusiasm for the project has enabled this book to come to fruition.

Preface

Winning an Oscar is an accolade that has long been the preserve of American films. For everyone else, there is currently only one Oscar for live action movies – for the 'Best Foreign Language Film' – thereby assuring that the United States sweep the board in most other categories.

But in the wonderful world of film animation, boundaries are being broken; mere words have been replaced by language, *and the essential magic of these masterpieces elicits more feelings of enchantment than comparisons between* performances *of this or that technician.*

From the great collection of worldwide animation, Olivier Cotte has chosen thirteen of the most incredible Oscar-winning experiences. Through these thirteen perfect films, he offers us the immense pleasure of breaking a unique and secret code. In this tour de force, he succeeds in explaining techniques without revealing any tricks of the trade; with the author's complicity he exposes the mechanics of each film without in any way affecting their charm and spellbinding perfection. His secret is simple: he is a director himself. So as an interviewer, he is both an enthusiast and an expert, eager for information and reality, *an unrivaled guide through these acclaimed and awarded works, each so very different from the next.*

As a simple spectator, I savored these pages as if I were on an extraordinary journey, like a little mouse that had crept onto the shoulders of these great geniuses of animation. I experienced a strange feeling – I now understood aspects of these films that I had never appreciated before, despite having watched them so many times. It was almost like discovering the secrets of those who we know and love.

As I allowed myself to be cradled by these thirteen stories, I became a child once more.

Serge Bromberg
Artistic Director
Annecy International Animated
Film Festival

Foreword

I first met Olivier Cotte, in the mid-1980's when I was directing animated shorts for my company Aardman, and he was a young journalist. We shared a passion for animated film-making in all its forms. Since then, our respective careers have grown and flourished. Aardman has become a major player in world animation – notably for our Wallace and Gromit films, and for two successful animated features, while Olivier became a very successful computer artist, specialising in FX for feature films and of course in animation. He's also continued to publish widely, a series of books about animation and animators.

Secrets of Oscar-winning Animation is about a subject dear to my heart – Academy Award winning animated shorts. This category has always been a very special one, allowing brilliant independent film-makers to bring their work to the world's largest stage. Often, as the book shows, launching hugely successful careers.

It seems like one of those obvious ideas for a book that leaves you wondering why it hasn't been done before. Olivier has managed to get his hands on some fascinating (and beautiful) original documents, and most importantly has conducted a series of in-depth interviews with some of the Greats of film animation. The insights into ideas and techniques are many and detailed. As a teacher, a writer and an animation practitioner, Olivier is uniquely qualified to conduct the interviews, drawing out those subjects of particular interest to the general reader as well as to young film-makers and students of animation. His respect for the film-makers and love for their films shines through.

Simply, this is exactly the sort of book I'd have loved to have owned early in my career as an insight into the minds and techniques of the undisputed masters of their art.

Peter Lord, Aardman Animation Creator, director

Introduction

An animated film that wins an Oscar always carries a certain prestige, because, these days, any award that comes out of North America is certain to attract films from all over the globe. To some extent, when one such film is elected 'Animated Short Film of the Year', it is awarded an international honor. In reality, though, things are certainly not that simple. The choice of a winner is always debatable and, amongst specialists, there is no shortage of critics; but it is undeniable that the chosen work impacts very strongly upon the Academy's voters, or at the very least becomes a part of the zeitgeist.

For a long time, the Animation category (originally called 'Cartoon' when it was created in 1931) was reserved for American productions. Up until 1939, Walt Disney won all the Oscars, but thereafter had to share them with other American animation companies. It was not until the beginning of the 1960s that a production from another country (*Surogat*, by Dusan Vukotic, Zagreb Film) was awarded an Oscar. From this moment on, there was no going back; the short films that have been distinguished since then have reflected a multiplicity of cultures.

My wish was that the thirteen films presented would complement each other, that they would each possess an original aesthetic and employ different techniques; I was also limited to productions recent enough that the knowledge and methodologies are still available. Throughout this work, the voices of the producers and their collaborators are heard; they tell how their desire to make a film is born, show their working techniques and analyze their work with as much honesty as possible. Whether you are a producer, student, amateur artist, or simply just curious, you will be in turn fascinated, amused and even, I hope, encouraged by all the stories.

If animation is a solitary profession, there exists, however, a community culture which has made the writing of this book possible, a collaboration which has broken through sociological, linguistic and cultural barriers: I would like to thank once more all the artists whose work is depicted in this book for placing their trust in me so generously.

The techniques used for the creation of these films have also evolved through the twentieth century, and they continue to develop, in line with technical progress and public taste. Until the middle of the 1970s, nearly all animated films were created on celluloid. From then on, the media began to diversify: modelling clay, digital technology, paper cutouts… The industry has become even more fascinating, for the cinema is a wonderful place to present differences.

Within the context of my professional experience in animated cinema and live-action feature films, I have often noticed great similarities between the experiences of different people; every producer and every technician shares the same fascination for their art and for the cinematographic illusion. The idea for this book was born from the desire to tell the story of the passion and determination that are needed to create a work of animation.

Summary

Summary

Neighbours

This lyrical short film, filmed in frame by frame live action, tells the story of two neighbors. At the beginning, they read their newspapers quietly in their gardens whilst smoking their pipes – a peaceful scene. But a flower grows between the two of them; at first both of them are delighted by it, but then they lose their tempers as they attempt to keep it. They come to blows, and with increasing violence, accidentally stamp on the highly-prized flower in uncontrollable rage. They massacre their respective families and finally kill each other. In the end, a flower grows on each of their graves…

Oscar 1952

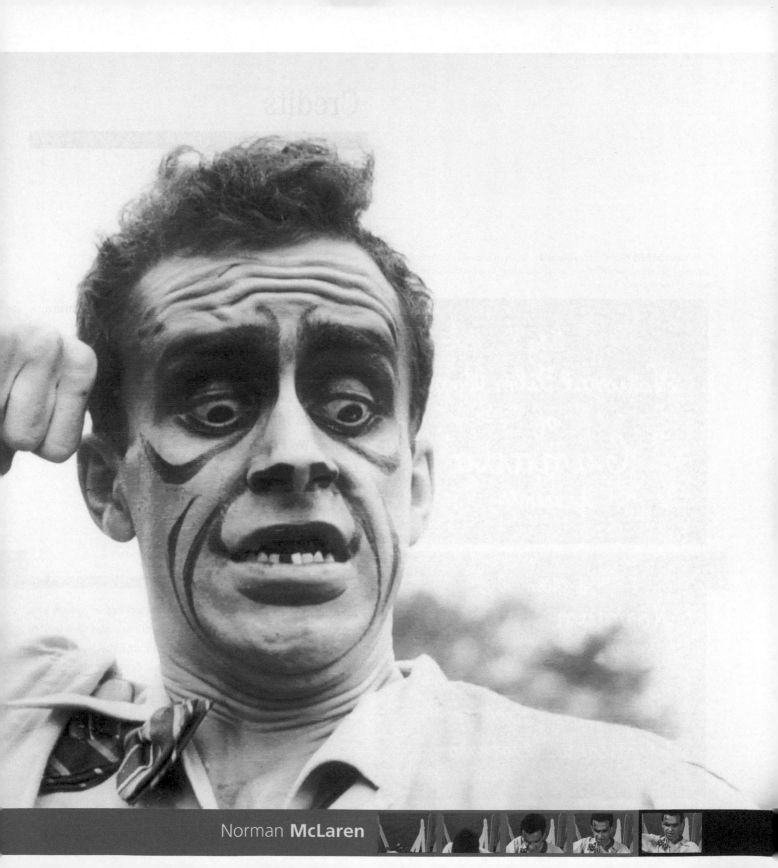

Credits

Title: *Neighbours*

Year: 1952

Country: Canada

Director: Norman McLaren

Production, distribution: National Film Board

Producer: Norman McLaren

Screenplay, animation: Norman McLaren, Grant Munro, Jean-Paul Ladouceur, Wolf Koenig

Technique used: Pixilation

Music: Norman McLaren

Sound: Clarke Daprato

Cast: Grant Munro and Jean-Paul Ladouceur

Camera: Wolf Koenig

Length: 8 minutes 10 seconds

The National Film Board's title painted by McLaren himself. The credits are simple as the technical team is small and wants to move straight to the heart of the matter.

Norman McLaren was born in Scotland. He worked in London with John Grierson, later he emigrated to New York and was then invited to Montreal by Grierson (who had just founded the National Film Board of Canada) to set up an animation department, where he directed and produced his own films, encouraged new artists and won international recognition for the National Film Board. Norman McLaren is quite simply the greatest genius in the history of animation: the artist who created the most original techniques, using them in frame by frame film-making. With more than 50 films, he is the film-maker who has best demonstrated that the medium *defines the expression*.

The Idea

Let us go back to the strange definition of a 'live action film shot frame by frame', which may seem surprising. If animation is defined as 'the art of giving the illusion of life by creating each frame in a film separately and from scratch', then the materials used are generally those employed in the visual arts. Nevertheless any other element can be used, including human beings, who can be animated like puppets by deciding on the sequence of poses they must hold, frame by frame. This is what has been done in this film.

This technique, invented by Norman McLaren, is called *pixilation*. There is no doubt that Norman McLaren created it to combine his two interests: body movement and cinema. (The art of dance was of particular interest to McLaren; he even admitted that he would have preferred to have worked in this field, rather than in animated film; some of his last films are hymns to the human body and the art of choreography.)

The two men literally slide around the flower. It is a dance (their feet almost in the ballet "second position") a spring celebration of sorts...

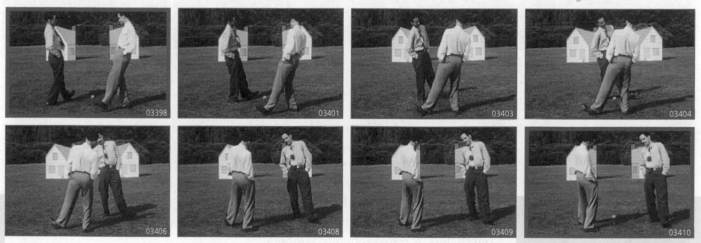

Shortly before the filming of *Neighbours*, McLaren returned from a UNESCO-sponsored visit to China with the aim of initiating the Chinese in animated film making. He was in China for four months from August 1949; during this time, he was a spectator to one of the most significant events of the twentieth century: the Maoist revolution. He also witnessed the force imposed by the Chinese army in the villages. As far as his artistic work was concerned, this journey left little mark on him; however, it developed his humanist spirit further.

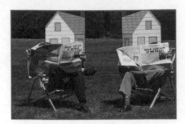

The symmetry of the image, the theatrical design of the houses in the background: all of this characterizes the film-maker's desire to tell an allegorical tale through an almost minimalist image.

On the other hand, the Korean War, which started soon after he returned to the West (in June 1950), inspired him to make an anti-war film. It is for this reason that *Neighbours* opens with the image of two men who are similar in almost every way; they are positioned symmetrically on the set, in front of their respective houses, dressed in a similar fashion, each sitting on a deckchair smoking their pipes. Only the newspapers they are reading have different headlines: 'War Certain if no Peace' and 'Peace Certain if no War'. While McLaren continued to develop new techniques throughout his career, he admitted that, in the case of this particular film, the theme was the sole driving force.

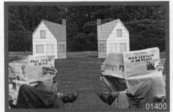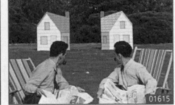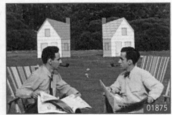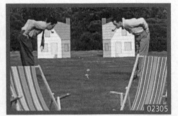

The appearance of the flower and the reactions it provokes in the two protagonists. However the frame is still symmetrical and the shot wide: we're 'voyeurs' to the scene.

The message of the film must be simple and comprehensible enough to impress viewers. The allegory becomes crucial because of the length restrictions on short films. There are consequently few essential elements to the film: two men, their wives and children (who appear very late and only fleetingly on the screen), their houses and the flower which triggers the chain of events. According to McLaren, the choice of a flower was simply guided by the need for there to be a catalyst to set off the story. Nonetheless, it remains highly symbolic.

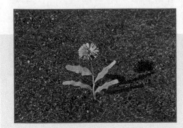

The object of desire which will lead the two protagonists into a merciless war: the flower is fake; its arrival is animated in stop motion. It even sways, slightly mischievously, to announce its appearance.

As technical experimentation was such a key aspect of the filming process, the screenplay was not fully written in advance (far from it), which is rare for an animated film. Filming started with a general idea made up of several guiding themes: the opposition of the two men, the situation which develops into a dramatic crisis, the use of a flower as a triggering factor. The original pitch and synopsis were thus incomplete and, of course, there was no storyboard of any kind. The two actors (Grant Munro and Jean-Paul Ladouceur), Wolf Koenig

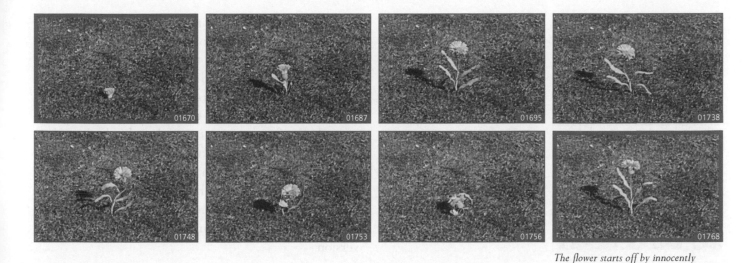

01670 01687 01695 01738 01748 01753 01756 01768

The flower starts off by innocently delighting the two men. Its appearance is hailed as a small miracle of life. Who could imagine what would come next?

(cameraman) and Norman McLaren thus had to improvise continuously. Each morning, they sat for an hour on the grass, thinking and planning for the day ahead. For this reason, each of them contributed to the film in their own way. For example, Grant Munro had the idea of wearing make-up to symbolize the regression into savagery in the scene involving the massacre of the families.

When three-quarters of the film had been completed, the end of the story was still undecided; the team debated whether the film should have a happy ending or, on the contrary, the destructive logic should be left to reach a tragic end. It was decided that they would show the two protagonists killing each other if they could not come up with any other idea. As no alternative came to light, McLaren kept this fatal ending.

Norman McLaren pondering how the screenplay will develop: writing the script for this type of film is always problematic - attempting to communicate a serious message, whilst trying not to appear self-righteous, often has the effect of distancing the audience.

After the deadly fight, the men are buried. The fencing that once separated their gardens is used to enclose their graves. A flower grows on each one, a final proof, if one is needed, of the pathetic and ridiculous nature of their behavior.

McLaren animating the pieces of fencing which become the set for the tombs. He works with a stick so as not to mark the coating on the fence, which could flicker on the screen.

The film was received in different ways. One of the most revealing reactions concerned the scene in which each man destroys the home of the other and massacres his family. A chain of Italian cinemas and American distributors refused to distribute the short because of the violence in that scene. McLaren had to resign himself to cutting it out of the edit, thinking that it would be better to remove a part of the film rather than not to have it shown at all. During the Vietnam War, on the other hand, he was criticized for having remove these parts; he thus reinstated the first edit. Today, it is still sometimes possible to see either version.

The two men are dead cross fade to the burial. The pieces of fencing build a cemetery set and a flower grows on each of the graves. The irony is biting. Here again the symmetry of image from the beginning of the film is echoed; the narrative logic merely appears more horrific.

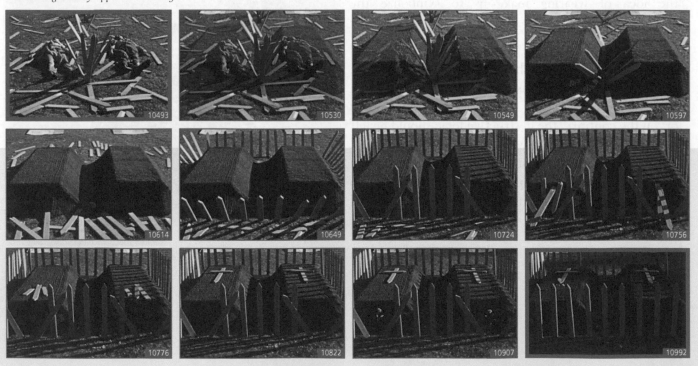

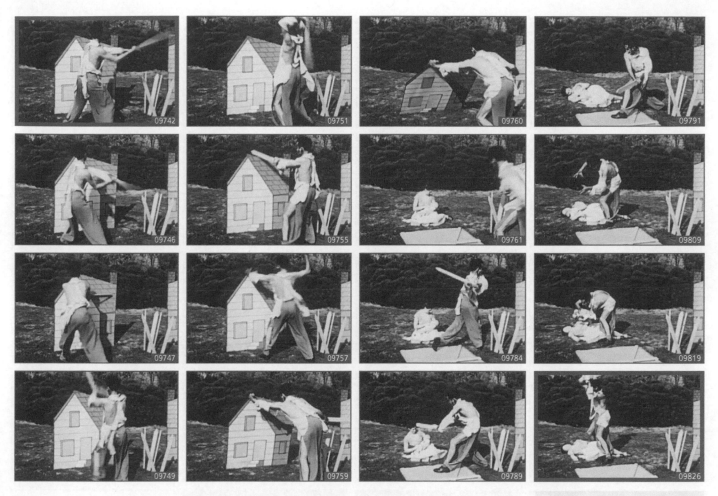

Neighbours was made in 1952; many of the artists who took part in making it are now dead. Norman McLaren died in 1987 and Jean-Paul Ladouceur in 1992. Grant Munro, who played the role of one of the two characters (and who was an excellent film-maker at the National Film Board), is still alive to tell us about this adventure.

This scene of carnage was schocking even though it's a wide shot and the action tends towards caricature. It was the symbolic and cruel aspect that was shocking at the time.

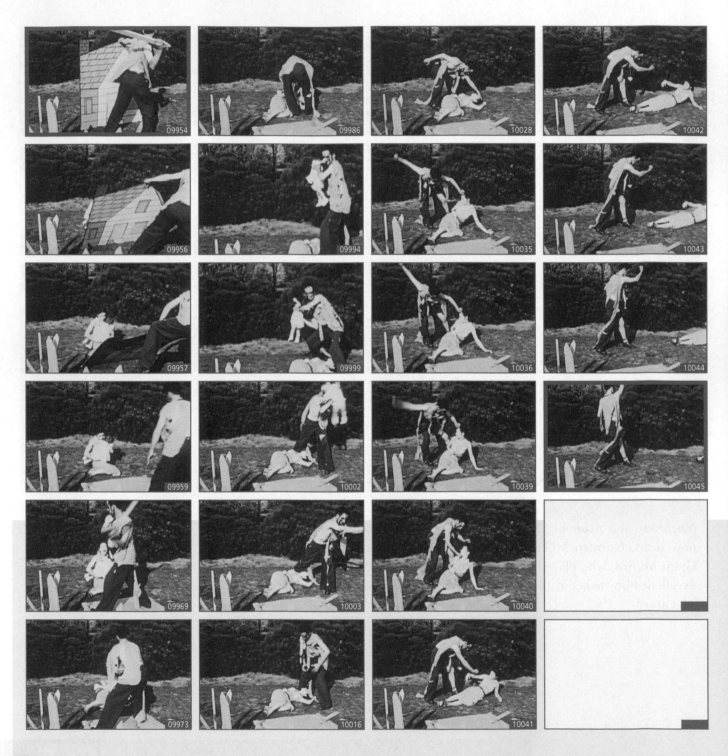

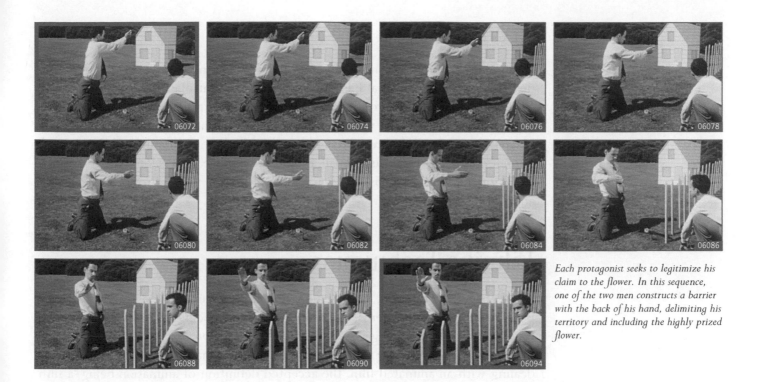

Each protagonist seeks to legitimize his claim to the flower. In this sequence, one of the two men constructs a barrier with the back of his hand, delimiting his territory and including the highly prized flower.

O.C.: How did the idea of making Neighbours *come to McLaren?*

G.M.: When he came back from China, Norman was determined to make a film that clearly condemned violence.

O.C.: The film is highly minimalist...

G.M.: Yes, he wanted to reduce the elements as far as possible to get his message across more effectively: two neighbors (animated animators, Jean-Paul Ladouceur and me), two deckchairs, a fence and a flower. The rest (the wives and babies) came afterwards.

O.C.: What part did improvisation play while you were filming?

G.M.: We knew that the story would start with two neighbors and one flower, and would end with a fight to the death. That's all. Every day, we discussed the rest of the story. There was complete collaboration between us and we were really excited!

Production

Producing the film posed no problem at all, as McLaren, who set up the animation department at the National Film Board, was a star film-maker and had never had to struggle to finance a project in his life. It should be pointed out as well that his films, as is often the case with animation, needed minimal financial backing. For *Neighbours*, the technical team was reduced to the bare minimum and the amount of materials needed was quite small, even if the footage used is longer than average for animated films. Moreover, it was a 16 mm camera, which further reduces film and laboratory costs.

Filming Technique

As we have already seen, where animation film-makers generally use drawings, puppets or other visual items, *Neighbours* uses human beings as its basic element. A type of live action filming is used, or I would say *non live action*, as the actors' movements, created using a stop-motion device, is unnatural. We are quite clearly dealing with an animated film, the accepted definition of animation being 'a film made by any means except live action', which is taken to mean 'without the use of a camera that records images at 24 frames per second'.

For the record, this film won an Oscar in the best documentary category – not for animation. This may seem surprising for two reasons: can a film based on a fictional scenario (and not a more or less objective testimony of the external world captured on film) and using actors whose actions are controlled (*and not people outside of production*) seriously be considered a documentary? Furthermore, from a technical point of view, *Neighbours* is unquestionably an animated film as it has been filmed frame by frame.

The pixilation used in *Neighbours* is very simple: a camera, with a frame by frame motor is mounted on a tripod and the actors perform by holding the

successive poses that correspond to the different phases of the final movement. If the general mechanism is simple, actually doing it is less so. The actors' work is difficult as they must reduce each of the movements they have to make.

Thus, when Grant Munro appears to jump in the air with his legs tucked underneath him, he had to jump in the air while McLaren (or Wolf Koenig) set the camera to shoot a single frame while the actor was at the height of his jump. Of course, he had to repeat the action a number of times so that the sequence had a particular length. This effort meant that, during filming, he had to rest between every 25–30 jumps. Anecdotally, Jean-Paul Ladouceur, who was suffering from a cardiac murmur (which the other members of the filming crew were unaware of at the time) found the jumps absolutely exhausting.

A truly spectacular scene which shows the unsuspected possibilities of animation: we enter a world of fantasy. The actor 'floats' above the lawn. This scene, which could not have been filmed without using a stop-motion device, shows that the film clearly belongs to the animation genre.

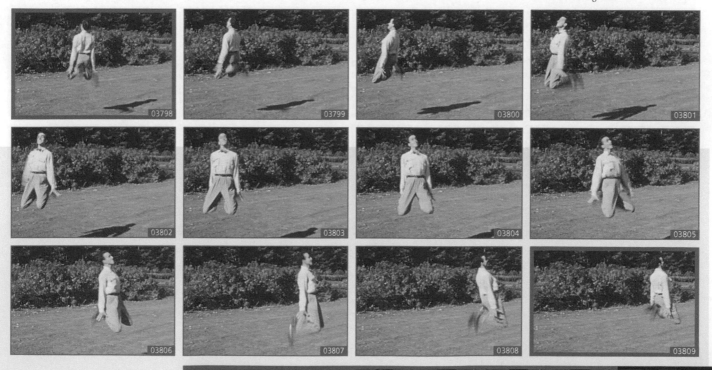

Photographing the actor when he is at the peak of his jump offered two advantages: not only was it the moment most likely to produce a spectacular effect because the character is highest above the ground, but it is also the exact moment when he briefly experiences weightlessness as he descends from the point of elevation; this leaves a brief time lapse in which to shoot the frame. The exposure time could also be fairly fast without the risk of the character being blurred. Moreover, if the actor carefully develops a similar muscular force in all the jumps, the height that he is above the ground at the peak of his jump will have a greater chance of being similar frame after frame.

Let us now take another less taxing example of movement: in order to make a character slumped on the ground slide along, the actor moves a specific distance between two consecutive shots and each time resumes the original slumped position for the recording phase.

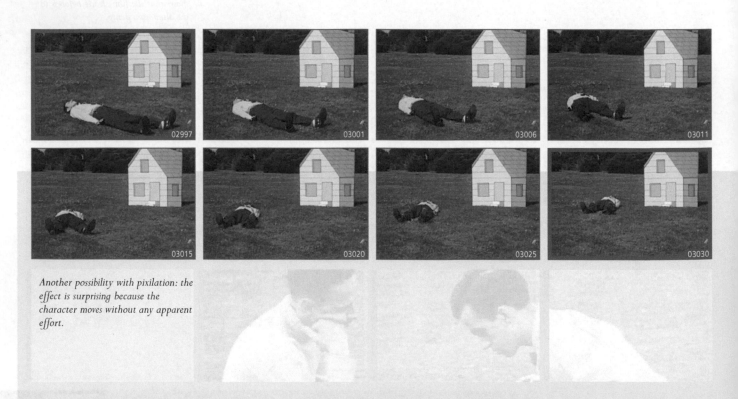

Another possibility with pixilation: the effect is surprising because the character moves without any apparent effort.

Problems Encountered

In reality, using pixilation is not that simple. First of all, what may seem easy to do in the studio is less so outdoors. While frames are shot to recreate the movement little by little, the environment itself continues to gradually change. For example, any sequence showing the sky displays an acceleration of natural phenomenon, such as the movement of the clouds. We thus see two temporal universes on the screen: one, a human universe, recreating an unnatural movement (but one which is accepted by the viewer as being 'in real time', once they have accepted that the protagonists' movements do not follow a realistic logic), and the other universe represented by the natural phenomenon speeded up, a far more disturbing visual image because of the clear discrepancy with reality.

To avoid this, the film-maker must include the sky (or any other part of the set which could contain elements that have their own, uncontrollable movement, such as the movement of leaves blown by the wind) only if it cannot be *partitioned* in any other way. Nevertheless, because the movements of the characters are not realistic,

In the background, the trees can be seen rustling slightly. It was difficult to have sets throughout the film that did not include the natural environment.

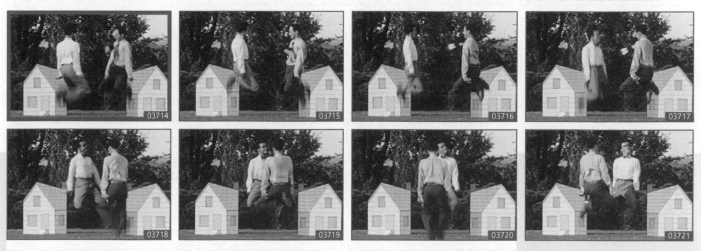

these inconsistencies are paradoxically well accepted by the audience: the spectator may not even notice the strangeness of the phenomenon.

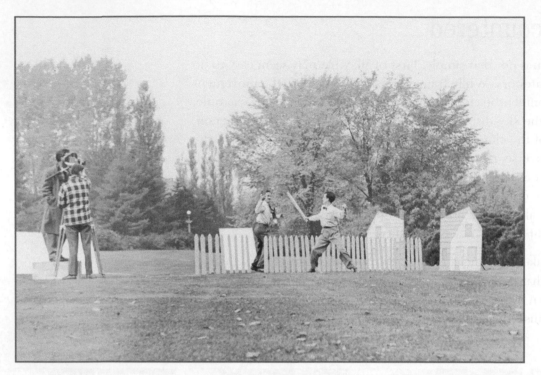

The minimum filming crew: the camera is turned towards the ground (high angle) to limit the sky's presence in the frame and to highlight the angle of the pickets. Note the presence of a reflector behind the character on the left to soften the shadows.

On the other hand, changes in light intensity due to the movement of the sun and/or the clouds posed greater problems. Firstly, the time of year to film had to be carefully chosen, as well as the day and time, so that the hours of sunlight viewed in fast motion did not show too much variation. Secondly, the frames in a sequence had to be shot within the shortest period of time possible and finished before the end of the day.

Another type of problem, easier to overcome this time, can arise from the actor's interaction with their environment. For example, it is not advisable to walk on the grass between two recordings of an image, as it bends under foot and then comes upright again after some time. On screen this would give us the feeling that the grass shakes without any reason. *Neighbours*, which was filmed on an outdoor lawn, has all these problems to clear with.

Linking one pixilated character to another who does not move enough to seem animated: in this sequence, the pixilation is associated with elation and enthusiasm.

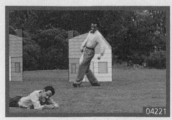
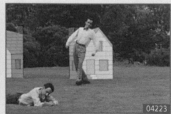
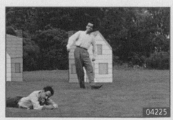
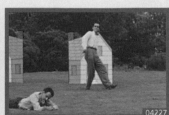

A Variant of Pixilation

In order to maintain the rhythm, and because the technique had to be adapted to all the different sequences in the film, McLaren also used the camera in continuous rolling mode. As in the case of filming using an intervalometer, the camera was programed to automatically and regularly record images at intervals during which the actors could assume their new poses. This time lapse lasted from 1/16 of a second to five minutes. It could also be varied within a sequence to be adapted to the technical requirements linked to the characters' action. The most rapid speeds (only 2, 4 or 8 times slower than the traditional 24 frames per second) were used for the simple movements the actors performed themselves, 2, 4 or 8 times slower than in reality. The movement on the screen thus seems identical to that which the film-maker would have obtained had he filmed using 24 frames per second with actors performing in real time; the difference is almost a form of visual filter that enriches the performance (trembling limbs, poses impossible to hold during filming, etc.) and creates quite strange body movements.

In the October 1953 edition of *Canadian Film News*, Norman McLaren explained that this process gave the possibility, where shots were fairly spaced out, of twirling a woman around without her skirt billowing out due to the centrifugal force. This also makes the audience feel that either this natural force does not exist in the filmed world or that the skirt is made of lead or a very heavy material. This type of pixilation allows more realistic movements than those that are highly controlled in stop-motion (such as in the flight analyzed above, which was created through consecutive jumps). Moreover, it does not require much time to film and thus allows the film-maker to avoid, or at least to limit, the problems that arise from interacting with the environment. Finally, it allows, by simply varying the speed of the camera and not that of the actor, the exact acceleration or deceleration of a given movement.

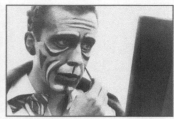

McLaren sitting next to Grant Munro as he puts on his make-up for the murder scene in which he regresses into a primitive state. This idea came from Grant himself, adding a powerful dimension to the story: war is a consequence of the bestial nature of man.

The development of the make-up follows the dramatic composition. Pixilation and the editing allow the passage from one stage to the next. Here, the make-up is simple and artistic, as the murder has not yet been committed.

The make-up at a more advanced stage of the character's evolution: the hand pose expresses aggressiveness. The clothes have also changed: the bow tie is undone, the shirtsleeves unbuttoned...

After the massacre: only the tattered clothes remain, the face seems relaxed. The light shows that it is the end of the day: the twilight of humanity.

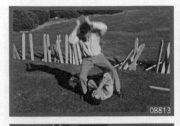
08813

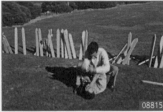
08815

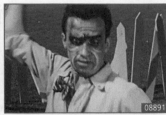
08839

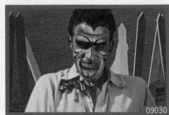
08891

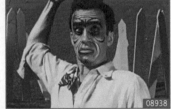
08938

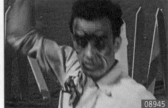
08945

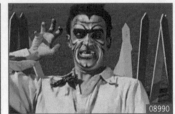
08990

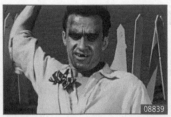
09030

The final result on screen: filming is accelerated and there is a break between each stage of the make-up (the frame jumps slightly). It is one of the most brutal scenes in the film: the climax.

O. C.: *Between the end of the 1940s and the early 1950's, you organized a lot of tests with McLaren to understand and learn the technique of pixilation. How did this develop?*

G. M.: *We did lots of tests between 1946 and 1951. Single images, double images, 16 images per second, 24 images per second, 8 images per second... In spite of all that, there was a lot of improvisation throughout filming, which lasted four weeks if I remember correctly.*

O. C.: *How did you deal with the changes in lighting caused by changes in the exposure to sunlight?*

G. M.: *We had to stop filming when it rained or when the sun was hidden behind a cloud. It was very hard and tiring.*

O. C.: *Was the film edited during filming to make sure that everything was okay?*

G. M.: *No, I edited it at the end. It was also my first editing job.*

During the fight, the highly prized flower is trampled on. The object of desire is forgotten in the wake of pure savagery.

09276

09282

09298

09426

O. C.: *What were the main difficulties that you encountered during filming? I'm thinking in particular of the grass stirring when it's walked upon...*

G. M.: *There were several different problems. For example, some leaves change color, the grass ripples, the shadows of the characters change... We also had to redo the scene of the death of the characters because it was destroyed in the laboratory. Then it was winter and we had to deal with a frozen field covered in snow.*

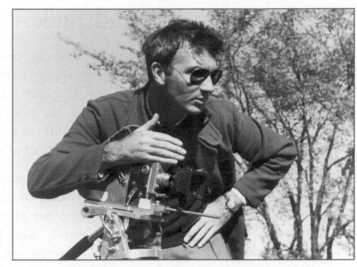

McLaren and his film camera: a classic 16 mm which looks quite small on its tripod. Note the use of a sun shade which was all the more necessary as filming often took place when the sun was low in the sky.

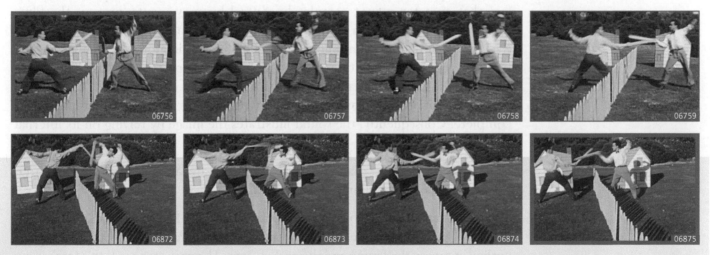

The action appears speeded up in these two sequences. The movement is achieved through the recording dynamic, the rhythm of the shots. The light changes sides from one sequence to another: the shadows show that the two sequences were filmed at different times.

Soundtrack

Among his numerous revolutionary inventions, Norman McLaren perfected a number of techniques to produce sounds synthetically from drawings. *Neighbours* is the first film in a long list that would allow him to explore the possibilities of animated sound. The imagery in *Neighbours*, with its rather particular dynamic, does not support a traditional soundtrack. The use of an acoustic orchestra, in particular, would have seemed out of step, regardless of the composition of the score.

Pixilated animation prompts the creation of highly abstract movements which lack flexibility. Consequently, the soundtrack must use rhythmic rather than melodic or harmonic effects. The choice of the film-maker, who had already worked extensively using pieces of jazz music, could have naturally fallen on a sound based on percussion, or at least one which was highly rhythmic. However, the acoustic nature of traditional instruments risks sounding awkward alongside the fantasy developed by the image.

For fairly simple technical reasons, it is difficult to anticipate precisely the final result of a pixilated shot. The various parameters of the shot, and particularly the fact that an actor cannot completely control his movements, prevent the film-maker from calculating a precise timing. We have also seen that the story in *Neighbours* developed continuously throughout production: the length of the film and of the different sequences that it is composed of were manipulate during editing and essentially decided upon at the end of production. Given these special conditions, the soundtrack was written after the image continuity was complete. Consequently, the sound illustrates the image by relying on its internal rhythm.

Having developed the technical process to create animated sound, McLaren himself composed the soundtrack to the film.

The classic optical sound consisted of juxtaposing on the film (next to the images that make up the visual continuity) a continuous, transparent track with an irregular outline, between the frames and the perforations. The projector reads this track using a lamp that projects the information onto a photocell, which converts light intensity into sound waves. According to the outline of this track, the pitch, tone and volume of the sound vary in time.

The precision of this mechanism, which has always been used in talking films (with the exception of magnetic tracks, later developed to have a greater band-pass), is exact enough to reproduce the music, sound effects and even voices. Simply, it was visual information transformed into sound. McLaren had the idea of using this technique to invent a sound from scratch using visual information; in this way, he *inverted* the original process.

The technique relied on a system of cards shot under the camera. Based on research carried out previously by Rudolph Pfenninger in Germany at the beginning of the 1930s, McLaren painted black stripes on many pieces of white cards to represent specific sounds. There were a considerable number of small boards, arranged by pitch, that he filmed one after the other. The cards were almost 51cm long and 10cm wide. There was one for each semitone over a range of 6 octaves.

Each note was obtained by drawing stripes of identical length but differently spaced, on the card. Thus, for the A corresponding to a frequency of 440 Hz, 440 bands had to be juxtaposed along the edge of a film moving for one second to create the right note. A simple calculation allows the number of bands required for each image to be determined, by dividing the frequency by the number of frames needed to create a second of film: 444/24 = 18.33. A card with 18 1/3 grooves photographed integrally will produce the sound in a frame as a correct A. Other frequencies are obtained by using similar calculations (the frequency of the A of the high octave is doubled and is thus made with a card bearing 36 stripes and 2/3).

The intermediate frequencies, slightly more difficult to calculate, are created by applying the same basic principle. The cards were kept in a box that McLaren used, in his own words, like a keyboard. The length of a sound depends on the length of the track on the edge of the film moving in the projector and thus the number of images recorded. A short sound is only recorded for a single frame. A long note needs an exposure of 20 to 30 frames (roughly one second).

The force of the sound, the volume, remains to be dealt with. If the sound must be heard pianissimo, the card will be lightly covered by a black sheet which reduces the visible (and thus recorded) surface of the drawing. A crescendo can be created simply by progressively uncovering the card by moving the sheet.

The box in which the different cards were kept was decorated like a piano keyboard to make it easier to find the right note.

McLaren places one of the cards in the device, which modulates the intensity. Above, one can see the slit which will reduce the total surface area of the basic card.

In order to optimize the *attack* and the resonance, McLaren made a device that allowed two black masks to slide over the card. This was placed underneath and was more or less visible during exposure, depending on the angle formed by these two shutters.

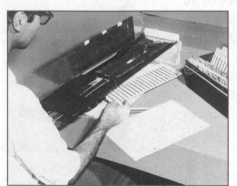

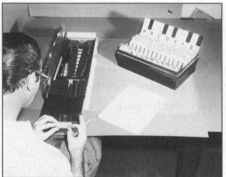

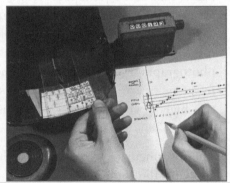

McLaren slides the card in the device, which allows him to make the attack (the start) and sustain (the hold at the end of the note) of a sound.

You can clearly see the striped card that corresponds to a given frequency displayed by the two sides of the device shaped like a pair of scissors.

Work to synthesize the sound takes place after the music is composed. The film-maker is helped by a score which shows the techniques required to transpose the 'sound cards' into the system.

In spite of his interest, pixilation is a seldom-used process, because, ideally, the dynamic of the image produced must be consistent with the drama of the film. For *Neighbours*, the behavioral dysfunction and progressive violence of the characters are perfectly appropriate. Their style of moving closely follows

the psychological progression: it is here that we find the basic principle of animation, which involves using movement meaningfully. This technique also allows the use of some temporal short cuts while introducing a fantasy that sets the film apart from a live action film. This is the case, for example, when the two protagonists build a barrier by simply showing the back of their hand. Norman McLaren unites the body and the soul, discourse and technique, experimentation and narrative. His greatest talent is knowing the best way of inventing intelligently and profoundly while entertaining.

This film primarily has a moral and philosophic mission; it closes with a series of title cards in different languages as a reminder that it is not merely a comedy.

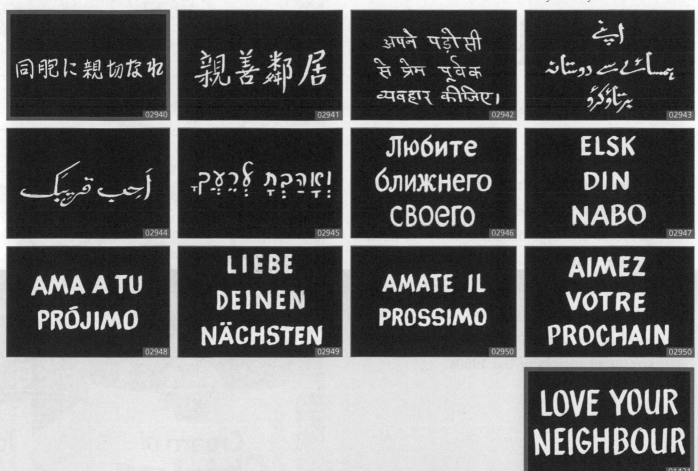

Frank Film

This film is a narcissistic, tongue-in-cheek autobiography. The voice-over narrates the personal experiences of the director; the commentary is illustrated by hundreds of thousands of pasted images – mounted, gathered and organized in a powerful visual stream that represents the creator's own world (a youth ultimately similar to that of many others) as much as it does the culture in which he grew up – that of the American consumer society of the 1960s.

Oscar 1973

Frank **MOURIS**

Credits

descriptive

Title: *Frank Film*

Year: 1973

Country: United States

Director: Frank Mouris

Producers: Frank and Caroline Mouris

Screenplay, graphic design, animation: Frank Mouris

Technique used: Cutout and collage, paper

Sound: Tony Schwartz

Length: 8 min 40 seconds

Frank Mouris began his career in cinema animation after studying graphic art, architecture and cinema. This broad base of experience freed his spirit and set him apart from traditional film-makers. He used his fondness for cutout images as the basis of his work. The principal techniques used in *Frank Film* were developed in his subsequent works – either his own, or those commissioned (particularly for television). With the support of his wife Caroline, who produces the films, Frank Mouris remains an independent film-maker, making a living from his work whilst, at the same time, developing an aesthetic that is all his own.

Screenplay

In the counter-culture movement of the late 1960s and early 1970s, new ways of thinking and innovative aesthetics began to take prominence all over the world, especially in the United States. Alongside painters, musicians, choreographers and dramatists, the visual artists of cinema animation explored hitherto unknown or unrecognized pathways. Traditional narration in particular was abandoned in favor of a more individual expression, far from being aimed at the average viewer/audience. These artists also appropriated new plastic materials, and reinvented cinematography by using the mechanical and *psycho-physiological specificities* of the medium itself.

Frank Film is one of the most emblematic works of this innovative and explorative generation. Organized like an autobiographical story, an exhibitionist one, the film pushes the boundaries of filmic perception by imposing an extremely rapid pace upon the viewer: we are at the very limit of animation, the flow of images overwhelms us. Each new image partially overlaps all previous ones, creating a constantly changing temporal relationship.

Frank Mouris loves animals, and when you love something, you don't keep count... Anywhere else this would be difficult. In the film, the director talks about the domestic animals that he had in his youth; here, the archetype of a pet animal is magnified by the quantity.

This work is evenly structured and based upon the systematic use of cutouts and collages sourced from magazines, which is typical of the Pop Art movement. This truly innovative iconoclastic work, with its use of groundbreaking techniques, won an Oscar in 1973; a rare occurrence for a first film of this era.

The Idea

The idea of making a film based upon his own life occured to Frank Mouris when he was a student at the University of Yale in the graphic design department between 1966 and 1969. He followed the teachings of Stanley Kauffmann at the Yale Drama School; it is there that he learnt that François Truffaut and Federico Fellini began their careers when they were still unruly adolescents, and that their own lives formed the basis of the screenplays for their first creations. One of his teachers told him repeatedly that many film-makers write and create their films from autobiographical facts. This discovery was a revelation to Frank Mouris. The idea for his first film was then decided – he did not suffer the typical indecision of the young film-maker over the subject of his first work. For him this autobiographical principle of plot development presented itself as an obvious opportunity for using the cutouts that he had been so fond of for years.

O. C.: Where did the idea for this film come from?

F. M.: I wanted to be an artist, but I realized that it would not be through graphic design, painting or sculpture. On the other hand, it was possible to express myself through film. We were the revolutionaries of the 1960s, fascinated by European cinema and American experimentation. But, contrary to what you might believe, there is no special message in this film.

O. C.: Your beginnings were quite disorganized. You do actually explain this in Frank Film*: you try many directions before choosing cinema. Yet to make a film of this nature, you need perseverance.*

F. M. I worked in London for three months on the credits of a Woody Allen Film (Don't Drink the Water)[1], I also wanted to work with Richard Williams, but that wasn't possible. When I returned to the United States, Caroline, whom I had married just before going up to Yale, advised me to work on the content of my films. She taught me how to structure most of the scenes; she's excellent at that (maybe that's because she studied psychology and finance at Harvard!). She's constantly there to guide me.

Finance

Another obstacle that often confronts the young film-maker is financing the film. Few producers are ready to place their trust in a beginner who, although full of good intentions, is without a single reference or guarantee. This eternal problem can become a vicious circle that is difficult for the young artist to break. Luckily, some governmental solutions exist in the United States that give the fortunate few a leg-up…

O. C.: How did you find the money to finance Frank Film?

F. M.: Many graphics students applied for scholarships from the American Film Institute. I was one of three award winners who were given 500 dollars. Yale applied to the Film Institute for grants for each of the 12 students in the class, but A.F.I. objected, so Yale ended up giving us the money directly. It was a great piece of luck, as we didn't have any money at all. On the other hand, we earned it afterwards, when the film went into distribution…

[1] *'Don't Drink the Water'*, directed by Howard Morris, 1969, from the original stage play by Woody Allen.

O.C.: *Did its success exceed all your expectations?*

F.M.: *Oh, yes,* Frank Film *was only ever intended to be 'an experimental graduation project', like so many others. I barely managed to make it to Annecy to attend the official première!*

O.C.: *What were the reactions there?*

F.M.: *Varied. But Roland Topor and François de Roubaix, who were on the jury, loved the film. The Annecy Grand Prix, which the film won, was not given coverage in the United States, but afterwards* Frank Film *won the Oscar.*

Here, you can see religion's influence on the director, with a growing sense of irony over the years. Throughout the film, you can see his fondness of using icons as a link.

Graphic Elements

Frank Mouris' desire was to develop an autobiographical story, whilst at the same time utilising the magazine cutting of which he is so found. He had already begun to collect these graphic elements before thinking of using them in the context of a cinematic creation. On the face of it, collecting these elements only requires a large quantity of visually-based material (thousands of magazines) and a good pair of scissors! Obviously in reality it was not that simple.

O. C.: How long did the screenplay take to write?

F. M.: Just a few days; the collection of the graphic elements took quite a bit longer: six years in fact...

O. C.: How was it organized?

F. M: The main technique consisted of collecting absolutely everything that I could find. When I created the shots, based around these cuttings, there were no scenes that posed any particular problems; it is the principal of 'objet trouvé', or 'found art'. The collage process doesn't work systematically, but there is always a magic side to it.

O. C.: You must have needed to collect an impressive quantity of original material!

F. M.: Above all, you need to be lucky enough to come across the right visuals at the right moment. For example, I didn't have many images of architecture, yet architecture had been very important at one time in my life, while I was studying it. I mention it in the film, so I needed to show it. There was someone at Harvard who was going through a difficult divorce and had left his wife with piles of his old architecture magazines. She wanted to get rid of them and gave them to me – a coincidence ...

Once again by chance, I met two authors of romantic novels at a dinner, who were going to move house; they asked for my help... to get rid of piles and piles of magazines, which, of course, I collected! Over the course of three days, I aquired an incredible quantity of magazines which dated back over decades. Stuff that I'd never have been able to buy.

An accumulation of all kinds of furniture. The interest created by these images comes from the enormous variety of styles. Each image stays on screen for between 1/6 and 1/12 of a second.

'I see you!' 500,000 paper cutouts can lead one to think that the number of necessary phases is what is important in animating a film, but certain images already comprise many elements by themselves.

O. C.: How many cutouts did you need to create this film?

F. M.: 500,000.

O. C.: That represents an enormous number of magazines! You had to find them...

F. M: When I was in London, I used to buy second-hand magazines. My mother and her friends used to give me theirs. I even 'borrowed' them from doctors' waiting rooms... But that wasn't enough. So then I bought the cheapest.

publications (Family Circle, Woman's Day) in packs of 20 from local supermarkets. Obviously I must have seemed like an odd person.

O. C.: Weren't there any serious differences, in terms of coloration, or contrast, or even in the print quality between one magazine and another? When you create a composite image, that can quickly become a problem...

F. M.: I had many doubts, and I was concerned about it, but, luckily, I need not have worried; all the magazines were printed more or less in the same manner, and, besides, the speed was so fast... In fact, the results might been better if there had been even more variation.

This surrealist collage, which could have been created by Max Ernst himself, brings together two of Frank Mouris' major obsessions – food and sex. Needless to say, not all the images used here came from the cooking pages of the women's magazines of the time.

An accumulation of images can be arranged around the same object stacked up to infinity. In this case, it is not so much the diversity of goods on offer in consumer societies that is being represented, but, rather, the idea that the quantity kills the essence of the object itself.

Filming Technique

The principal technique of this film, despite its great originality, is one of theoretical simplicity. It is a question of placing some 500,000 illustrations and photos on an animation stand, and recording them on film, so that they remain on screen for the correct length of time. The numerous graphic images are positioned and organized geometrically, so that they form a tableau for each frame of the film; they are replaced or stacked up at each phase of filming, so that the dynamic image produced keeps on changing.

In practice, the job is not so easy. In fact, it is almost impossible to manipulate so many cutouts (half a million, remember…) on the animation stand with perfect precision and, above all, in a reasonable length of time. Amongst the typical problems that can arise with this type of shooting are: estimating position, curling of cutouts caused by the heat from the lamps, difficulty of removing one element without moving another, etc. It is absolutely essential to develop a methodology to optimize the work involved. The aim of the paper cutout technique is freedom from using cels. Paradoxically, though, the cel will become Frank Mouris' indispensable assistant; as important to him as to the traditionally animated films of Walt Disney.

The cutouts were previously organized and stuck onto a cel, before being filmed on the animation stand. This film was not created by animating the cutouts themselves, as one would expect in this type of animation, but on cel. However, the graphic images are not drawn or painted on the cel surface – they are glued on[2]. This original process consisted of dabbing the back of the cutout with a glue that has an equal compatibility with the paper and the plastic (very difficult to find at that time) and applying it to the cel: after one or two seconds the piece of paper 'holds', the great advantage of this method being that you can gently lift it off for repositioning.

[2]This explains the small quantity of illustrations in this chapter; over time, the glue has corroded the paper and, unfortunately, there remains nothing left today of the original material.

Another technique was developed by Frank Mouris to optimize the work involved in shooting on the animation stand. He could not imagine spending his days in endless repetition of the same series of typical movements; placing a cel, wiping it with a duster, placing the glass on top to flatten it, taking one or two pictures, lifting the glass, removing the cel, putting it away, taking the next one, etc. So he carried out a quite unusual experiment: deciding to not remove the cels, he piled them on top of one another, thus saving himself at least half the work. On projection, instead of seeing a classic sequence of 'cuts' from one cel to another, the images behind are still visible. But only until a certain point; the cels are not totally transparent, so the progressive increase in the number and level of images gently and gradually makes the bottom cels disappear into a sort of greyish fog. The manipulation of the glass plate intended for smoothing out the cels was also eliminated, as the static electricity in the pile of cels stuck them together, ensuring that they remained flat. The animation stand was equipped with polarizing lenses, so there were no reflections.

O.C.: Shooting this film on the animation stand must have been amazing.

F.M.: Yes, there was only one eight-minute sequence.

O.C.: There was no allowance for mistakes then!

F.M: I worked for a week on an Oxberry (at Harvard), ten hours a day, to film the whole thing. I couldn't stand any more, and couldn't see the end.

O.C.: It was that hard?

F.M.: Yes, especially the sequence with the TV sets: because it was made up of cross fades, it was very tiring. I shortened it to get it done quicker. Physically, I couldn't have coped any longer working like that.

O.C.: Despite the preparation, mistakes are always possible...

F.M: I did make one mistake, with two images. As a result, I had to learn editing techniques (using roll-A and roll-B).

O.C.: And that was all?

F.M: The title also needed editing.

09772 09773 09774 09775 09776 09777 09778 09779 09780 09781 09782 09783 09784 09785 09786 09787 09788 09789 09790 09791 09792 09793 09794 09795

Facing page: the animation is able to develop within the geometry of the frame. When viewing a sculpted work of art that uses the principle of accumulation (a work by Arman, for example), the viewer chooses the direction his gaze will follow. When viewing a work of film, it is instead guided by the director's intentional use of the frame.

O.C.: *Weren't there any technical problems in accumulating the cels in such a way?*

F.M.: *Yes, especially the problem of focus. It was necessary to adjust the lens to the distance of the cel on the top of the pile. But this distance got smaller as the pile of cels got bigger... Fortunately, in working with a very small aperture, I could improve the depth of field to limit the damage. I thought for a moment that there was a real problem with focusing, that the image had become blurred, but this was not the case.*

O.C.: *But, with the pile that thick, surely the cels couldn't be locked into position on the pegbar, because the pegs are only a centimetre or so high...*

F.M.: *That's right. I'd even thought about making a really deep pegbar, but that wouldn't have been useful, as my animation doesn't need great precision of placement. The cels stuck together through static electricity so there was no problem, even with the cels standing higher than the pegs.*

Here is an example which really demonstrates the principle of accumulation of graphic elements. We can see that the background and the collages in front darken with an increase in the number of cels. At the bottom, we can see the perforations for the pegbar and the imprecision of the positioning.

Animation

It took a year to organize and stick the cutouts onto the cels; quite a significant length of time, even taking into account the number of elements to be handled. It was never just a question of assembling them on one surface. The feeling of simplicity in the animation itself is also reinforced by the view that one has of the film: with the exception of a few sequences, the cutouts seem to be positioned with the sole aim of being seen just as and when they appear; but here, again, the work is more carefully planned than it seems.

O.C.: How is the development of the timing organized? You must have had to find a good balance between the flow of the images and the public's capacity for perception...

F.M.: There are many timing variations in Frank Film: the fast, the very fast and the super fast! We have often been told that the film 'goes too fast'. But the public can 'see' images that follow each other very quickly, especially in recent years, because their perception has improved thanks to commercials, pop promos, and the general pace of modern cinema.

There was an amusing experiment, precisely in relation to the perception of rapid images: an American army general had wanted to train his men to increase their speed of visual perception; he showed them a film and, contrary to what you would think, they were capable of perceiving images that only lasted 1/50 or even 1/100 of a second, because all of them saw the image, however furtive, of a naked woman!

A famous sequence from the film. The accumulation technique gives way to a more traditional piece of animation organised around a central figure: Frankenstein. There is a play on words between the name of the director and that of the character.

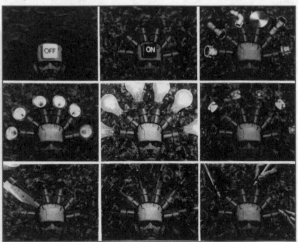

O.C.: These techniques and experiments concerning cinematographic perception were explored by film directors in the 1960s; this is quite a common basis for the work of directors of your generation and your culture.

F.M.: We are not only interested in 'telling a story', but also in making the brain work in a different way.

O.C.: We've been talking about the perception of images. Just how was the right tempo worked out?

F.M.: That was the most sensitive issue. In the end, the animation was made 'on twos'. We had a valuable piece of equipment at Harvard, a projector which was used by the coaches for the study of sports events,

and its speed could be changed. This tool enabled me to do tests, researching tempo. Despite everything, it would not have bothered me to animate it all on one image[3], but Caroline stopped me; it's true that, at that speed, the public wouldn't have perceived the movements, and hardly even the images... Animation 'on twos' also allowed me to economize since, otherwise, it would have needed twice as many graphic elements

O. C.: Let's talk a bit about the animation itself. Did you sketch it out before you put the cutouts on the cels, or was it created as it went along?

F. M.: My method was simple, as I am neither a good painter, nor a classic animator. I began with a first cel; I placed and stuck an element on it, then another and yet another, until I had almost filled the surface ('almost' because I was leaving part of the cel untouched, so that you could see through it to the cels beneath). Then I would take the next cel and put the elements that should appear on it in the free spaces, and so on.

O. C.: Nevertheless, the whole film isn't organized on this principle, as there are sequences in which some elements stay fixed, whilst others are animated: I'm thinking especially of the TV sets that are fixed, but whose contents are animated, or the image of Buddha in the center of the screen, or the bust of Frankenstein...

F. M.: For that, I used a technique that is definitely more traditional: quite simply, you have a cel that does not change and others that are replaced underneath in animated series. That meant more work for me, but it was necessary.

O. C.: Let's look at the sequence of the piled up TVs, for example.

F. M.: That was hard work, as I had to forever lift and replace the cel above and cover up the 'contents' of the screens. On the other hand, I enjoyed creating this televisual padding, the series of cels, before filming. The elements depicting the TV content were able to overflow from the TV screens. I put the cel of the TV sets underneath, then the cels onto which I was sticking the 'content' on top and positioned them relative to the screen shape that had been removed from the TVs.

O. C.: And for the Buddha?

F. M.: There were several cels: one for the Buddha, and others for each of the letters that appear and stay on screen (until you can spell a word). That was quite a pile of images.

Television, object of consumerism par excellence, and the flow of images that constantly pour from it. Critic of the media? Object of fascination? Emblem of 1960s youth? The images of the actual TVs sets are fixed onto cels, one on top of another. The random images that then appear and change on the screens are placed on cels underneath.

[3] *Animation on ones: each image of the definitive film is different to the preceding one. There are therefore 24 distinct images for one second of film, which allows for a smoother-flowing animation, particularly in the context of rapid movement. Generally, for production reasons, animation is done 'on twos' (12 drawings per second). In the case of Frank Film, an animation on one (image) would have resulted in a pulpy mixture that would have been difficult for the viewer to comprehend.*

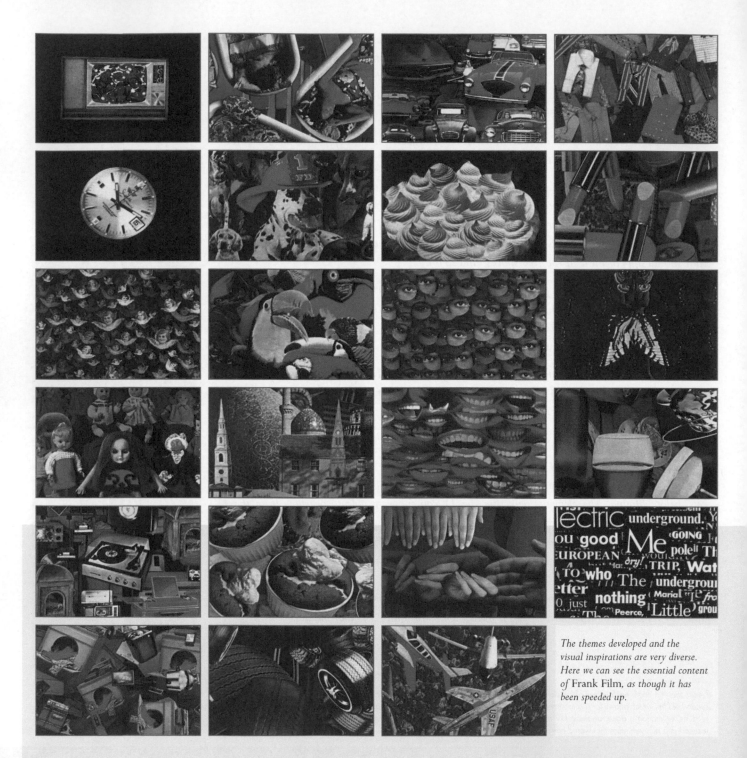

The themes developed and the visual inspirations are very diverse. Here we can see the essential content of Frank Film, as though it has been speeded up.

Soundtrack

Rarely has a soundtrack appeared so simple: a voice, without music or sound effects, serves up a summary text, read in a monotonous tone. There is as much a desire to minimize the technical methods as the dramatic ones. This simplicity is obviously intended: it contrasts with the maelstrom of images that fill the frame and provides a counterpoint that is reassuring as the visual text gives the necessary reference points to comprehend the visual information.

O. C.: In the context of animation, mainly for reasons of synchronization, the soundtrack is usually done before the visual one.

F. M.: Yes, but not for Frank Film. There was some editing – scenes had been filmed at different speeds in order to do tests and, finally, we opted for animation 'on twos', so the definitive length wasn't established until the end. The film tells the history of my life, past, present and, to some extent, my future. We didn't know what to do for a soundtrack.

O. C.: There is no music…

F. M.: In the 1960s, I was interested in composers such as Philip Glass and Steve Reich. I wanted to use their work, but it didn't happen like that.

O. C.: Why was that?

F. M.: I was familiar with the radio adverts of Tony Schwartz (notably for Pepsi), which only consisted of sound effects and edited voices. When we were in New York, I thought that it would be enough to just go and see him for him to agree to do our soundtrack. Obviously that was not the case. So I asked him to come and see the film with no sound, while I explained my intentions for the soundtrack.

O. C.: And did these intentions amount to a voice-over?

F. M.: It was one of my intentions. My idea was to use only words beginning with an 'f'. I set the projector running and read my list of words beginning with 'f' (that I had taken from my dictionary) to Tony. After only a few minutes, he told me to stop, and proclaimed that it had nothing to do with the film! He then fixed me up with a microphone and told me to tell the story of my life while the film was running, and that he was going to record me... That was the longest nine minutes of my entire life.

O. C.: All the same, you can hear the two tracks, even if the more classical narration plays over the top...

F. M.: We played the narrative recording and the images together and Tony said 'There's your soundtrack!' But we were not entirely convinced. I struggled with it – I was sure that I really did want my list of things beginning with 'f' – could we maybe mix the two together? What was there to lose?

O. C.: Did this editing take a long time?

F. M.: He left with the material and edited the whole thing. At that time, we used to edit by cutting the tape with razor blades. He came back several hours later and we were staggered by it: the mixture worked perfectly.

O. C.: This list of words beginning with an 'f' is nevertheless unusual.

F. M.: I used my old dictionary (Webster's New World Dictionary of American Language, 1960 edition) and I noticed that there were 71 pages of words beginning with the letter 'f'. The only words spoken that do not begin with this letter are the birth date, the years 1945 and 1973, and the names of people and domestic pets.

O. C.: How do you feel when you are describing your life and when you claim at the end of the dialog that the film would win a prize in a big festival and would maybe even win an Oscar? (Which did happen!)

F. M.: I was 29 years old and I hadn't done many things. So, I invented my future and, in doing so, made it the best one possible. I put on a voice that was very tight lipped with no humor. This was obviously interpreted very badly by some people...

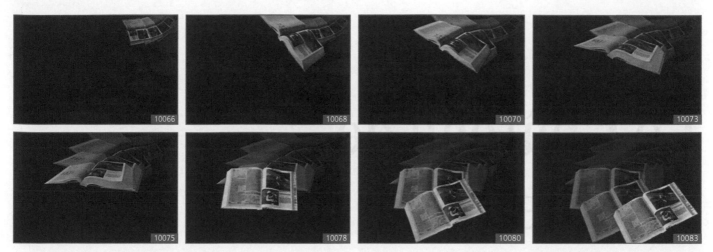

An almost classic piece of animation.
The magazine takes off and flies around
in the background. Notice the logic of
the perspective and the remanence of
the frontal positions, due to the piling
up of the cels.

Frank Film is rarely broadcast, you would have to be very lucky to be present at a showing. Just like most of the experimental productions of the East Coast in the 1960s and 1970s, copies are rare and the few distributors that sent out the film have shut up shop. *Frank Film* should, however, go and meet a new public; this ultimate experiment, symptomatic of a certain way of interpreting cinematography, is sorely missed these days and is only viewed in cinema as an offshoot of the novelistic tradition. Watching *Frank Film* gives us the opportunity to free ourselves from habits and conventions. The spectacle, beyond the pleasure engendered by its deadpan humor, enables us to go back to our roots and to consider the art of cinema in a liberating way.

Le Château de Sable (The Sand Castle)

A creature made out of sand emerges from a dune in a desert landscape. By sculpting the surrounding sand, he brings to life other creatures who, under his direction, build an impressive sand castle; each creature contributes according to its physical attributes. After a series of events, the castle is ready. However, when the characters celebrate the completion of their work, the wind blows, destroying everything and causing the entire team to disappear under the sand waves.

Oscar 1977

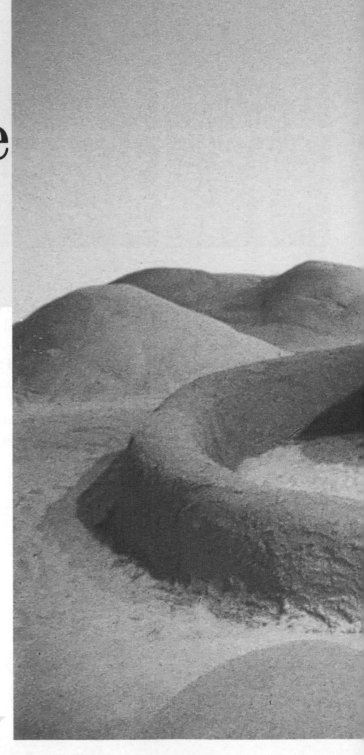

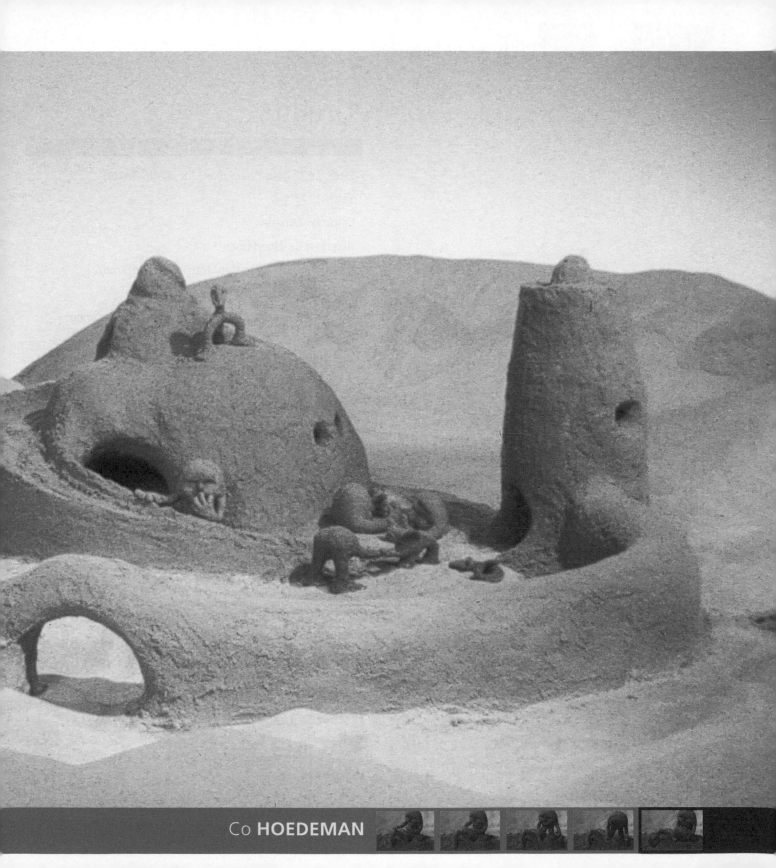

Credits

descriptive

Title: *Le Château de Sable* (*The Sand Castle*)

Year: 1977

Country: Canada

Director: Co Hoedeman

Production, distribution: National Film Board

Producer: Gaston Sarault

Screenplay, animation, set, artwork: Co Hoedeman

Technique used: Stop Motion Puppet Animation

Music: Normand Roger

Sound: Jean-Pierre Joutel

Editing: Jacques Drouin

Length: 13 minutes 12 seconds

Jacobus Willem (Co) Hoedeman was born in Amsterdam in 1940. After studying art and specializing in cinema, he settled in Canada and joined the NFB when he was 25. Some of his early films were inspired by Inuit art and legends. He also studied puppet animation in Czechoslovakia and quickly became one of the main film-makers specializing in puppet animation at the NFB. His work is mainly geared towards children and abounds with technical difficulties: for example, *The Sand Castle* (1977) uses sand, *The Treasure of the Grotoceans* (1980) presents weightless seabed creatures and *The Sniffling Bear* (1992) combines 2D characters and 3D sets, etc.

Screenplay

The most incredible trademark of Co Hoedeman's work is perhaps the perfect and pertinent way in which he makes use of basic materials to enrich the narrative. In each of his films, the animated elements are carefully chosen so that they are in one way or another well integrated in the structure of the story. Thus, in *Tchou-Tchou*, the children's toys (blocks which have parts of characters painted on their faces) are animated not only in terms of movement, but also in terms of artwork: in each frame, the cubes are replaced by doubles other blocks showing the characters at another stage in the animation of the legs, torso or head.

In *The Sniffling Bear*, the characters are flat. They are made of torn up pieces of hand made paper, following the outline of the stages of the animation; they move on a three dimensional snow field in stop-motion. This unusual, destabilizing choice creates a multidimensional universe that supports the theme of the film perfectly – to explain the dangers of drug addiction. The film has its share of technical difficulties because the characters (including the birds) must be made to stand without any visible support, even when they start to bend, frame by frame, to suddenly assume a curious dimension somewhere between flat and a volume.

Co Hoedeman adds the extra dimension of size to all of these technical requirements: the camera is usually placed at the same level as the protagonists, in order to draw the audience into the fantasy world of the story. Regardless of the film, the characters also acquire a special realism due to the ease with which they evolve in their setting: they can jump, slide, and lose balance, all of this in spite of the difficulty the film-maker faces in making them hold the pose for the time it takes to record the image.

In *The Sand Castle*, the mix of wet and dry sand, animation, characters that move on a soft sand surface and the final sand strom which devastates the castle, are technical difficulties which initially appear insurmountable.

The original purpose of all these elements is to draw us into the special world of the film-maker. Let's consider the methods used by Co Hoedeman and the often inventive and surprising 'tricks' he has used in this film.

O.C.: Where did the idea for this film come from?

C.H.: I was on holiday with my family on the beach in Holland in 1975 when I was struck by how serious people are when they make sand castles, as the rising tide will inevitably wash it all away. This idea hounded me for some time before I had the opportunity to be able to work on the film project.

O.C.: What in particular interested you about this subject?

C.H.: I wanted to create a story, like in a dream, with small fantasy characters that live in the sand and build a magnificent castle, all without real people in it.

O.C.: Did you want to communicate a particular message?

C.H.: No, I just wanted to make an entertaining film for children. It was afterwards, once the film was finished, that I received quite interesting feedback and I realized that there were a good number of 'messages' in the film. Some people interpret this film as being like a biblical parable, others see it as an allegory about industry or the economy... but I'm sure that children only think of it as a magical tale with small, funny creatures.

O.C.: With this type of entertainment film, do you think a lot about the audience when you are making it?

A close-up of the castle: the frame shows the characters and the set very naturally.

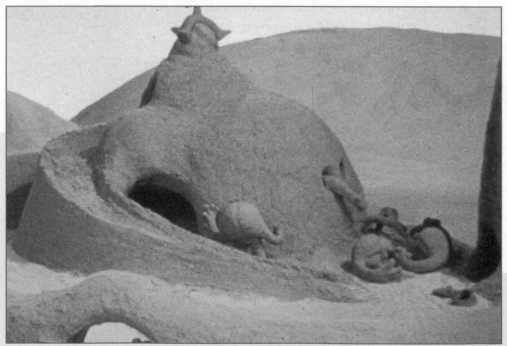

C.H.: One of my greatest fears is that the audience won't like the film. Of course, the fact that this is a form of personal expression matters a lot as well. Nonetheless, making a film is naturally a way of communicating with the audience and, subsequently, it would be wrong not to take its reaction into consideration.

The Idea

It is surprising that a film-maker who shows such technical brilliance does not follow the usual production chronology. Generally, the more technical difficulties a film contains, the greater the importance attached to the preparatory stage; a list of the problems that will arise is compiled. A solution is found for each of them, which is then tested and improved upon before embarking on the actual production stage. This is not how Co Hoedeman works: the storyboard design and layout stages are abandoned in favor of continual improvisation. Moreover, it is unbelievable that a production company would allow a film-maker such freedom. This is due to the trust that has developed between the NFB and some of its in-house artists, allowing people like Co Hoedeman to work under such conditions, and it is this that has enabled him to make such exceptional films.

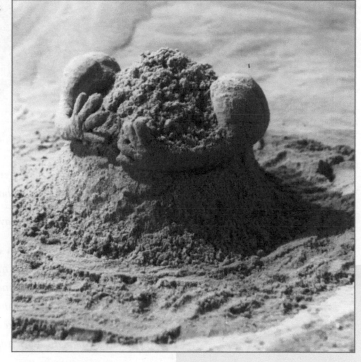

The two Pushers build one of the first towers. In each frame, a little wet sand is added to increase the general size of the building.

" *O. C.: Was the film clear in your mind from the start?*

C. H.: Yes, but I worked without a detailed script or storyboard. I structured the film as I went along.

O. C.: Did you spend a lot of time on the idea?

C. H.: No, a few minutes of daydreaming here and there... When I sit myself down to think about it seriously, the ideas just come. In The Sand Castle, the only real difficulty was creating an impression of great simplicity on the set, which always requires a lot of work.

O. C.: But how do you work on a project as complex as this without a storyboard?

C. H.: By progressing gradually. You start at the beginning with a plan in your mind, and you work on it until a problem arises. Once the problem is resolved, you start again until

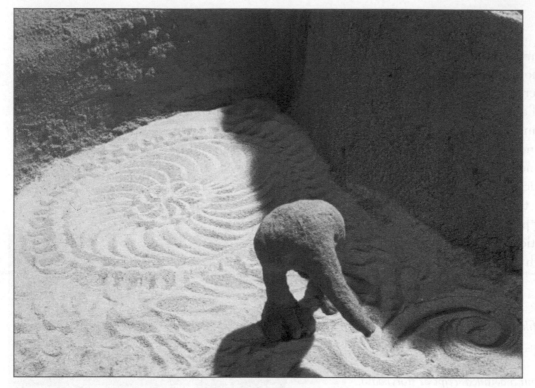

Animating the character and the ground was done simultaneously: all the movements had to be memorized to avoid making mistakes.

the next problem, and so on. But this method can only succeed if you work alone, without anyone else beside you.

O. C.: *The NFB accepted that?*

C. H.: *You have a lot of freedom here. For the project approval, I only had the general story outline. I submitted it to Gaston Sarault, a producer in the French animation department, who liked it. So I prepared a synopsis and I presented it, with a budget, to the program committee. I remember that some members of the committee weren't too convinced by the story; they thought that it wouldn't interest children. But fortunately the project was approved. After that, I had complete freedom in making it.*

O. C.: *All the same, did you have any 'images' in mind before you started?*

C. H.: *At the beginning, when I thought of the idea, the images that I wanted to obtain were perfectly clear, even if sometimes they show up in fragments. Once the story is in place, they don't change. But while filming, new spontaneous ideas came to me concerning details or how to animate a scene. For example, when the main character creates the little three-legged creature, I decided on the spur of the moment to make its feet perform a little dance before the creature was complete, without waiting for it to have a head.*

O. C.: *It's instinctive work...*

C. H.: *What's surprising all the same is, when I'm in the theater and I watch the film with the audience, I see and perceive it in the same manner as they do: I become emotionally involved as if I have never seen it before.*

The Stage

Like most of Co Hoedeman's productions, *The Sand Castle* obliged him to invent different techniques. While sand is a fascinating material, it is very badly-suited for use in animation. The list of obstacles to its use is long: the difficulty of only being able to modify a small part of the scene (sand is a fairly free loose material!), problems with the mechanical resistance of the material in the shots, it is impossible to suspend sand in the air, etc.

One of the main difficulties was to keep the sand moist for many hours. The dry sand didn't risk of becoming moist (except for the capillary effect through contact with a mass of moist sand). However, moist sand dries very quickly under the heat generated by the spot lights and projectors; the texture and color of the material then change completely. The solution was to use glycerin, instead of water, to moisten the sand. As Hoedeman admits amusingly, this solution also had the advantage of making his hands soft and beautiful.

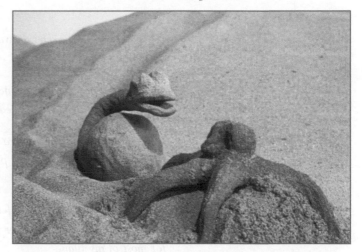

The camera is at the level of the characters, allowing the viewer to be drawn into the environment created by the film-maker.

The Sets

One of the possibilities in this film was not to use real sand or at least to alternate between real and fake sand, depending on the difficulties posed by each sequence. This choice was abandoned. Nevertheless, the dunes were sculpted in advance out of a solid plastic material to limit the quantity of sand on the work surface (sand is very heavy) and also to save time, because shaping the dunes using sand is a lengthy process.

The ground was made from plastic foam cut by hand. For each scene, Co Hoedeman chose the appropriate plastic dune shapes and placed them in front of the camera to create the scenery. The surface was then covered with a fine layer of sand chosen from samples kept in different boxes. These samples had all the different tones, colors and textures to create the desired look.

In order to recreate the necessary space for movement of the cameras (there were several), the studio was large: 7 by 8 meters and 4 meters high. This large space also made it easier to control the lighting quality. The spot lights were suspended above the set. This arrangement had the advantage of freeing the area around the sets from the stands and cables that usually clutter a studio and prevent the animator from moving around freely; moreover, the cameras could move more easily as nothing was in their way. The sky was simply the background wall painted blue.

O.C.: The set was quite large. When did you realize the advantages of working on such a large scale?

C.H.: Mainly for the final scene, because the set for the castle alone was nearly 4 by 5 meters and 1.25 meters high. I needed to use all the space available in the studio to film.

O.C.: In your films, the camera is often close to the characters, at their level. In this particular case, how did you manage to position the camera within the set and maintain its mobility at the same time?

C.H.: As the set was made of little sections that fitted together, I often built it around the camera. This makes the viewer feel that they are in the middle of the scene. I use this method for most of my films.

The finished castle: the set is big enough to accommodate all the characters making it easier to control the lighting.

O.C.: When we talk about the camera, we know that the mechanisms inside and the lenses loathe sand – it's one of a cameraman's worst enemies. Were there any problems?

C.H.: It's true that the camera was very often surrounded by sand, but it was always protected by plastic sheets. However, sand did get inside it and even inside the lenses.

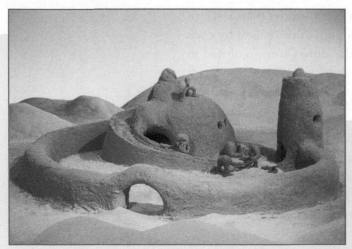

The horizon is almost at the same level as the Sandman. This frame clearly shows that the camera was close to the set and the characters.

O.C.: It's probably best to forget this awful point! What type of lighting did you use?

C.H.: The sky was lit by big flood lights set up independently of the rest of the set. For the dunes and the castle, I used 750W spotlights, which could be adjusted individually to avoid generating double shadows. To soften the shadows, a large flood light was placed next to the camera.

This photograph taken of the filming process gives a good idea of the size of the set and the difficulties posed by its size: it is not easy to reach the elements to be animated.

Making the Puppets

The characters used by Co Hoedeman differ greatly from one film to another: wooden blocks (*Tchou-Tchou*), torn paper (*The Sniffling Bear*), creatures covered in fur (*The Owl and the Lemming*), objects (*Matrioska*, made with the help of Russian dolls). In *The Sand Castle*, the characters give the illusion that they are made with the sand. This is clearly not how they were made; to articulate the puppets, metal armatures were inserted into them it was impossible to sculpt the puppets out of wet sand and animate them at the same time, therefore the characters had to be made in a special way. Co Hoedeman stated that the main difficulty (apart from creating the sandstorm and keeping the sand moist) was solving the problem of how to make the puppets.

O.C.: To make it clearer and because it's amusing, I'd like to know the names of the different characters.

C.H.: The main character, the one who appears first, is called the Sandman, the three-legged creature is the Stamper, the one with a trunk is the Gardener, the big head with arms is the Pusher, the body with a long neck that puts its head in the sand is the Ostrich — because it had feet before I cut them off!

O.C.: How were the puppets made?

The main characters in the film.

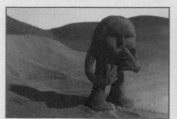
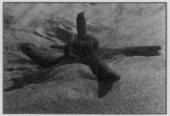
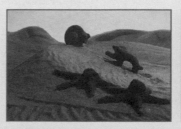
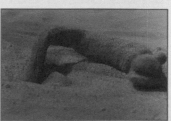

*Co Hoedeman and one of his puppets:
it is large enough to be handled easily.*

C. H.: *Rather than sculpting them from clay or pouring them into latex molds, I decided to cut them out of foam with a pair of scissors. In this way, I could give them a rough look. The next stage involved inserting the main armatures. I then soaked them in liquid latex, rolled them in sand and baked them all in a domestic oven at a low heat. It was the only way that they could appear to be made out of sand and at the same time make them flexible enough to be manipulated.*

O. C.: *Was there a risk of fingerprints being left on the puppets during filming?*

C. H.: *No, my fingers didn't leave any marks. But by handling the characters, the baked sand ended up crumbling off, somewhat changing their overall texture.*

O. C.: *Did the puppets need to be repaired often?*

C. H.: *From the outset, I made doubles in case the armature broke or any other accidents. Sometimes I had to repair a broken arm or a leg and to open the puppets carefully to repair the armature.*

O. C.: *While he was being made, the Pusher put on his own nose. Did you have to make two puppets or was this purely a sculpting trick?*

C. H.: *I simply added the nose at the right moment. To make sure that this would work, I made his hand sort of cover his face. It was the same for the Stamper onto whom the Sandman put a head: I carefully removed the headless puppet, added the head and then replaced them together.*

*The Pusher puts on his nose. This
independence allows him to continue
even though he is not yet complete.*

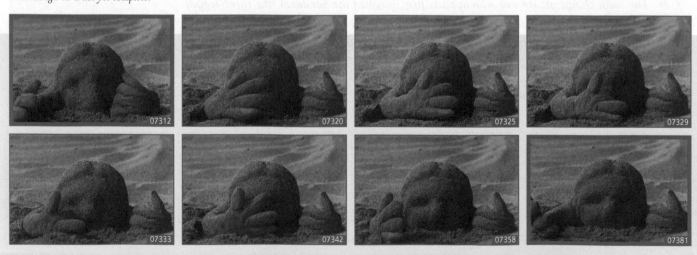

Animation

If making the puppets was a first major step, they then had to be given their own life through movement. However, even before thinking in terms of dramatic composition and expression, the technical problems linked to this type of animation need to be considered.

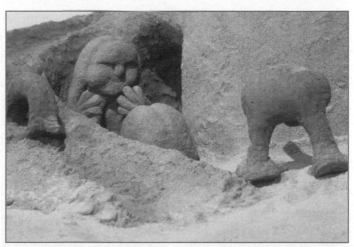

With their physical peculiarities, each character has its own way of moving. These characteristics must be controlled in the animation, even when there are several characters in the same scene.

> *O.C.: One question strikes me: how could you keep the puppets standing upright with sand as a base?*

C.H.: As the whole set was covered with a fine layer of sand, I could pin the puppets down with long needles stuck in the plastic or the surface of the table.

O.C.: Were these pins detachable enough for you to be able to remove them when their feet were above the ground?

C.H.: Yes, because the base was soft, I could remove them easily. Sometimes, to make sure that they couldn't be seen, I covered them with a little sand.

O.C.: Was this same method used to make the Pusher come down from the castle tower?

C.H.: Yes, you think that he's suspended in the air when in fact he's attached to the surface with pins.

O.C.: There is one particularly impressive scene in which all the characters dance in front of the finished castle. Did you animate it alone? Memorizing so many movements is an incredible achievement...

C.H.: It was actually the most difficult scene to film. The set was too big for me to be able to reach all the puppets from the front or even the sides.

The puppet conceals the device that allows him to be suspended in the air: using ordinary pins.

10912

10916

10918

10922

I made an opening in the table, just big enough for me, out of camera view, hidden behind a wall of sand. I wormed my way through the hole, moved the 13 puppets and hid under the table to take one frame.

So as not to confuse myself, I always animated the puppets in the same order, but even like this, the work was very challenging and demanded incredible concentration. At that time, the mid-1970s, video-assist did not exist which would have allowed me to check what I was doing; I had to remember all the movements.

There is usually one animator per character or at least the work is shared. In this production, Co Hoedeman animated all the protagonists by himself.

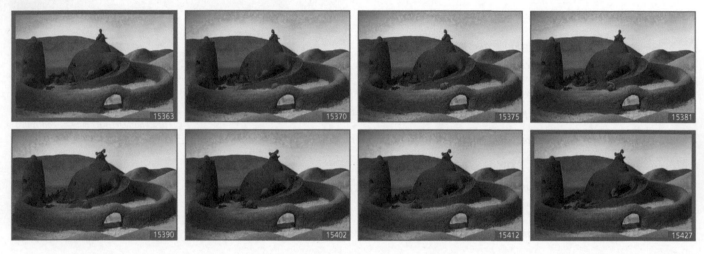

O. C.: *At the beginning, the Sandman emerges from the dune. How did you animate this without changing the surroundings, as at first the character is completely buried?*

C. H.: *For each frame, I brushed some of the excessive sand and pulled the sandman a little way out of the dune. I had to be very careful not to distrub the sand surrounding the puppet. As I made the sandman emerge, some sand fell down on both sides, adding to the realism of the effect.*

O. C.: *How did you do the Ostrich regurgitating the sand which brings the materials necessary for the building of the castle?*

C. H.: *I added moist sand (with glycerin) in front of the puppet, frame by frame. Then, I replaced the character every three frames with a smaller version, except for when he swallowed the sand, then I replaced him with a larger puppet.*

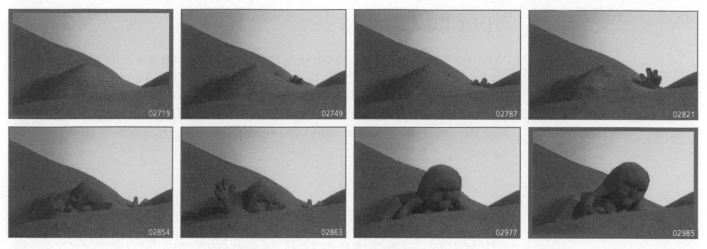

The Sandman emerging from the ground: a scene that had to be created carefully.

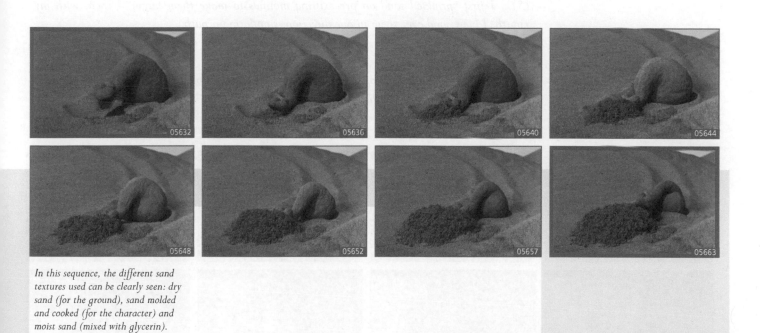

In this sequence, the different sand textures used can be clearly seen: dry sand (for the ground), sand molded and cooked (for the character) and moist sand (mixed with glycerin).

Special Effects

We have seen that, from a technical point of view, films made by Co Hoedeman are systematically complex to make. He gives priority to his imagination before thinking about technical feasibility. So, he often has to resort to the tricks of the trade i.e. special effects. In *The Sand Castle*, the whole film needed special tricks so that the characters' actions could be presented as being like *those of the elements in nature*.

O. C.: Which scenes were particularly difficult to do?

C. H.: Creating the sandstorm to start with was quite complicated. It was impossible to do on a large surface as that would have required an enormous amount of sand. The only solution was to film these sequences very close to the camera.

O. C.: In concrete terms, how did you do that?

C. H.: I first sprinkled sand on pre-existing mounds to make them larger. I then, with my mouth, I blew sand over them in one direction, simulating a path.

O. C.: And the sand in the air?

C. H.: I threw sand in the air and took a frame at the same moment and repeated that for each frame: modifying the dune, throwing sand in the air...

To make the sandstorm effect credible, the rhythm of the animation had to be accurate and the soundtrack complements the action.

00643 00704 00785 00986

Sand is also used to spell out the title: this gives the film coherence as a simple title card would have detached the audience from the story.

O. C.: Even the film title is amazing: the letters are written in dry sand, as if they have been hand written. How did you do this?

C. H.: The title was drawn frame by frame in the sand. For each frame, I drew the letters with my finger or a pen. It's the same trick that I used when the Gardener draws patterns in the sand. I also used cross-dissolves to make the patterns disappear, notably when the title fades away (in five seconds). On the other hand, the patterns drawn in the castle were gradually erased by sprinkling sand on the shapes until they disappeared completely.

O. C.: One of the animation sequences is puzzling: in the scene where, the Pig jumps over a mound and is blurry. It's completely logical, as he is moving, but how did you manage to do this in stop-motion?

C.H.: It's simple: he was suspended from a thread and swung like a pendulum. I took the frame when he was in just the right position and the right spot. The camera was adjusted to an exposure time of ¼ second (while moving, the nylon thread became invisible).

Seeing a moving character as a blur seems natural and logical to us. But if you think about it, you immediately wonder how this effect was achieved...

06388 06395 06397 06399
06401 06403 06405 06407

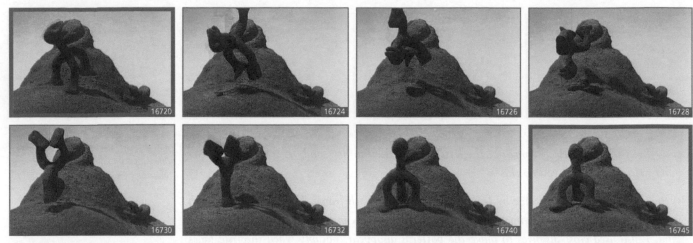

The Stamper somersaults: if you look
carefully, you can see threads and
Plexiglas cubes, but as these aids change
in each frame, they become invisible in
the film, even on the big screen.

The special effect to destroy the wall of
the castle must appear natural so as not
to ruin the magic of the scene. The
means to do this is simple but require
great accuracy.

O.C.: When the Gardener jumped over the Ostrich, I'm sure I saw some threads and transparent cubes.

C.H.: I mainly used highly polished Plexiglass cubes, but in this case, I sometimes combined Plexiglas cubes with nylon thread. That's also what I did when the Stamper was dancing.

O.C.: The final destruction of the castle is impressive: you really feel that you are an eye witness to this event, in live action and not animation. What method did you use?

C.H.: This was quite difficult to do. The walls of the castle were made of wet sand. Those that had to collapse were gradually scraped, while dry sand was added from above. At the same time, outside the set, I used a small air compressor to blow the dry sand at the same time I shot the frame. The same process was repeated for each frame: manual destruction of the wall, adding sand from above, blowing sand in the air. I had to redo this operation 120 times for five seconds of film (5x24); this sequence was filmed in a single take.

Sound and Music

Co Hoedeman works regularly with Normand Roger, a composer specializing in music for animated films (even if he also works on documentaries and other kinds of productions). We will come across him several times in this book, as he is credited in eight short animated films that have won Oscars, four of which are presented in this book (*The Sand Castle, The Man who Planted Trees, The Old Man and the Sea, Father and Daughter*).

As well as Normand Roger's undeniable talent, several other factors can explain his incredible success. Firstly, he is self-taught; he was not trained at the most prestigious music schools or conservatories. In his youth, he was a member of a rock band. This experience allows him to move easily from a synthesizer to a grand orchestra; he is not an orthodox musician. On the contrary, Normand Roger is always concerned about the overall soundtrack of a film; sound effects are just as important to him as the music score. Moreover, he has developed a singular ability to devote himself to the ideas, the film-makers' feelings and the specific needs of each film. For him, the film is not merely a medium to show off his work; he considers himself to be a real collaborator with the film-maker.

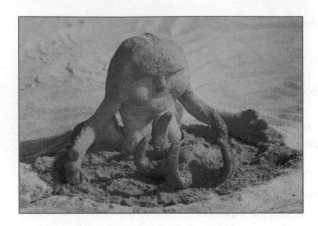

The Sandman puts the last touches to a starfish: as soon as it starts to move, its movements will be accompanied by the sound of sandpaper which will serve both as music and a sound effect.

The Sand Castle is the first film that Normand Roger worked on to win an Oscar; at that time, Normand had only been composing for five years. This short film is geared towards young children and the imagery is very clear, thus the music simply has to follow the narrative plot and try to stick to it as closely as possible.

O. C.: *You normally work in a particular way that I would like you to explain.*

N. R.: *I always compose after the film has been edited; the rhythm of the imagery guides me. I also talk to the film-maker a lot about their ideas and intentions. Then I spend varying amounts of time viewing the film over and over again until I have absorbed it and an idea comes to me. I suggest it to the film-maker and I make a first version. Today, the Home Studio is excellent for doing this; before, I had to do it on the piano. For a short film, the sound covers the whole length of the film; I then submit it to the film-maker. Some changes are made and it is then finalized by being recorded definitively.*

O. C.: *How much time do you need to compose the score for a ten minute film?*

N. R.: *Seven to eight weeks on average.*

O. C.: *For* The Sand Castle, *you composed acoustic music. On what basis did you choose your instruments?*

N. R.: *I was inspired by the elements, which played an important role in the film. I decided very early on to give greater importance to wind instruments: flutes (recorder, bass flute), an oboe, a bassoon, as well as fine tuned bottles in which you blow like panpipes.*

O. C.: *An instrument for each character?*

N. R.: *Yes, an instrument and a theme per character. The bassoon is associated with the Pig, the oboe the snake, the three-legged character's theme is based on a three beat rhythm, the sound of wind blowing is made by the bass flute and the starfish are associated with the rhythm of sandpaper being scraped.*

O. C.: *When you talk about the starfish and the sandpaper, we are between music and sound effects?*

N. R.: Sound effects are part of the general concept. I always make a first cut showing the alternation between the music score and sound effects. I think that the moments when the music starts and stops are quite strong moments, dramatically speaking, and correspond to the key moments that serves me as the basis for the structure of the general soundtrack.

O. C.: At the end, the characters dance in front of the finished castle to a short piece of ballet music...

N. R.: At the begining, the music evolves from the wind and the flute, then the introduction of different characters and their roles, moving into the more complex associations to build the castle. The final music score matches the festivities: all the instruments are combined before returning to the wind and the disappearance of the protagonists.

O. C.: Exactly how long did it take you to compose this soundtrack?

N. R.: I remember that there were renovations going on in the studio at the NFB which meant that I had to do everything in one weekend! The recording had to be made at a private studio.

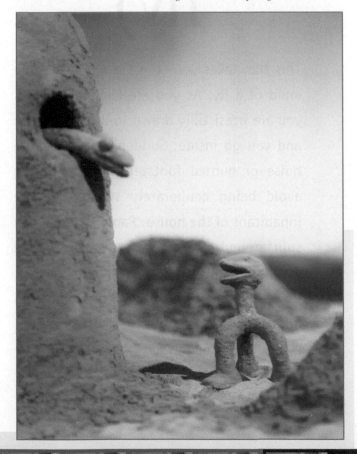

Having been created by the same person, each member of the team of builders works contentedly. Being good-natured and cooperative is one of the essential components of the film, as it is geared towards a young audience.

Animation is often considered to be associated with a young audience. This is clearly the case of most animated television series and many feature films. The phenomenon is not as common in independent short films. In this respect, Co Hoedemans is an exceptional film-maker, as most of his films are made for children. From the outset, *The Sand Castle* is made as a story following a clear narrative plot, with simple characters; the editing follows the film-maker's desire for total comprehension. But as we have seen, the film-maker's respect for his audience has not made him shy away from any difficulties. In an age of commercial productions that do not take into sufficient consideration the intelligence of children and their ability to appreciate the quality of a film, *The Sand Castle* deserves our full attention. This quality makes it enjoyable for adults as well.

A légy (The fly)

This film takes you (the viewer) inside the mind of a fly. As you are leaving a forest, you are irresistibly drawn to a lonely house and you go inside. Suddenly you hear the noise of hurried footsteps, and only just avoid being deliberately swatted by the inhabitant of the house. Panic stricken, you spin around, searching for a place where you can land to escape your pursuer. However, you will eventually be caught and pinned in a box alongside other insects. Life is really tough...

Oscar 1980

Ferenc **Rófusz**

Credits

descriptive

Title: *A légy* (The fly)

Year: 1980

Country: Hungary

Director: Ferenc Rófusz

Production, distribution: Pannonia Film

Screenplay, graphic design, story board, layout, set, animation, camera: Ferenc Rófusz

Technique used: Drawing on cel

Length: 3 min 8 seconds

Ferenc Rófusz was born in 1946 in Budapest. He was one of the third generation of a family of artists. In 1973, he directed a short film and a series of films with Gustavus as the main character. *A légy* provoked immediate recognition of his talent at many festivals and propelled him onto the international scene. Then followed *Holtpont* (*Dead Centre*) in 1982 and *Gravitáció* (*Gravitation*) in 1984. Ferenc went on to complete television projects and also direct some commercial works; in particular, he collaborated as animator on *Stowaways on the Ark* (1988, Wolfgang Urchs). In 2002, he started his own studio, *Animation.hu* in Budapest.

Screenplay

This short film is one of the most surprising films that animated cinema has ever offered us. Usually, the main character of a film is presented objectively, in front of the camera, in such a way that the viewer has the impression of being beside him, with some degree of distance, but always 'on the outside'. In *A légy*, the audience is inside the fly's body: free from gravity. It spirals from one place to another, seeking to escape his aggressor. To accentuate this sensation, the director adopts a distorted vision of the fly's universe throughout the whole film, via an ultra wide-angle lens. This effectively convinces the audience that they are not seeing the world on screen through human eyes.

The film is made in a single sequence (one long shot), in order to transport the audience inside the body of the fly. Which removes the spectators from the role of detached observers; they are no longer able to choose and modify their points of view. There is no use of multiple framing and editing. This original concept, rarely exploited in film, generates questions about other potential styles unused by traditional cinematography: new narrative methods are discovered by escaping from the beaten track.

A simple camera movement from low to high distorts of the countryside in an impressive manner. Technical mastery is required to create this kind of animation.

A légy is the ultimate form of cinematographic spectacle, it aims to project the public into a total illusion from a totally subjective viewpoint.

O. C.: The concept of this short film is tremendous! How did you get the idea?

F. R.: *Four years before throwing myself into this project, I kind of had a flash of inspiration: I was listening to Pink Floyd, Ummagumma, in which there is a fly-theme. It appeared to be a 'real sound', and this inspired me. The end of my film, however, is very different to Pink Floyd's creation; in their song you can clearly hear that the fly eventually escapes up into the sky.*

O. C.: Yes, your version is rather more pessimistic! Apart from this one, the majority of the films you have written are dark and one can detect certain political allusions...

F. R.: *That's because I had to play the role of 'storyteller' during the socialist era. So, consequently, I imprisoned my fly. I had it killed by a human hand and pinned in a box as part of an insect collection. It was really necessary to do that to show how dangerous man's egotistical behavior can be.*

O. C.: What aspect of this project interested you most?

F. R.: *It was the first time that a film was ever made solely using animated backgrounds: you don't see a single person in it. This subjective camera action hasn't been used anywhere in such a radical way since this film (at least in animation), and it was exactly the effect that I wanted to obtain.*

O. C.: In your opinion, why has no other director taken this direction?

F. R.: *Some months after starting the film, I understood why: it involves a great deal of work! My assistants gave up, one after the other; they couldn't see any light at the end of the tunnel.*

From time to time the fly's shadow appears on the objects on which it lands. These are the only times the viewer is allowed to gain a glimpse of the film's central character.

And worse still, when I was filming on the animation stand, I realized that it was all much too fast and that I would have to draw some new in-betweens. It was driving me mad and I ended up asking myself if I ever would see the end of it...

O. C.: You say that your assistants gave up – that's very unusual; generally animators are patient people, it's an essential requirement for the job.

F. R.: Yes, and yet they often left after only a few days' work. Only one woman stayed right until the end: Ilona Visnyei. It was her first experience of the world of animation... and her last – she never did it again.

O. C.: And I suppose you must have had trouble imagining how it was going to turn out. It could quickly send you into despair.

F. R.: In-between after in-between; I only began to have a precise idea of the final result after a year and a half. I had to hang in there.

O. C.: How many drawings were created in total?

F. R.: 4,000 in three years, but you only see 3,000 to 3,500 in the film. The rest were cut.

O. C.: The story is rather sad. What message were you trying to convey?

F. R.: This film is about bad luck; even if you wander peacefully and aimlessly through life but you make a buzzing noise – in other words you don't hide yourself – there is always a risk that sooner or later you will be beaten to death, pinned and put in a box. To survive, you need to be discreet.

03686

03695

03705

03720

03732

03737

03745

03759

The end is morbid: the fly is pinned in a box which houses an insect collection. This pessimistic feel was common in the films originating from Eastern Europe at the time.

The very nature of the shapes inherent in the interior structure of the house makes animating it a difficult exercise, stylistically speaking. The original cels were created in black and white, the sepia tint was added at a later stage.

O. C.: How long did you spend on the concept?

F. R.: Not very long. The music of Pink Floyd had a very strong impact on me. It happened straight away. I literally 'saw' the film in its entirety. All that was left for me to do was to draw it. Just draw it...

O. C.: So it was perfectly prepared and clear in your mind. Even so, weren't there any modifications in the course of production?

F. R.: As you had to submit the project to the studio authorities for acceptance, the film was in fact fully planned and ready to be started even before the production phase. That didn't prevent me from having nume-rous new ideas during the making of the film. Unfortunately, the system at that time (a Communist government – Hungary was under the control of the USSR) was too strict to accept the slightest modification. I thought, for example, that at the end, the fly could win and kill the guy... I had even done the drawings of the guy dead, which I still have at home, but I didn't succeed in getting them into the film and I had to continue with the original version.

O. C.: Do you think about the public's reactions much when you are writing?

F. R.: In reality, I didn't have a clue about how the film would be received, because work of this genre had never been done before. The film was screened for the first time at Ottawa[1], two weeks after we had finished it. The public began to whistle and yell from the very beginning... I panicked, but in fact it seems that this is the way that the North American public react positively to a show! The film won all the prizes imaginable from everywhere that year, it was a great surprise.

[1] An international festival of animated films.

Production

During the period of Soviet rule, all cinema studios were under state control; the directors were state employees, 'in the service of the people'. The entire means of production was publicly owned; the notion of profitability was meaningless. Directors could, therefore, dedicate a relatively long time to the making of a film, without being worried by the constraints of planning or budget. On the other hand, the project had to be accepted by the political and cultural authorities. The political control, overall, was critical; the authorities had to make sure that films were not hiding any 'subversive elements'…

This censure tempted certain directors to encode the messages in their films using subtleties of language. In this respect, *A légy* is a work which could be regarded as subversive, but whose pessimistic content can be interpreted in different ways. What does the hand that kills the fly symbolize – the capitalist West or the Communist oppressor of the country? So that the project would be accepted by the authorities, it was advisable to present it as 'judiciously' as possible.

O. C.: How was the film received by the authorities of the time?

F. R.: It took several years for the most bureaucratic committees to finally give their approval, but they didn't ask for a single change.

O. C.: How was the finance organized?

F. R.: At the time when I directed this film, everything was subsidized by the state; all that I had to do was to propose and convince. The problem was that the money would arrive little by little. The last year and a half of production was paid for by my wife. The budget wasn't very large. However, what mattered was a film of 3,000 cels on a single level, done in wax crayon.

The fly enters the forest, his natural habitat. These pictures show the vegetation from the fly's own perspective. The film-maker's desire to include so much detail in the drawings made for a long and painstaking job.

O. C.: *Did you have to work on any other projects at the same time?*

F. R.: *The film took a lot of time. I couldn't really work on anything else... However, I did direct some commercials, but they distracted me too much from my work on A légy.*

Technique

The spectacular nature of this work provides the initial impact of the film. It is unique to see a film animated in a single sequence and which, just as importantly, plays with geometric distortion. Before Ferenc Rófusz was considered as a film-maker of definite artistic originality, he was regarded as a virtuoso of animation. It is this strength that contributed to the recognition and success of this short film; notwithstanding the technical difficulties, which must have seemed insurmountable...

O. C.: Were any of the scenes more difficult to create than others?

F. R.: No. Unfortunately, all the scenes were equally complicated. There wasn't even one scene in which I could use any techniques to simplify the work. For example, I tried to use a certain camera movement, to avoid having to constantly animate the whole scene, but you could see it. The result didn't fit well with the continuity. So we realized very quickly that we would always have to animate the whole background.

O. C.: The fish-eye lens distortion that you use throughout the film is really astonishing. When A légy *was released, we were all really stunned by the difficulty that this represents from an animation point of view. How did you create this effect?*

F. R.: A fly's eye is made up of multiple hexagonal facets which each register an elementary image; I wanted to reproduce their extraordinary panoramic mode of vision. But I soon realized that the result wouldn't be any good. So I eventually chose just to use the fish-eye. To help me with the animation, I took about 50 black and white photos of the scenes with a camera to which I had attached a fish-eye lens (in a very old fashioned way, because the lens didn't really fit the camera – don't forget that video and digital cameras didn't exist in those days!).

O. C.: The graphic rendering is also very unusual. How is it achieved? It looks like a wash drawing.

It really feels as if this original drawing is an actual painting, with a richness of texture that comes from the use of wax crayon. This is very removed from the traditional flat tint which is typically used on animation cels.

The fly is trapped in the house and cannot escape. It bumps into the window.

F. R.: *The drawings were all done in wax crayon, directly onto the cel. I had begun to create the images with watercolors in brown and yellow tones, but after two months, it occurred to me that I might never finish it; it took too long and was too difficult.*

O. C.: *How about the color?*

F. R.: *We shot the film in black and white and used calibration to get a sepia tint when we processed it. It was quite simple and economical and gave the look of an old photograph.*

O. C.: *The fly is attracted to the house by a sparkling window. I suppose that this effect isn't drawn?*

F.R.: No, but it is created very simply by placing photo paper (which is quite opaque) that has been pierced with a hole, over a light table. You light it strongly from beneath to illuminate it and then just organize the timing of its appearance precisely to create the impression of a flash of light.

Once the film has been changed into sepia, the atmosphere is stifling and a sense of drama is created.

The flash of light could not be drawn directly onto the cel, so a special effect was needed.

Soundtrack

The idea for the whole film was inspired by the music of Pink Floyd. However, their music has not been used on the soundtrack; instead all the sounds employed are taken from real life. This adds to the realism and to the harshness of the story. As we are about to find out, this choice was largely influenced by the production conditions of the film.

O.C.: As your inspiration came from Pink Floyd, wouldn't you maybe have liked to use their music?

F. R.: Yes, that would have been perfect as the basis for the film. But the situation in Hungary at that time didn't allow it; the studio told me that they didn't have the 4,000 or 5,000 dollars for the reproduction rights. So I had to find another way. We went into the country, with a friend who was a sound engineer, and we recorded lots of material on a UHF tape recorder, mainly the sounds of nature and sounds from inside a house.

O.C.: Was the soundtrack created before or after the film?

F. R.: After. My assistants and I also ran up and down stairs, in and out of rooms and back and forth with a tape recorder, to simulate the sounds in the house that the fly and the audience hears. Someone imitated the buzzing of the fly, because it would have been impossible to record the actual noise of a fly. In any case, we could never have synchronized it with the image...

Facing page: the story board uses many drawing and painting techniques. You can see that the perspective has already been put in place.

It often happens that animation film-makers – talented designers who love technical challenges – like to develop a style that enables them to create a visual firework display. This is indeed the case with this film, which in its era impressed so many with its incontestable virtuosity.

But the function is also perfectly adapted to the form. What better way to denounce the danger that hovers over every human being living in a totalitarian regime than to put the audience in the role of a mere insect? With this formidable stroke of inspiration, *A légy* provokes not only a legitimate marvelling at the *tour de force* of the direction, but equally represents a philosophical and political fable which demands reflection on the part of the audience.

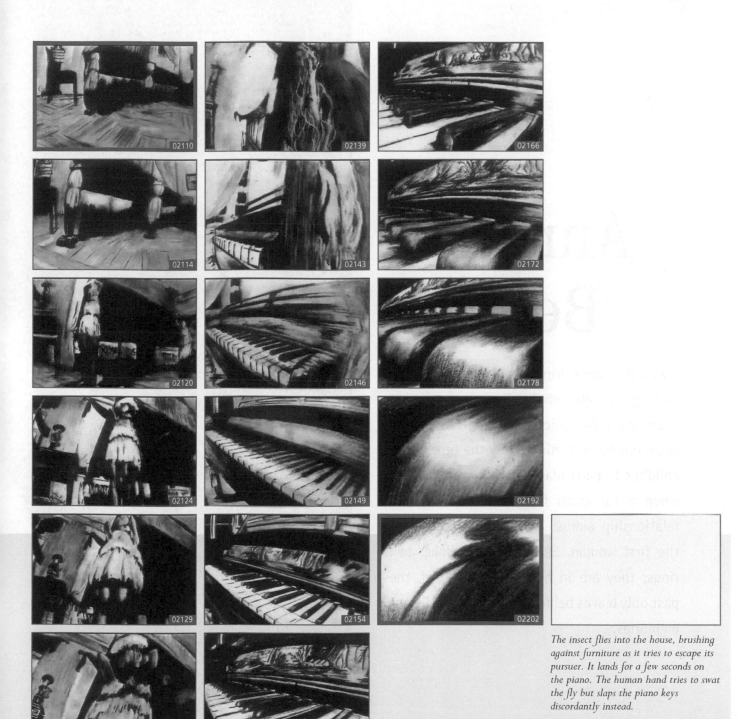

The insect flies into the house, brushing against furniture as it tries to escape its pursuer. It lands for a few seconds on the piano. The human hand tries to swat the fly but slaps the piano keys discordantly instead.

Anna &
Bella

Two old women drink, laugh and cry whilst looking through a photo album, remembering their lives. We quickly realize that one of them has been dominated by the other since childhood, particularly during adolescence, when a car crash following the end of a relationship almost results in the death of the first woman. Suddenly, the dinner bell rings: they are in heaven. In the end, the past only leaves behind the shadow of distant memories…

Oscar 1985

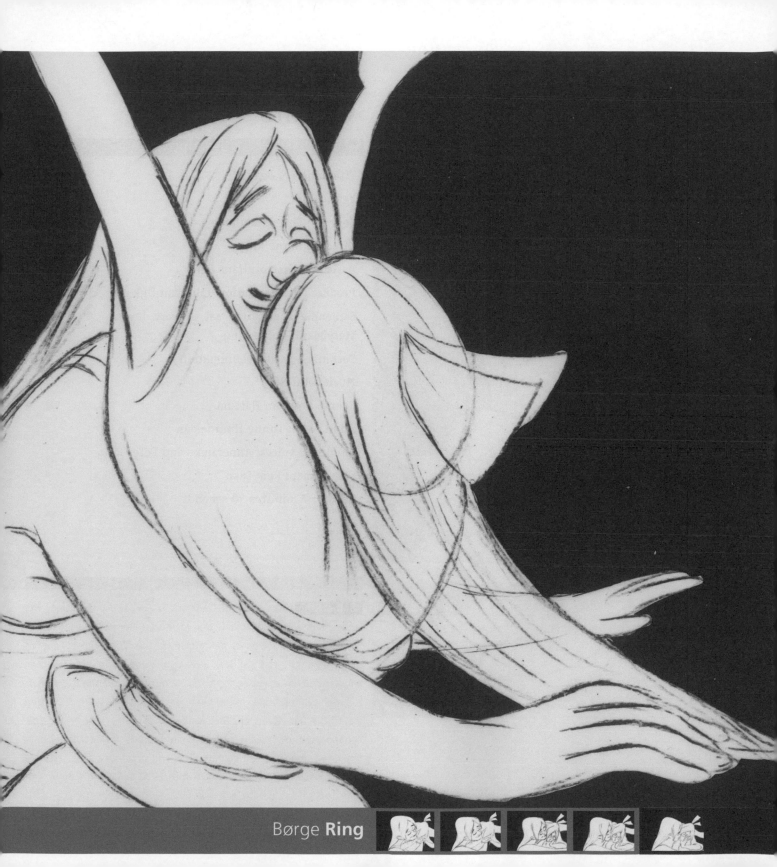

One of the animated drawings of the film transferred onto a cel, which will later be placed on the background.

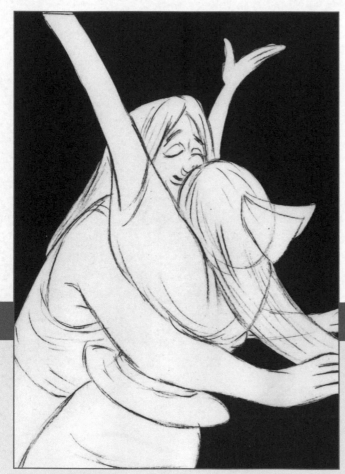

Credits

descriptive

Title: *Anna & Bella*

Year: 1984

Country: The Netherlands

Director: Børge Ring

Assistant director: Hans Perk

Production, distribution: Cilia Van Dijk

Screenplay, animation, set, artwork, layout, storyboard: Børge Ring

Technique used: Cel animation

Music: Oluf Ring

Sound: Boy Van Hattum

Adult voice: Tonny Huurdeman

Children's voices: Annemieke and Peter Ring

Cameraman: Rem Laan

Length: 7 minutes 30 seconds

Børge Ring was born in Denmark in 1921. At the time, his father was a composer and taught music. Børge Ring made his first film at the age of 13. However, his first career was in music as a guitarist and jazz bassist, playing with Sidney Bechet and Kenny Clarke amongst others. He returned to animation when he was 28, and has since then devoted all his time to this field. He has lived in the Netherlands since 1952. He has collaborated on many internationally produced feature films, animated and directed commercials and art-house films. *Oh My Darling* was nominated for an Oscar in 1978 and *Anna & Bella* won it in 1985.

Screenplay

Family relations, love and the conflicts that can arise from them, is one of the most explored themes in dramatic art; it provides theater, literature and cinema with a rich source of inspiration. Animated films, however, often refrain from dealing with this subject, simply because the lack of realism inherent in this genre hampers the scriptwriter or the film-maker's efforts to deal with a subject that is difficult to reconcile with the visual representation of human beings.

Animation excels far more at creating images of eccentric universes; for many film-makers, fantasy, quirky humor and stories based on make-believe are hard to depict in traditional films. Ironically, animals are often given human emotions, as in many Walt Disney films (particularly the earlier ones): human beings are relegated to second place and provide no significant dramatic weight. The reason for this is that accepting the improbable in an animated work (animals who can speak, magic, mindless violence, etc.) prevents viewers from being able to completely identify with it; when they are less on the defensive, they are more likely to understand the message the film-maker is trying to communicate.

However, these characters often lack weight, credibility, *flesh*; making a film based entirely on the conflict between the memories of two sisters, with their love, jealousy, fears, joys and disappointment, was the considerable challenge that Børge Ring took on with *Anna & Bella*. The success of this film is most certainly down to the outstanding quality of the animated sequences and also the creativity in the editing, which, without moving away from the difficult subject matter or the specifications of the visual presentation, intelligently uses the resources available to the art of animation.

> O. C.: How did the idea of this film come to you?
>
> *B. R.:* *To start off with, the story was supposed to be about the lives of two brothers, Abel and Bernard (twins). But at the same time, I had a film that was making the rounds on the festival circuit,* Oh My Darling, *in which the main character was a girl, who was neither an angel, witch, prostitute nor high priestess; in short, none of the usual archetypes. Women loved this character. They could identify with her; they even stopped to talk to me about her in the supermarket.*
>
> *O. C.: That's really encouraging!*
>
> *B. R.:* *So I changed the characters from two brothers to two sisters, with the idea of contributing in some small way to eradicating the reasons for which feminism exists.*
>
> *O. C.: What helped you to develop the idea?*
>
> *B. R.:* *I love the old* Tom and Jerry *cartoons that Hanna Barbera made for MGM. I said to myself that it could be possible to make a short film that is like a* Tom and Jerry *cartoon, but with a story that appeals to an adult audience through a message.*
>
> *O. C.: That's a complex mix in terms of dramatic composition.*
>
> *B. R.:* Oh My Darling *was a first successful attempt; what's more, it was Oscar-nominated in 1978.*

The only very colorful sequences are those set in the present day, in which the two old ladies recall their memories. Before the flashback sequence, their facial expressions show us that the past has left behind haunting and unpleasant memories.

The blue in this sequence does not just represent the approaching night, but also the character caught up in a dream (or a nightmare), who is touched deep within herself, in her unconscious.

The Idea

Anna & Bella develops a surprising mix of realism and fantasy images, a particularly difficult task when there is a considerable risk of appearing ridiculous. Thus, the writing must be controlled; imagination and intuition must be allowed to flow and work freely while the writer stays on top of the main theme, the big idea. A method and a particular discipline need to be followed to carry out this work.

O. C.: How was the writing structured?

B. R.: I started by listing a number of things I wanted to see in the film. I set down all these elements of the story and I looked at how to make them interesting. I wanted at least 40% of these scenes or incidents to be uniquely feasible through animation. For example, when one of the characters says, 'She was heartbroken. She felt crushed', I literally cut her into pieces; she shatters like a pane of glass breaking into tiny pieces. The audience doesn't think of this as a gag, a visual joke. It accepts the event quite simply.

O. C.: This means that you think a lot about the audience's reaction when you write?

B. R.: Absolutely. You tell a story to someone; you want to get their attention and hold it. Everything revolves around that.

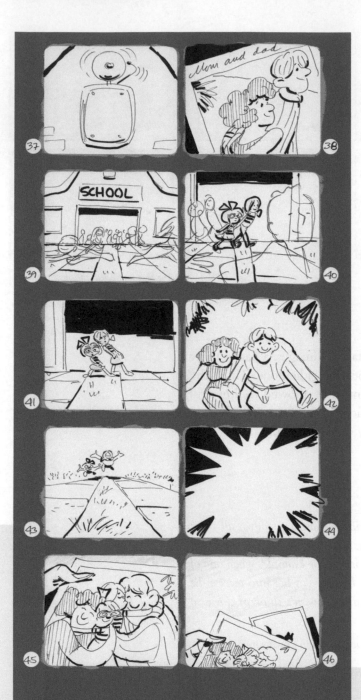

School's out sequence: you can see the different scenes that compose it frame by frame.

O. C.: *How long did you spend on the idea?*

B. R.: *I don't know...*

O. C.: *Do you conceptualize the whole film, from the beginning, even before you draw the storyboard?*

B. R.: *No. The mind,* like a pencil, *is constantly searching, constantly experimenting. The bulk of the work consists of questioning where your subconscious is leading you.*

O. C.: *The film has a freedom that is expressed particularly in the artwork. For example, when the children are coming out of school, they are drawn: there are animated sketches placed directly on the background as transparent shapes. This makes one think of some of the animations produced by UPA, particularly those made by the Hubleys.*

B. R.: *These rough animated sketches often have a charm that the fair copies don't. They retain the magic of animation. They show the human side of it. Using xerography, transferring the animated drawings onto cels, you can keep this energy so that the outline is clear enough for you to know what to fill it with during painting. Richard Williams, in London, found that xerography did not provide enough shades and discovered Keuffel and Esser, which makes a pencil that can be used on cel.*

O. C.: *And this is what you used in* Anna & Bella?

B. R.: *Yes. The animation is done on paper; the drawings are then neatly copied straight onto the cel. These pens can produce a line that goes from being very fine to brushstrokes.*

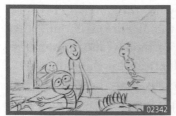
02342

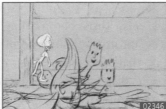
02346

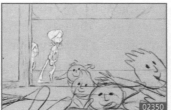
02350

02354

Almost nothing is needed to highlight an element in a frame: here, the only characters that concern us are in color and opaque. Thus, the parents waiting for their children outside the school are recreated as the subjective focus.
This visual idea is also used to maintain an atmosphere with limited color harmonies, which match the images in the photo album the protagonists are leafing through.

The initial ideas about the different sequences in the film are freely jotted down on large pieces of paper, without worrying about the form. It is precisely this freedom that is desired.

Xerography (Xerox process) consists of photocopying the animated paper drawings directly onto the cels, thus eliminating the need trace onto this support. The technique saves a considerable amount of money and production time. Another advantage is that the outline is identical to the animator's and remains quite lifelike. The disadvantage, however, is that the style of the artwork is the style of each animator, which is problematic when several people are working on one film; moreover, not all artwork is suitable for this visual effect.

Production

After his first Oscar nomination for *Oh My Darling,* and due to Børge Ring's recognition by the profession, it was not very difficult to finance this production. Furthermore, the film was not very expensive to make: few people were involved in making it and not many materials were required. The Netherlands also has an arts funding policy which makes it quite easy to get financial backing. Nonetheless, production is never that simple because the producers have to be convinced and the necessary time to make the film has to be found.

As soon as the film starts, the first element of the screenplay is introduced: the photograph album, which serves as a catalyst and a link between the two sisters.

O. C.: *How did you organize financial backing?*

B. R.: *I got a grant from the Dutch government.*

O.C.: *Were the writing and production carried out full time?*

B. R.: *No, I drew* Anna & Bella *in the slack period between two adverts and work on a French* Astérix *feature length film.*

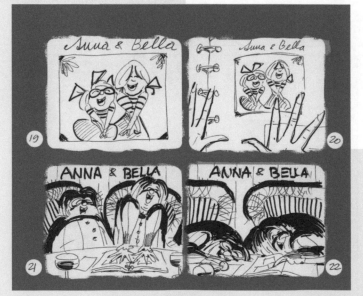

Cel Technique

In *Anna & Bella*, Børge Ring used the classic animation method, more commonly called 'cel animation'; the use of celluloid has had such an effect on the history of animated film that the two have become synonymous.

Cel technique has been used throughout the twentieth century and was used extensively by the Walt Disney studios, all the major cartoon companies (Warner Bros, MGM, etc.) and even by the vast majority of independent productions. This success is due to the graphic flexibility allowed by this technique; it is the method that best accentuates the animator's work. On the other hand, however, it closes the door to many stylistic possibilities, because, for example, it is difficult to create images other than with simple flat tints. Furthermore, the production costs are high. Cels are expensive and require a whole production line making use of many different skills. Before going into the details of some peculiarities specific to the production of *Anna & Bella*, the broad outlines of this production technique need to be explained.

The first steps in the creation of the screenplay and research into the artwork to be used are quite similar to those to be employed in the making of any animated film. The storyboard then sets out the continuity, the script from which the film is actually made. The layout, more specific to cel animation, organizes the movement of the characters, objects and the camera in each sequence. It is a sort guide which gives the rest of the work its bearings.

The very term 'animated drawings' implies that the main work is carried out with the help of tools traditionally used in drawing. Everything to be animated is drawn on a series of sheets of paper. Each sheet corresponds to a different stage in the movement. The main drawings are first sketched rapidly to lay out the main stages of the movement; these are called the *keys*. Once these main poses have been sketched, the missing drawings have to be executed – the in-betweens – by starting with the main inbetweens, which show the positions the characters must assume between two keys. The timing is created through the number of in-betweens, which provide the general rhythm of the action, with its speeding up and slowing down giving energy to the movement.

A series of sheets are used for each character, or even each specific element, which means that the same protagonist can be broken down separately into several animated parts. The animators facilitate this work by using a special inclined table, which has a revolving round glass plate set in it. This animation drawing disk is lit from underneath, allowing several transparent sketches to be viewed simultaneously.

The drawings are then *cleaned*, and the sizes of the characters and objects are made consistent, taking the model sheet into account; this is the template. At the same time, or sometimes beforehand, the exposure sheet is written, informing the rostrum cameraman of the order and the number of cels to film. Traditionally, this series of drawings is then transferred onto the cels using pencils, an ink drawing pen (rapidograph), or it is painted on the front (the side facing the camera during recording), and the colors (traditionally gouache, acrylic paint in the last few decades) are then applied to the back.

The background is painted on paper using traditional techniques. After numerous checks and approvals, everything is handed over to the cameraman, who records the sequence of cels laid on the background. So that these images are all pegged geometrically, the sheets of paper, cels, backgrounds and all the elements that make up a scene are perforated with three holes, a central round hole and one oblong hole on each side. This system is international and universal: there are special hole punches used to make holes in the paper which can then be aligned with similarly shaped round and oblong pegs on a peg bar.

After having been used in the vast majority of productions for decades, cel animation is seldom used nowadays due to the digital revolution.

Børge Ring at work at his drafting table with animation disk: above and below the surface, you can see the peg bar, which aligns the back lit area.

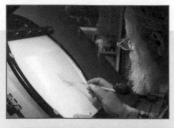

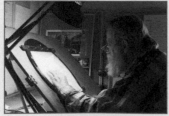

The young girl's transformation into an adolescent appears quite violent. Nonetheless, these extreme poses are on the screen for a very short time (see the numbers) and simply provide a way to give the animation rhythm.

Animation

Børge Ring did not simply choose cel animation simply because, at the time the film was made, there was no computerized system available to simplify process; rather, his past career encouraged him to work with a method that he was familiar with and which inspired him, one that was linked to his cultural universe. Børge Ring is quite clearly recognized as one of the best animators in the world. It is for this reason – the scripting and directing strokes of inspiration aside – that *Anna & Bella* is above all an animator's film. The intense images and repeat scenes provide insight into the movements and the psychological expressiveness of the characters; I would recommend it to any fan of animation.

O.C.: Before starting production, did you think that some of the animation would be difficult?

B. R.: *Yes. I had to learn to animate semi-realistic characters, which was new for me at the time.*

O.C.: You are considered one of the best animators in the world and your animation respects the classic rules (even if it takes some liberties with them). Which animators did you find particularly influential when you started out?

B. R.: *Norman Ferguson and Art Babbitt were huge icons for me when I started.*

O.C.: When you say Disney, your selection is perfectly clear!

B. R.: *I learned everything from the former masters at Disney, and I continue to watch and study their work. This is why I have put a portrait of Disney (with Donald) in the film – it's a tribute.*

Opposite page: a typical feature in his films, Børge Ring uses visual ellipsis to get to the heart of the matter. Here, changes over several years are condensed into a few frames.

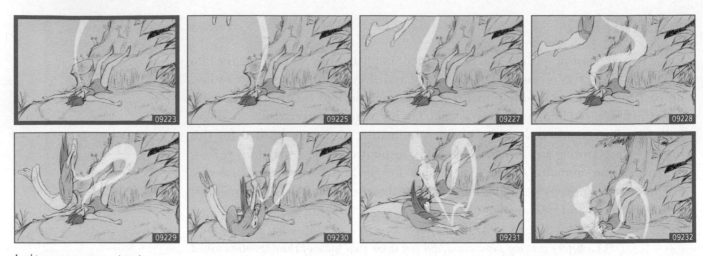

In this sequence, you can imagine a heavy body falling and the vivid representation of a weightless soul. This scene shows a particular physical and psychological violence: the balance is hard to strike.

O. C.: *How do you organize your animation sessions? What do you aim to achieve?*

B. R.: *I use the storyboard as a base because, when I am drawing it, I make sketches off the top of my head, which are far more inspired than those I make later. I try to transfer these qualities to the keyframes. I'm on the lookout for clarity and simplicity in the presentation.*

O. C.: *Do you prefer to think a lot about your drawings in advance, or to do the drawings over and over until you get the desired effect?*

B. R.: *In my opinion, timing is the most potent ingredient in animation. As a result, I definitely think a lot before starting to do anything. A little line test might be a good way of testing the animation; it stops you from asking pointless questions. Sometimes, I start a scene with some quickly drawn sketches to check that the timing is correct and that everything is as I want it to be. At this stage, you can still make adjustments easily.*

O. C.: *When you made* Anna & Bella, *there was no digital line test. Nonetheless, some early models worked on video. Did you use them?*

B. R.: *I had just bought my very first line test machine, a Lyon Lamb – which used tape – but I didn't use it a lot. I preferred flipping the drawings, like in the good old days. Unfortunately, today the line test has for some become a kind of oracle that tells you whether you are right or not...*

O. C.: But it removes any doubt.

B. R.: There is one scene that was problematic: the one in which Anna falls on the ground losing her sister's soul. I corrected it many times and I tested the sequence nine times! Years later, I put all these versions in my machine and I couldn't see the slightest difference between them.

O. C.: What happened?

B. R.: Often, the first test is good – the first sketch. But as you get tired, you are not aware of that anymore.

O. C.: I find the poses amazing. It looks as if all the animation has been organized around an artistic construction that gives expression to...

B. R.: I spent an incredible amount of time working on it. Ray Patterson[1] said, 'Your animation is never better than your poses'.

A remarkable dynamism in the pose: you can clearly see who is dominating, who is fighting against this and how the balance changes from the way the characters are posed. The result is not only artistically superb, but also very expressive and psychologically intense.

[1] Ray Patterson (1911–2001) is a veteran animator who started his career at Mintz; he worked on *Dumbo* and *Fantasia* at Disney, then at MGM for Hanna Barbera (on *Tom and Jerry*) and for Tex Avery from 1941, before co-founding his own studio in 1954.

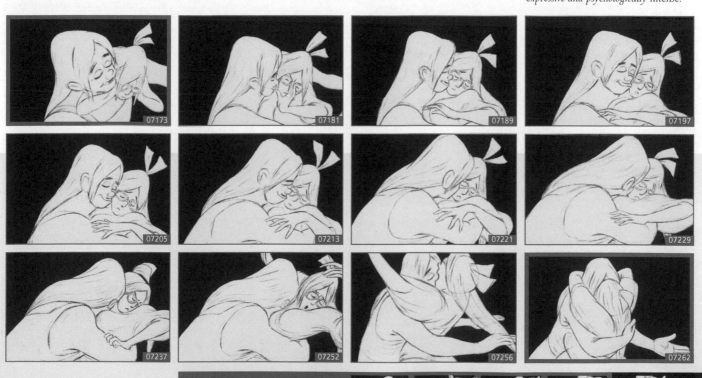

Cel animation

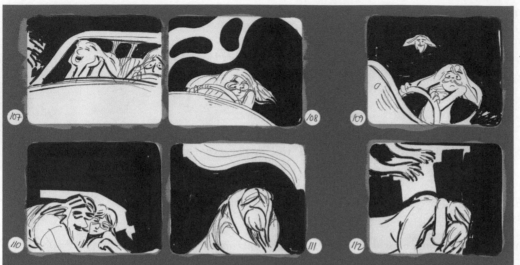

An idea is evident in the storyboard, even if these frames are very simple and do not yet express the intensity of the finished image.

On the exposure sheet, which helps during filming, you can see which drawings are to come. Note the different levels which correspond to the various animations.

Below, different stages in the paper drawn animation before being transferred to cel: for some animation sequences that show small, repetitive movements (here, the swaying of the feet), a series of separate drawings are made.

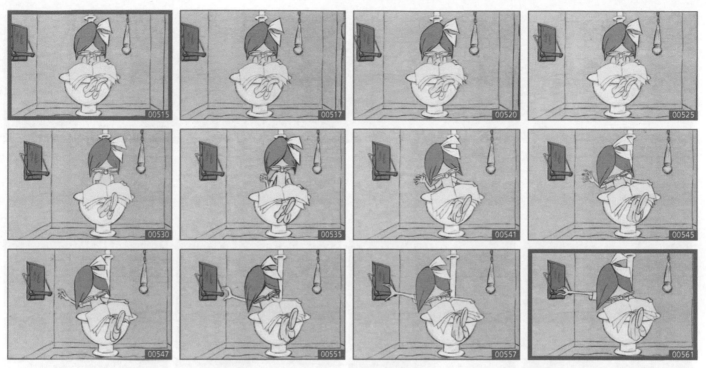

The final result, in color and seen in its continuity: the artwork is monochromatic, as it represents a memory, and must match the photos the two old women are contemplating.

Some Special Effects

If *Anna & Bella* is a traditional animated film and like many others, it needs some special effects. The use of this term is not a reference to one of the spectacular scenes in films that we have become accustomed to in contemporary cinema, but rather the use of specific techniques that would be impossible to make directly on paper. Special effects have always played a role in traditional cel animation. Walt Disney made extensive use of them in his productions to represent natural phenomena (rain, steam, ocean, fire, etc.) and lighting effects (shadows, illuminations), employing enough artists to justify a department all of its own at the studio. In *Anna & Bella*, special effects are not used to create a hyperrealist effect, but to enrich the presentation.

The accident storyboard: the panels are below.
One of the drawings has been scored through when it was abandoned during production.
Some of the animation timings have already been noted.

A surprising visual effect in the middle of an otherwise classic film: the treatment of night, symbolized by highlighting the landscape. There is a sudden violence in the image, which leads directly to the car crash.

> *O. C.: During the car journey at night, there is quite a strange sequence in which it looks as though the film has been scratched. How was this done?*
>
> *B. R.: I thought about the scene for some time, and then I drew the animation very quickly with a very thick 4B pencil. That took me ten minutes. When I saw the test, I decided to keep it that way. It was printed in negative because it's a night scene.*
>
> *O. C.: The white paper becomes black and the outline becomes white...*
>
> *B. R.: Yes, but there was a mistake: we should have used Plus X film to keep the softness of the outline, but instead, high contrast film was used and we didn't have the budget to shoot it again. That's what gives it that scratched film feel, an effect that I don't really like anyway.*

Soundtrack

It must be remembered that Børge Ring was a professional musician before devoting himself to animation when he was nearly 30. This love of and skill for music came from his father, who was also a musician. Given this cultural background, it is clear that considerable care and attention were given to the composition of the soundtrack.

In his films, Børge Ring often uses a single theme which is transformed according to the ambiance in each scene. Once this theme is chosen, the serious task of musical variation is carried out to keep it as close as possible to the narrative framework, this is organized at a fairly fast pace.

O. C.: Why do you only use the one theme, arranged in different ways, in your films?

B. R.: My aim is to find a good theme, one that is short enough to be repeated many times in seven and a half minutes. If the audience hears it continually, the melodies will be tattooed in their minds. I learned this from Carol Reed's film **The Third Man**, in which, from the beginning to the end, Anton Karras performs a very ordinary piece of music on a Tyrolean lyre. As I mainly play jazz, I am used to improvising with lots of very short passages; that makes it quite easy to create a piece of music that goes with the animation.

O. C.: The theme to **Anna & Bella** was originally composed by your father. How was the score organized? You can hear acoustics, a synthesizer...

B. R.: In fact, I jazzed up the theme into a complete series of variations. They are quite easy to listen to and didn't cost too much to make. I work with a talented pianist, Jan Huydts, who is particularly good at jazz. He came in at the end with the synthesizer. I played the guitar and bass parts and whistled the melody.

O. C.: Nevertheless, weren't there still some problems with the internal rhythm of the image?

B. R.: Yes, especially in the scene where the three lovers are walking in the moonlight. All the music in **Anna & Bella** is arranged on bars based on a 12 beat with the metronome set at 120. This works well throughout, except for this sequence, because suddenly, as the characters walk at the same pace, you think of a military march, which doesn't match either the ambience or the narrative.
So I kept the animation but changed the music by switching from a 4/4 beat to a 3/4[2]. And I had to increase the tempo to 180. As a result, the beats came every eight frames and each bar lasted a second. This removed the military effect. The difficulty was in doing this without affecting the overall score, so I added a transition at the beginning with a flute, before the jazzy waltz starts.

O. C.: All of this was written in advance?

B. R.: Not completely. With Jan, we played and improvised from this idea. Then we let the music guide us and, at the end, it was longer than we had thought and needed it to be. In the end, I left the whole piece of music in because I didn't want to cut this piece that worked so well.

[2] 4/4: four beats per bar. 3/4: three beats per bar, also known as triple time (a waltz)

O. C.: We've spoken about the theme and the rhythm; what about the harmony?

B. R.: I played around with it! In one of the variations, for example, when one of the sisters is drunk and bubbly, the theme is in C major and the accompaniment is in A flat major. This clearly sounds quite wrong, but it's very beautiful, a little like some Picasso portraits in which you have the front and the side profile views at the same time. It's a trick that I pinched from Stravinsky in Circus Polka.

This film may initially be surprising because of its classicism. In actual fact, the film does follow a particular tradition, in the best sense. But it should not mislead you; the theme is far more serious than it appears to be, the many visual and narrative strokes of inspiration also provide proof of the modernity that can only be developed when the use of all the classic tools has been assimilated. The word modernity here is used simply to mean that formal experimentation is not the only means towards new narrative forms.

Anna & Bella touches the audience through the life experiences of the characters and the tenderness and cruelty shown; funny in its way of using shortcuts, tragic in other aspects of the story and surprising in the final punch line. The film is an entertaining piece of work in the best possible meaning of the word, straightforwardly mixing genres and codes with incomparable technical skill.

L'homme qui plantait des arbres (The Man who Planted Trees)

At the turn of the twentieth century, a rambler called Jean Giono was on a walking tour across a barren region of Provence (France). One day he met a shepherd, whose habit it was to plant a few acorns every day. Over the years, Giono continued to visit the shepherd and discovered that a whole new forest was gradually reclaiming the hills and re-seeding all the surrounding countryside. The streams had begun to babble once again; life, joy and people were returning to the region. All this was thanks to the determination of this one man, who carried out his secret task with such humility.

Oscar 1987

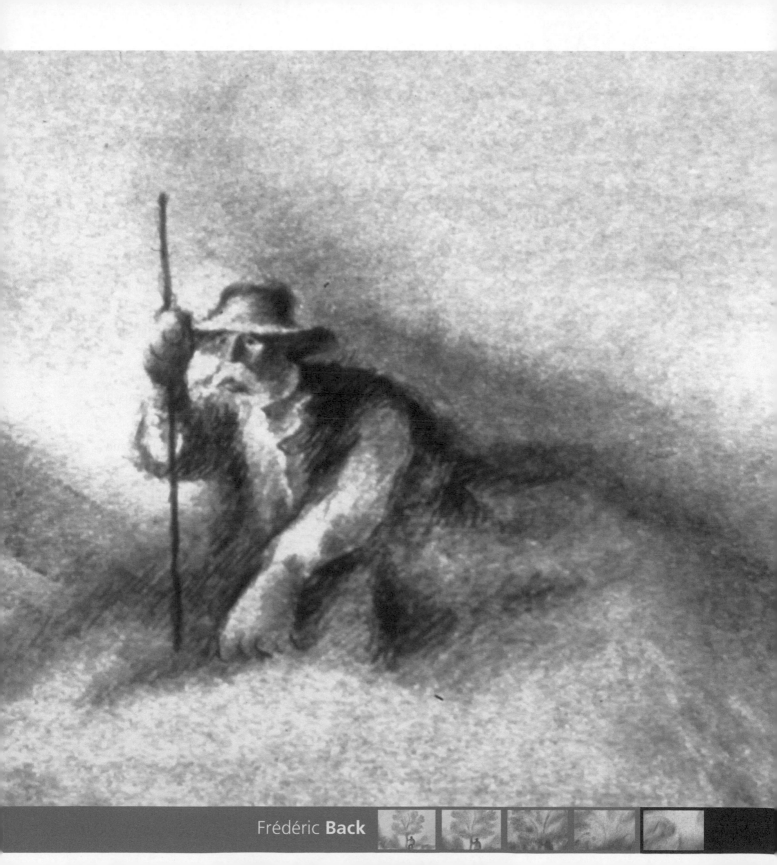

Frédéric **Back**

Credits

Title: *L'homme qui plantait des arbres (The Man who Planted Trees)*

Year: 1987

Country: Canada

Director: Frédéric Back

Production, distribution: Société Radio Canada

Producer: Hubert Tison

Screenplay, graphics, storyboard, background, animation: Frédéric Back

Animation (In-betweener): Lina Gagnon

Camera: Claude Lapierre and Jean Robillard

Technique used: Drawing on frosted cel

Music: Normand Roger and Denis Chartrand

Sound, mixing: Michel Descombes

Voice: Philippe Noiret and Christopher Plummer

Length: 30 minutes

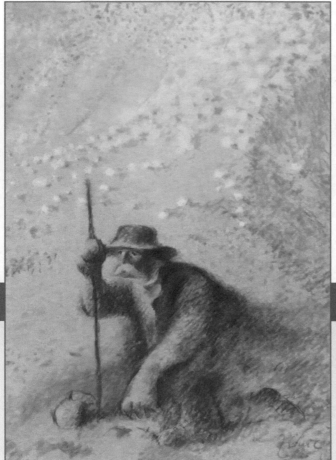

Frédéric Back was born in 1924, in Sarrebrück (then a part of France). He studied in Strasbourg, in Paris (École Estienne) and in Rennes (École des Beaux Arts). He arrived in Quebec in 1948, where he met his future wife and taught at the École des Beaux Arts and the École du Meuble in Montreal. In 1952, Frédéric Back began working on cultural television programs and then went on to create educational films for the Animation Studio of Radio Canada. His most famous works include: *Abracadabra* (1970), *Inon ou la Conquête du feu* (1971), *Illusion* (1974). *Tout rien* (1978) which was nominated for an Oscar in 1981 and *Crac!* (1981) that won an Oscar in 1982. *L'homme qui plantait des arbres (The Man who Planted Trees*, 1987) won him a second Oscar in 1988. *Le fleuve aux grandes eaux (The Mighty River*, 1993) was also nominated.

Screenplay

Frédéric Back's previous short films were largely based around ecology and the culture of Quebec. Ecology is one of the author's main concerns and his recent films have all been dedicated to it. No-one can deny that he has good reason to campaign so actively; between 1954 and 1972, a quarter of the Antarctic ice-cap melted away; since 1850 the Alps have lost half their volume of ice; more than 270,000 species of animal and plant life are becoming extinct each year and 80% of the planet's primary forests have already disappeared… What will remain for the descendants of the human race if it doesn't pay attention to the global suicide that is happening now? Frédéric Back has decided to raise the awareness of the younger generation, the adults of the future, through the creation of his cautionary films. His most recent productions are longer, and have attracted larger and larger audiences to their screenings. Quite apart from their inherent beauty, they either bear witness to past mistakes (*Le fleuve aux grandes eaux*) or offer a more optimistic message, through stories that show what can be done to change things for the better, as is the case in *L'homme qui plantait des arbres*.

The man alone, and with few resources is faced with the enormity of the task at hand.

The fountain has dried up. The use of lines with sepia create the feeling of harsh and hot sunlight.

O. C.: When did your awareness of ecology begin?

F. B.: I think I have always been conscious of ecology. I wanted to create tools of awareness for the people of the entire world. The major problem is that our world is governed by money and the idea of happiness at any price.

O. C.: Creating films isn't the only way that you spread this message is it?

F. B.: No. I am a founder member of the SVP (Society for vanquishing pollution) and also the Quebec Society for the Defence of Animals. I designed their posters and built their information stands. I have always been deeply shocked by the way in which people exploit and mistreat animals.

O. C.: What did Jean Giono's book mean to you?

F. B.: It's mainly about the fate of the forests. After getting to know the novel, I planted some 10,000 trees myself. The story, which I found in the magazine Le Sauvage, *moved me deeply, because it is a lesson of patience and generosity. Giono had put into words everything that I wanted to express in my drawings.*

O. C: Did the idea of adapting it occur to you right away?

F. B.: I sketched a series of images immediately. When I found out that Elzéard Bouffier was in fact a fictitious person, I was disappointed. But then I collected all sorts of articles relating to the humble, generous achievements of people teaching reforestation in India, or recreating a forest on the opencast mines of Africa, or protecting the last virgin forest of a South American country, etc.

O. C.: Others like Elzéard Bouffier, but real people!

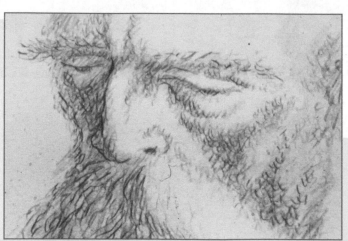

F. B.: Yes. I then started planting even more trees and worked on gradually improving the story whilst directing Taratata, Tout-rien, *and* Crac.

O. C.: So it took quite a long time?

F. B: Oh, yes.

The face of Elzéard Bouffier shortly before his death. The use of cross hatching vividly evokes the texture of his skin and conveys his vulnerability.

Working with the Text

The adaptation of a written text into a story suitable for on-screen viewing often requires radical changes. These changes will always involve a degree of simplification. For example, the number of characters can be reduced and compensated by creating a new character that combines the personalities of several of those that have been removed. At the most, the phrases that are not absolutely essential to the comprehension of the story can be eliminated. The higher the quality of the text, the more sensitive the changes need to be, so as not to appear irreverent. Our Western culture tends to hold the written word sacred, thereby rigidly preserving texts unchanged for eternity. But it is quite different when the source text contains just a few characters and no dialogue.

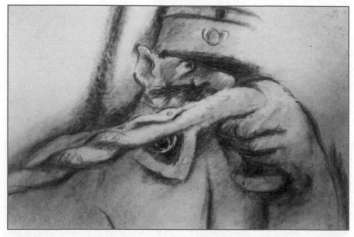

An official orders Elzéard not to light a fire in the forest. The phallic symbol of the cane is placed in the foreground expressing the stupidity of the character.

19159 19215 19294 19326
19376 19442 19581 19640
19692 19725 19756

The images often follow from one to another by metamorphose. The idea is emphasized by the semantic short-cut that has been created.

The storyboard shows drawings of the different phases for a long sequence shot.

As film-makers, we are caught between the legitimate humility we feel when faced with the work of the original author, and our professional understanding of the demands of screen writing. So, we are forced to consider only the final result, at the risk of betraying the source… We have to find a compromise somewhere between these two extremes.

O. C: L'homme qui plantait des arbres *by Jean Giono is a magnificent piece of writing. Did the adaptation cause any particular problems?*

F. B.: This piece always fascinated me. The imagery was a dream. I read all Giono's works to see if any other passages could be included visually in the film. But apart from the Grand Troupeau, it would have been quite difficult to incorporate any of them. As for the cuts, there was a section at the beginning of the book that really captured its 'raison d'être', and I wanted to use it. Normand Roger had created a beautiful score, but when the narrator read the extract over the music, the two didn't work together. So, regrettably, I had to cut the text.

O. C.: Was that all?

F. B.: I also had to remove the geographic details that Giono relies on to give credibility to the story. Not many people know the places mentioned, and the story is relevant to everyone because the extinction of the forests is a global problem.

O. C.: Were the visual changes difficult to achieve in relation to the story?

F. B.: In some cases it wasn't as good as I had imagined it would be. However, at other times it was completely the opposite; there were some improvements, particularly towards the end.

O. C.: What is fascinating is the way in which the story flows so naturally on film. From a cinematographic point of view,

there are few cuts; the shots flow from one to another, like the sentences in the story.

F. B.: The great challenge was effectively to go from one scene to another in an interesting way without interrupting the narrative.

Production

Jean Giono took 23 years to complete his book, during which time he kept it safe in a drawer, all the while continually improving and enriching it – this is what his widow, then almost a hundred years old, told Frédéric Back before the production. *Reader's Digest* had nevertheless refused publication of the story because the main character, Elzéard Bouffier, was fictitious. For this reason, Jean Giono gave the story (free of charge) to *Vogue* magazine, which published it in Paris in 1954.

Despite all the attention that Robert Roy (director of the Société Radio Canada) and the producer Hubert Tison gave to both the project and the original text, many problems arose straight away. Firstly, public interest in the subject matter was uncertain, especially as the storyline takes quite a long time to develop (almost half an hour). Secondly, the rights to the novel that Jean Giono had originally provided free of charge for publication had since been bought. The owners had to be begged for their authorization to use the text, and they even tried to limit the screenings to three showings. After many discussions, an agreement was reached and the production could recommence. But there was still the costly translation into English (Canadian businesses have to respect the bilingualism of the country). Also the fact that producing a medium length film based on a voice-over had never before been tried, either by Radio Canada, or even by the NFB… Finally, the film was able to go into production, thanks to the success of *Crac*.

34236

34290

34346

34373

Elzéard Bouffier towards the end of his life, and Jean Giono, as portrayed by Frédéric Back. The light shimmers on the surface of the drawing due to it being largely made up of tiny strokes of color.

The film was sold in sixty countries and translated into many languages; English, Japanese, German, Creole, Spanish, Malian, Mayan… Through all the educators who used it as a learning resource, it led to millions of trees being planted by children. In Quebec it was even used to teach French to immigrants; in Japan the English version is used to teach English.

Giono shown in the company of Elzéard Bouffier. Many readers believed that this character really existed.

In 1957, Jean Giono wrote a letter to Monsieur Valdeyron, the Commissioner for Rivers and Forests of Digne, on the subject of his novel:

Dear Sir,

I am so sorry to disappoint you, but Elzéard Bouffier is an fictitious character. My aim was to create a love for trees, or more precisely, to create a love for planting trees (an idea that has always been very dear to me). Now, judging by the results, my aim was achieved by this imaginary person. The text that you read in Trees and Life was translated into Danish, Finnish, Swedish, Norwegian, English, German, Russian, Czech, Hungarian, Spanish, Italian, Yiddish, and Polish. For all these reproductions, I gave away the rights – free of charge. An American has come to see me recently to ask my permission to print 100,000 copies to distribute free across America (to which I of course agreed). The University of Zagreb has translated it into Serbo-Croat. Of all my works, it is the one of which I am most proud. It has not earned me a penny and this is why it has fulfilled the purpose for which it was written.

I would like to meet you, if possible, to talk in more detail about the practical use of this book. I believe it is time that we had a 'tree policy', even if the word 'policy' seems rather unsuitable.

Very sincerely yours,

Jean Giono

Animation

The first animation tests were hard work. The poetic nature of the text did not provide any leeway; the imagery had to be exact and follow the prose to the letter, with the constant danger of either the text or the image becoming superfluous. The part dedicated to natural phenomena was tricky to transcribe visually. For example, depicting the wind caused huge problems, right from the very first shots. At the beginning, Frédéric Back, to use his own words, 'did a lot of work for the dustbin'. An atmosphere develops as the text progresses, which had to be translated by the choice of rhythm and cadence, as there was no other way of expressing this cinematographically and at the same time keeping the poetry of the original work. Furthermore, the character is realistic. He is just a man like any other. He had to appear credible on screen. The animation of realistic characters, even when they are slightly stylized, is difficult and arduous. Hubert Tison encouraged Frédéric Back as much as he could, as the film is long and the creation of characters took a considerable amount of work.

Illustration of the madness that descends upon the villagers in perdition. This stylistic difference in the graphics is completely appropriate.

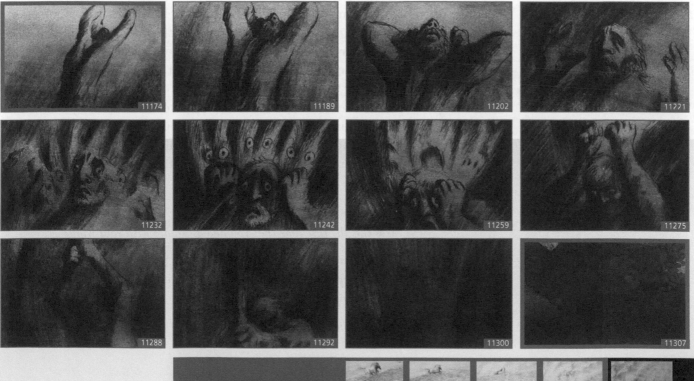

Animal movement is of great importance to the story. The film-maker must be in total possession of the technical skills of drawing and animation in order to achieve mastery over his project.

Once the work was underway, Frédéric Back accepted the help of Lina Gagnon. Her collaboration proved to be extremely valuable, due to her cooperation, discretion and the work that she accomplished.

Frédéric Back, who was used to working alone, now had to include the presence of a colleague in his working methods – he chose to entrust her with the job of in-betweener. When working alone, an animator can discard the fruit of several weeks work; but this is much more difficult when it is someone else's labour! However, as Lina Gagnon did not work on all the sequences, the director, quite legitimately, had to review all the work to harmonize the whole and to maintain the consistency; the personal style of Frédéric Back, delicate work of texture and quality, made this final touch essential. Lina Gagnon's contribution amounted to one third of the 20,000 drawings that made up the film.

The backgrounds were all painted by Frédéric Back, who also took charge of the calculations and technical parameters concerning camera movements and multiple exposures (see the following section). Besides this, he personally animated the more complex sequences. The size of the task in hand was such that he took his work with him to the country every weekend so as not to lose precious days.

Frédéric Back came up against a classic difficulty of animation that all film-makers working in the area of musical illustration know well; that of maintaining the nobility of the pre-existing work, without betraying it through weakness or lack of inspiration. This burden remained with him throughout the whole five years of production. Even now, he still expresses regrets, and thinks that certain details were over-emphasized, or that some ideas were poorly expressed, for example, the decision *not to show* the scene Frédéric Back would have loved to add: Jean Giorno opening the window of his house overlooking the mountains (but it was too late because the film was already selected for festivals). Unlike a live show that can be adjusted or improved over time, a film is essentially a fixed work of art.

O. C. Was this the first time that you had assistance with your work?

F. B.: No, but it is not my practice to work with other people. You save time, but you lose out in other ways. You have to prepare everything; verify, insist, intervene. You replace the problem of creating the film with the problems of human relationships.

O. C.: It's the same in big studios and in animation in general.

112

F. B.: Yes, and I ask myself how great animators can fit into the organizations of big productions where there are power struggles and politics; where, ultimately, an important part of their energy is dedicated to something other than creation, to the detriment of their artistic freedom and the quality of their work.

O. C.: It is a luxury to be independent...

F. B.: Oh, yes! It's thanks to Norman McLaren at the NFB and Hubert Tison at Radio Canada that individual work has stayed a priority. A film is created like a book. Previously, when the names of in-betweeners were added to the credits of my films, it was because I had accepted their help at the last

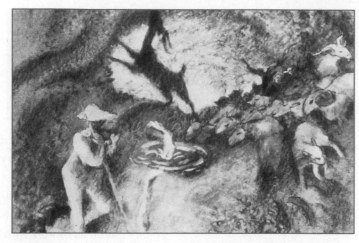

Towards the end of the film, the images merge together to show the effects of the tree planter's work. They become more rural and the representation remains naïve in style.

minute to finish on schedule. If they are not there, it is because I had the privilege of being able to create my films entirely by myself. Hubert Tison also helped me a lot with his comments, his critiques and by organizing the camera work.

O. C.: The animation was done on cel, but no ordinary cel...

F. B.: It's acetate that is frosted on one side – a frosted cel; its good for pencil drawing. I use a type of grease pencil with a wax base (from Prismacolor). The only problem is that this type of cel has become progressively smoother, as it is now mainly used by engineers who prefer it that way. So they don't accept the pigment so well. Because the colors are 'diluted', I sometimes double up the cels to improve the general density. This obviously generates more work...

O. C: It's well known that classic cels have a slight opacity; with frosted cels there is the added problem of diffusion, of a lack of sharpness, a little like the glass partition of a shower cabinet. Was that ever a problem?

F. B.: Yes. I had to superimpose several cels as much for density as for the multiplane effect. The transparency quite obviously suffered. So to get it back, and to maintain the colors of the backgrounds that had been created in dry pastel, I varnished the cels once I had done the drawing. The product I used was a quick-drying shellac, a toxic product. I waited until I was on my own to carry out this process; it is through this procedure that I lost an eye when I was fixing a drawing for Crac.

O. C.: Was that a handicap to you in your work on L'homme qui plantait des arbres?

08952 08973 08986 09021

Evening in the shepherd's house. Giono with his pipe: the light is created with a vast economy of resources.

F. B.: *I had to spend a lot of time receiving medical care during the making of the film. Moving on from that, the interest of a pencil drawing lies in its texture and style. Covering vast surfaces in color isn't interesting. It's therefore more worthwhile to work in small formats. On the whole, I wanted to keep the frame sizes at 10 cm by 15 cm so that, when projected, the enlargement of the texture brought a particular character to the lines and areas of color. As a result, I did a lot of work with the help of a magnifying glass.*

O. C.: *There were also some shots for which it must have been hard to imagine the amount of work involved, like the animation of the foliage. On each drawing, there are hundreds of leaves that move at the same time.*

With the life that is returning, the hunter reappears. A little further on, the wind blows the dead leaves towards the right of the frame (the future), so that they will fertilize the parts of the countryside that are still barren.

F. B: *Yes, with the wind, the leaves moved one by one. I had to spend days and days just drawing these tiny spots of color on the cels. The sequence where the leaves blow towards the valley, for*

28434 28532 28583 28681

28712 28723 28879 28924

28968 29017 29094 29173

example, took me more than three weeks, working 12 to 14 hours a day. And I still regret not having had the time to give it an extra week, because the effect would have been better if it had lasted longer.

O. C.: Was the animation done on paper first?

F. B.: No, it was done straight onto acetate (cels). First, the key drawings. Then the in-betweens. Obviously, some drawings didn't come out well and these I threw away. I didn't have the time to draw on paper and to transfer cel. It had to be done in one draft, as the task at hand was too vast.

O. C.: With an animation 'on twos', that works out at 12 drawings per second?

F. B.: Yes, except for the rapid movements, for which I used 24 drawings per second.

O. C.: Did you use mechanical aids, such as a rotoscope?

F. B.: I have never used one. All the movements were animated from memory. In the past I did many rough sketches from nature, and that helped me. I have resorted to the work of Muybridge for the animal movements and especially for the leg positions of the galloping horses.

The yellow spots must have a certain opacity to be visible on the blue background. Sometimes it was necessary to double the cels to create this type of effect.

An animation of a cavalry division from the 1914–1918 war. It is hard to imagine that this complex work was achieved without preliminary drawings on paper.

Working at the Animation Stand

The timing of the developing story requires smooth transitions from one drawing to another (I have even heard viewers claim that the film was made up of one single shot!). The images must follow on from each other softly – by use of fades – as cuts can cause a vibration that is visually inelegant. To mix so many drawings using fade-in/fade-out represents a substantial amount of work.

Theoretically, the number of fade-in/fade-outs is equal to that of the drawn phases, as one drawing is linked by a fade to the next, which is in turn linked to the one that follows, and so on. There is a process for getting an even better relationship between the drawings, which consists of fading them three by three. It was Claude Lapierre, the cameraman, who showed, Frédéric Back, a technique employed at the NFB to fade images from one to another easily, involving a series of successive mixes (multiple exposures) using a single sequence of drawings. It meant exposing the film four times the result being three drawing on screen simultaneously. Each pass, is made with a grey filter over the lens (after focusing) in order not to over-expose the film. The animation sequence is staggered and as it is shot four times, finally, each image consists of an outgoing drawing at 25% a another at 50% and an incoming drawing at 25%.

Another technique of multiple passes utilising a double exposure was also used. The first pass filmed in two's (12 drawings per second) is exposed at 50%. For the second pass, (also at 50%) the same series of drawings are staggered one frame (see diagram). The result being a frame of a drawing exposed at 100% alternating with a frame containing a mix of two drawings each one at 50%.

The director reserved the four-exposure method for shots that needed more fluidity; for the animation of the horses, the sequence where the woman loses her son, the face of Elzéard Bouffier near the end of the film and the color sequence in the

This sketch shows Frédéric Back's explanation of the system of multiple exposures. Simple and effective, it enables a vast amount of time to be saved.

credits. None of these scenes required a sharp focus, rather the impressionistic poetry of the final result was intended to linger powerfully in the viewer's mind.

This method, of using multi-passes with the same series of drawings staggered, is very interesting. It enables the drawings to be blended, counteracting the traditional economy of the animation. Preventing the viewers from fixing their gaze on each image while allowing them to observe the textural work. According to Frédéric Back, this technique 'considerably softens and enriches the images'. A small detail; as the breakdown of the film depended on the camera movements, the use of a computer-assisted animation stand was almost obligatory, so that the movement of the camera and the table could be repeated, precisely, when required. Of course, multiple exposures were used long before computers existed, but such a lengthy and complex task made the camera person anxious… Automation made this repetitive and exacting task much easier.

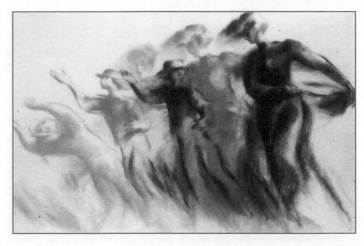

The process of fade-in/fade-out enables astonishing effects in which time enters a strange dimension. The scene where the death of loved ones is remembered thus assumes a deeper significance.

If the backgrounds are also cross dissolved for a graphic change, they don't follow the same rythm as the animation. Of course all the aforementioned operations used for the passes concerning the backgrounds were made while simultaneously filming the character animation and controlling the camera movements (on an animation stand, the movements of the multi-plane and of the camera up and down the column). Fortunately, the number of cells was fairly small; for certain shots, there was only one level. Occasionally the number might rise to three. The film was made on an Oxberry Computer-Assisted Animation stand, which was capable of seven simultaneous movements.

40737

40949

41075

41172

40807

40970

41093

41194

40835

40983

41102

41212

40858

41001

41114

41237

40890

41037

41121

41255

40922

41056

41155

41274

41305

41652

41754

41343

41612

41804

41422

41631

41816

41507

41645

41855

41517

41706

41927

41522

41735

The final sequence is a riot of moving colors. Life blazes across the screen – the work of one single man of vision and perseverance.

Soundtrack

Normand Roger, the composer of the film's music, had worked for Frédéric Back. The scale of the project encouraged him to develop a complex and very rich soundtrack, unusual in the context of a short animated film. Of course, such a work is the product of close collaboration with the director. The music is provided by a classical orchestral group with a luxurious sound. The length of the film and its complexity necessitates a very distinctive approach.

O.C.: The film's story is set in the natural world, and nature is effectively one of the film's characters, so the ambient sounds are very important...

F.B.: All through the work, I noted down the sound effects that were likely to accompany the action. A long time before it was finished, I had sent a list to Normand. There was, in particular, some birdsong that was specific to the region.

O.C.: Did that need editing for verification?

F.B.: When we had filmed enough scenes, we put together a pre-edit with Hubert Tison; Normand was able to watch the scenes and think about the musical themes in advance. As a colleague, he is extremely attentive to all the visual details and knows how to provide them with the appropriate accompaniment and emphasis.

O.C.: Why the choice of Philippe Noiret for the voice-over?

F.B.: I felt that it should be the voice of a French actor because many French people criticize the Quebecian way of speaking, often for silly reasons. I believed that such a detail should not be a reason for blocking the distribution of a film or video. Noiret had some knowledge of nature and horses, which he adores anyway. His phrasing was believable and his age corresponded to that of the storyteller, Giono.

O.C.: How was it done?

F.B.: The initial steps and the first session were difficult, but Hubert set up a session where the image was on a screen and the text scrolled past in the way Noiret was accustomed. The result is the soundtrack we know today.

Giono, shown shortly before the death of Elzéar Bouffier.
He is on his way to visit Bouffier by bus. The direction of the other passengers' gaze indicates the point of focal interest.

O.C.: I imagine that there must have been some editing involved, because to record for half an hour without interruption would have been impossible...

F.B.: Yes; in parts some of the splicing didn't work very well in my opinion. But there were very few critics. In fact, quite the opposite!

O.C.: And there were foreign language versions made...

F.B.: Christopher Plummer did the English version. In Japan, it was Rentaro Mikuni, who had a voice quite similar to Noiret's. He was so inspired by the script that he recorded for 12 hours without eating, drinking, or charging a fee! Since then there have been a whole host of versions; Italian, German, Spanish, Portuguese, Malian, Korean, Chinese; in some cases they are difficult to follow and judge on the basis of quality.

As the forest comes to life, the sunlight filters through the leaves and plays upon the characters. The use of the color blue brings comfort by alluding to water, in contrast to the hot desert colors used at the beginning of the film.

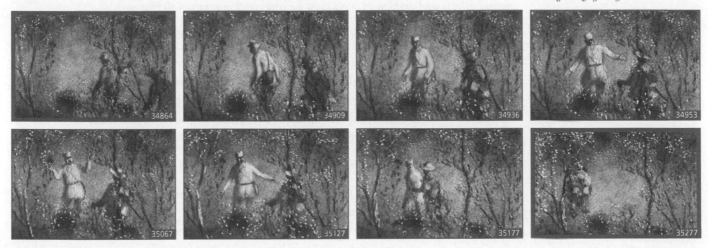

O.C.: How was the work organized on L'homme qui plantait des arbres?

N.R.: As is pretty much always the case, I worked on the edited film. Therefore the timings were exact and, as far as I can remember, definitive. The work was spread out over six to ten weeks.

O.C.: The classical orchestra is used frequently. How did you manage to choose the instruments?

N.R.: Generally, the orchestration and the composition are interdependent. They fit together. First, I choose the musical style and instrumentation, then I prepare the themes. After that, Denis Chartrand (my colleague who works on keyboard) and I try out different orchestration options.

O. C.: *The dramatic importance of the voice must have influenced the choice of music...*

N. R.: *The narration plays an important role in the choice of orchestration. In the case of this film, it was necessary to reserve some space especially for the sounds of nature, the other essential element of the screenplay – which is elsewhere often described by the narrator.*

O. C.: *So the voice was the primary guide.*

N. R.: *I did work with a narration guide; it was one of my main concerns, because the tone and the personality of the narrator are important for the accuracy of the music's intention. Consequently, I had to rely on Frédéric for all the information regarding the direction he intended to give to the final narration. I attributed a great deal of importance to this; it's not only a literary text, it is the central element of the soundtrack and all the other elements; music, sound effects and ambiences – all must be conceived in relation to this.*

O. C.: *Did you ask for any corrections or adjustments to the voice-over edit?*

N. R.: *It's normal to make changes to the narration in the course of production; most often, just minor positional changes in relation to music and sound. Sometimes we might make a small cut in the text to lighten a sequence, because the directors build the film around the voice-over, before the musical soundtrack and effects are created. However, I don't recall doing this in* L'homme qui plantait des arbres.

An extract from Normand Roger's score. Here, too, the text is present, serving as the metronomic basis of the work.

O. C.: *How many musicians and which type of instruments did you use?*

N. R.: *I seem to remember having 16 musicians; a string section, French horn, flute, clarinet, oboe, bassoon and harp. And also some more casual instruments; an accordion, a harmonica, a tambourine and a wooden flute for the shepherd sequence. There was some organ music in one of the flashback scenes of the wild villages and also some dulcimer (played on a keyboard) for the theme of the visitor-narrator.*

O. C.: *With such a soundtrack, were there lots of rehearsals?*

N. R.: *Normally there aren't really any rehearsals. The musicians did one or two read-throughs. We gave them the necessary information and we recorded. We re-recorded it until we were happy with it.*

O.C.: How long did the recording take?

N.R.: We recorded the bulk of the music in one day at the Radio Canada studios. I finished the rest of it at home.

O.C.: How did you proceed with regards to the synchronization?

N.R.: The musicians followed a film-guide with a metronome to make sure they kept to the timing. Therefore they didn't have to see the picture and could concentrate on their score. It was up to me to know if the interpretation was right and to direct them. Often, it's Denis who directs while I stay in the control room to oversee how the music fits in with the film and to provide spontaneous directives on the playing and nuances.

Some films can change a person's life, others can change the world. *L'homme qui plantait des arbres* is a film which, beyond its artistic and cinematic pleasures, has led to the planting of thousands of trees, as Frédéric Back himself has witnessed. One of his goals has therefore been achieved. But let us return to the film itself; it is one of those rare short films that will forever invoke powerful and lasting memories in its audience; for a film, even if it contains a message, works on an emotional level. This is certainly true of *L'homme qui plantait des arbres*, which stirs the very depths of the soul. Jean Giono's wonderful story, Frédéric Back's enchanting artwork and the indulgence that the producer and director have allowed themselves, of leading the audience so gently into their poetic world, make each viewer believe, even if only momentarily, that the future is bright. Anyone who still does not know this masterpiece should hurry to discover it and let themselves be transported into this sensitive world of indescribable charm.

Balance

Five men dressed in long coats are standing on a platform that is floating in mid-air. They are fishing. One of them catches a music box, which immediately arouses feelings of covetousness within them. By moving around and causing the platform to tilt, each man tries to make the box slide towards him. One by one, they fall overboard to their deaths, until there is only one left. But for all that, the survivor will never get to the box; it is on the opposite side of the platform. If he tries to get to it, he will be tipped into the void as well...

Oscar 1989

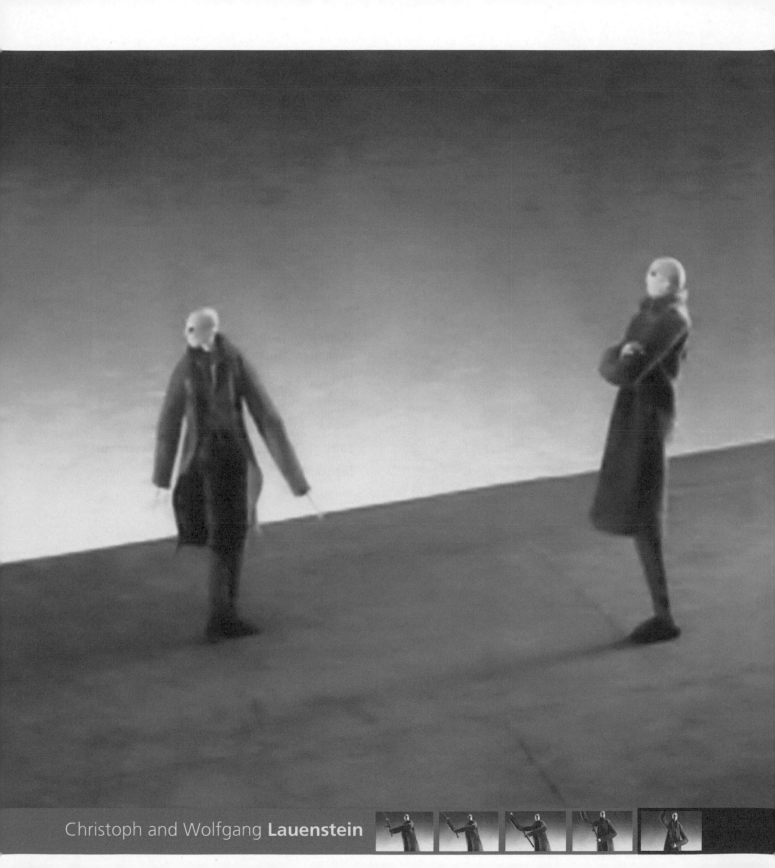

Christoph and Wolfgang **Lauenstein**

Credits

Title: *Balance*

Year: 1989

Country: Germany

Director: Christoph and Wolfgang Lauenstein

Production, distribution: Christoph and Wolfgang Lauenstein

Producers: Christoph and Wolfgang Lauenstein

Screenplay, graphics, storyboard, layout, background, animation: Christoph and Wolfgang Lauenstein

Technique used: Puppets, Stop Motion

Music: Christoph and Wolfgang Lauenstein

Sound: Christoph and Wolfgang Lauenstein

Editing: Christoph and Wolfgang Lauenstein

Length: 7 min 20 seconds

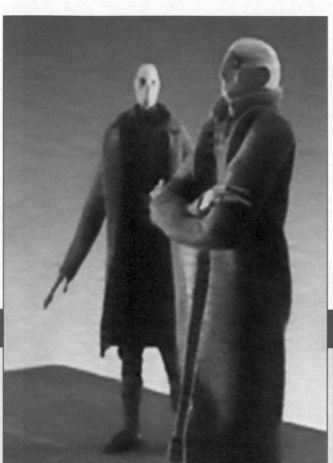

Christoph and Wolfgang Lauenstein are twins, born in 1962. Together they began creating their first animated short film in 1980, *Die Fremden (The Strangers)*. From 1985, Christoph attended the Academy of Arts in Kassel, whilst Wolfgang went to the Academy of Arts in Hamburg. At the same time, they made *Der Abstecher* (1984), *Pithecanthropus Erectus* (1986) and then *Balance* (1989), which won the Oscar for best animated short film. Today, at their studio, they mainly make films on commission, by combining stop motion animation, computer animation and plasticine animation.

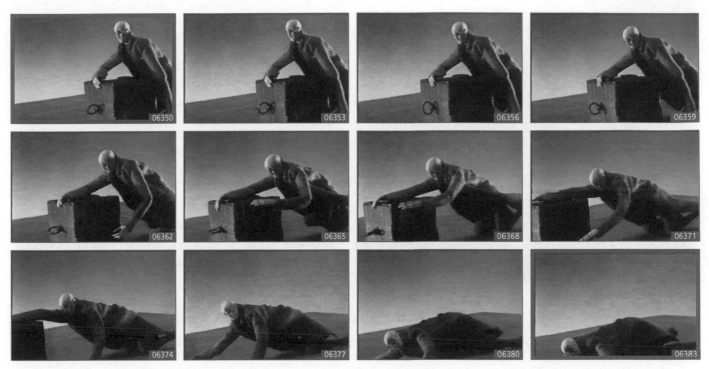

If the platform tips, the box slides out of the man's reach. This image, shown once in close-up, will serve as the leitmotif for the whole film.

Screenplay

'Balance'… this word, which also means 'harmony' (and has the added merit of being understood in many languages), was wisely chosen. The principal activity of the characters in this film involves constantly adjusting their respective positions on the platform to maintain their equilibrium and to prevent themselves from falling off… or causing others to fall. It is the mean spirit of one of the characters that leads him to commit serial murders, and to the pathos of the final situation. Even though they all have the capacity to move, each man is a prisoner in a cell without bars or walls. This film has the feel of a Samuel Becket play! The cruel and absurd drama that we are witnessing is not amusing; it has a kind of dreamlike realism.

In 1988, Christoph and Wolfgang Lauenstein were still animation students when they decided to make a new short film. Their work is above all cerebral and stems from discussion and exchanges of ideas; the main recurring question being, 'What does an animated film need to do to affect its audience?' Finding the right concept was a long

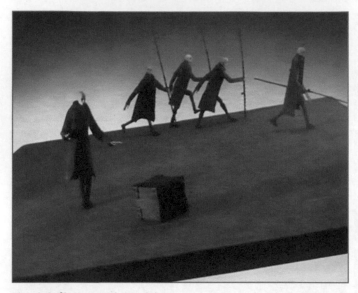

The whole film is centered around the idea of keeping the platform balanced; this causes the characters to interact with one another.

and tedious process. Christoph remembers perfectly when the idea for *Balance* was finally born.

He still remembers that feeling of personal certainty that he had unearthed 'the' right idea, the one he had been waiting for. Everything fell into place so rapidly that the title was decided straight away.

The technical choice to use puppets was also carefully considered. According to Christoph Lauenstein, the profound desire was not to create an ordinary film – yet another short film to be added to the long list of existing animated films – but to find a personal style, in a work which would perfectly exploit the specific possibilities of the puppet. The decision to use puppets was actually made before the concept was decided; in fact the puppets inspired the story. This step is quite typical of animated cinema, as the selection of a technique always influences the concept of the screenplay and the direction. The opposite is true in the context of live action films, which are essentially linked to the real world.

Working with puppets can also reduce production costs; for this film the brothers Lauenstein did not need a big budget, since once they had made the basic elements (the characters and the background), the only remaining issue is the time it takes to make the animation. The film does, however, need to be long enough to justify the efforts put into the making of the constituent elements (a whole set is rarely built for just two seconds on screen…). In this, *Balance* is a perfect example of the optimization of production resources in the service of a story, for its visuals are very simple, even minimalist; a platform, a box and some characters. It is this simplified picture, along with a screenplay that is itself pared right down, which must have charmed the members of the Academy for them to have awarded it an Oscar; simplicity being perhaps the hardest thing to achieve.

This image shows the only prop to be used throughout the whole film, apart from the music box. Even the sky is simplified. The light only ever has a few different hues – this also adds to the oppressive atmosphere of the film.

O.C.: *Did you have any difficulties in coming up with the general idea for the film?*

C.&W.L.: *For a long time, we were searching for our own style. Then the idea came out of the blue and everything became clear. We knew from our experience on other projects that you have to sometimes battle with an idea and mull it over for a long time, but this one didn't pose a single problem.*

O.C.: *Including the whole of the story?*

C.&W.L.: *We still hadn't perfectly foreseen the end. I remember that we wanted it to be an open ending. As a result, it came to us later, actually in the animation stage, when we were discussing ideas about how to move the characters.*

O.C.: *What does the puppet represent for you?*

C.&W.L.: *The animated puppet film can't develop the same themes as traditional cinema; for example, a love story with complex characters, which is rich in trivial detail, needs to be filmed with real actors. But for us, the choice of the puppet was appropriate to show human behavior whilst doing without trivialities. This fundamental notion is what drove us to make* **Balance**.

O.C.: *The film is very minimalist; few characters, very sparse scenery...*

Driven by his greed, the main character sends his rivals off into the void. The shots were chosen to show the viewpoints of both the murderer and the victims.

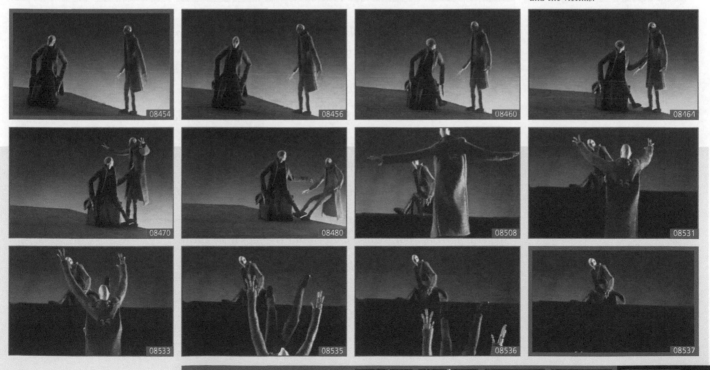

129

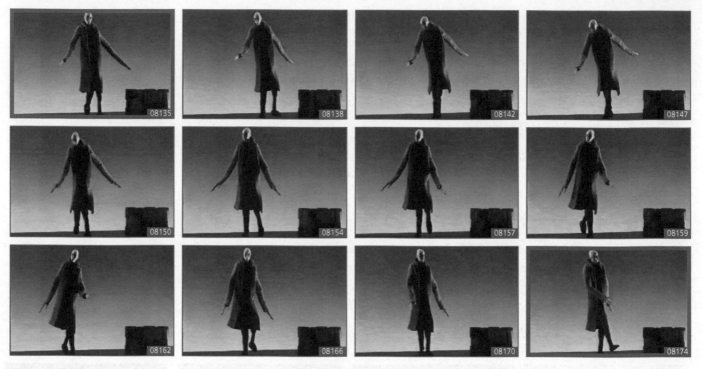

The one small demonstration of joy in the film; the dance done by one of the protagonists to the sound of the music-box.

C. & W. L.: At that time, we liked playing music and we used to compare cinematography with the art of music making. With music, you can create emotions by using only a few notes. We wanted to use this purity, this simplicity in the cinema. That is, we wanted to play with very few elements to obtain something true, to get to the essentials.

O. C.: It is a film with a message; you come away from it a little shaken up.

C. & W. L.: We wanted to create a universal picture of human behavior, in a way that everyone could understand. Interdependence is the keyword of this film.

O. C.: That sounds very intellectual when you say it, yet the film is absolutely not cerebral.

C. & W. L.: That is what we wanted to avoid. We wanted the viewer to feel that he was watching something 'true'. But we also didn't want the film to be elitist.

O. C.: Did you do a lot of work on the concept?

Not only are the characters all dressed in a similar way, also they turn their backs on each other in the first scene, immediately demonstrating their lack of sociability.

C. & W. L.: *Yes, we wanted to spend as much time as possible on it, so that we had a solid plot to rely on; we knew that the concept would inevitably become enriched while we were making the film, and we would no longer need to go back to the original.*

O. C.: *The five characters look a lot like each other. In fact they are clones.*

C. & W. L.: *We didn't want to create individuals. We weren't interested in individual behavior, but rather, in the typical mechanisms of human behavior – that of everyone. We were fascinated by the archetype.*

O. C.: *All the characters are dressed in a slightly sinister way; in a greatcoat with a number painted on their backs...*

C. & W. L.: *They are prisoners. Prisoners without their own personality. This is why they each have a number; they have no names or individuality.*

O. C.: *What does the music-box symbolize? What makes all the characters want to possess it so badly?*

C. & W. L.: *Everything that makes people live, that motivates them to act; like the apple of Adam and Eve. Without the existence of this box, we would be able to live perfectly together. It brings joy, but also trouble.*

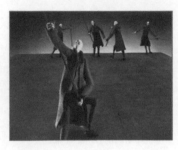

The weight of the box causes the men who are not fishing to retreat in order to avoid falling overboard.

Production

How do you produce a film when you are a student? With little professional experience it is difficult to contact a producer and convince him of your project's validity. Why would he throw himself into the production of an animated short film that will hardly be broadcast and will only appeal to a limited audience? Especially if the subject is serious and therefore not destined for children... Only determination can achieve such an exploit.

❝

O. C.: How did you produce this film?

C. & W. L.: Balance *is probably the smallest budget Oscar winning film in history! All we needed was a 16 mm camera and a room for filming; more precisely, a bedroom in our parents' house. We also needed half a ping-pong table and five puppets that we made ourselves by hand.*

O. C.: What sort of investment did that represent?

C. & W. L.: 5,000 marks at the time (2,500 Euros today) – all our pocket money and savings.

❞

The attitude of the characters is obvious; you can sense the powerful relationships that are setting them against each other.

Technique

Those who have seen this film will agree that the production conditions are modest. Furthermore, at this stage, the two film-makers had not had any actual professional experience to speak of. Add to this the customary complexity of the techniques used to direct an animated film. Certainly, the skilfully economic concept of background and characters enabled them to limit any difficulties, but many tricks of the trade were still needed to complete the production.

O.C.: Did you expect the scenes would be difficult to create/direct?

C.&W.L.: No.

O.C.: How were the marionettes made?

C.&W.L.: We used many materials. Wood for the skeletons, clay for the heads; the clothes were actual miniatures made by a dressmaker.

O.C.: The hands look like the hands of a skeleton. Why this decision?

C.&W.L.: This is typically the hand of a marionette; we wanted to show the characters more as mechanical marionettes than as human beings. We made them thin and tall for the same reason and in homage to the sculptures of Giacometti.

O.C.: What was the size of the film set?

C.&W.L.: The size of the room, 7 m × 3.5 m.

O.C.: And the scenery?

C.&W.L.: The sky was a backcloth 3.5 m long. The slab was made from half a ping-pong table.

O.C.: How did you get the platform to stay in the air?

The bony face, like the skeleton hands, give the characters a ghostly appearance; in this world, every man that falls prey to his passions is a dead man...

Clearly visible in this picture is the platform which was made from a simple ping-pong table. This surface has not even been smoothed out to create an illusion; we are in a symbolic world.

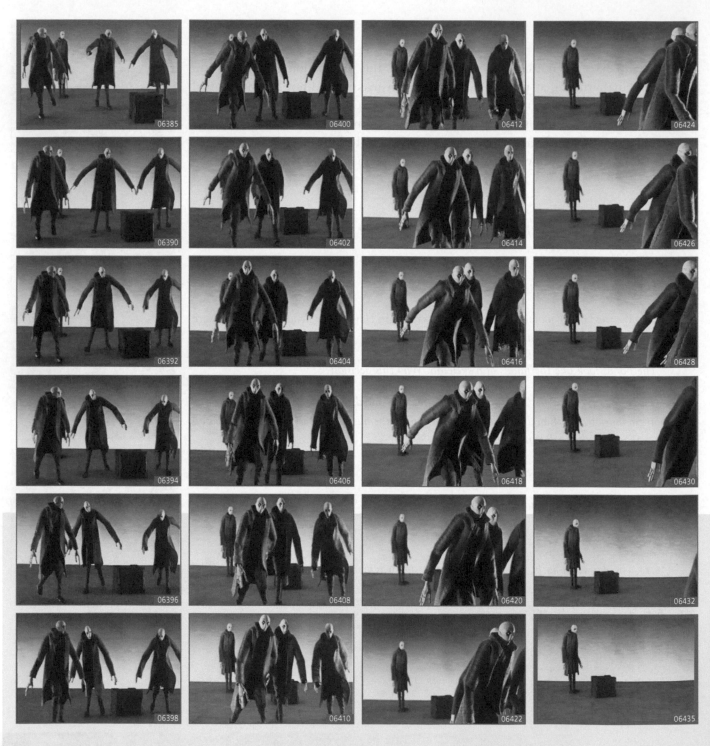

06385
06400
06412
06424
06390
06402
06414
06426
06392
06404
06416
06428
06394
06406
06418
06430
06396
06408
06420
06432
06398
06410
06422
06435

Facing page: Any movements are coordinated and mandatory, in order to preserve the equilibrium of the platform.

C. & W. L.: Animating it was quite simple; we used piles of books under each corner and we changed the height of the pile, shot by shot, to make the platform move. It was very low-tech...

O. C.: There are some scenes where you can see it floating completely...

C. & W. L.: Yes, three. We simply cut up a photo of the platform and fixed it to a glass plate. These three scenes weren't animated, so we didn't need to do anything else. The illusion was perfect.

O. C.: What process did you use to fix the characters to the platform?

C. & W. L.: We stuck layers of foam and cork onto the half ping-pong table. We could then easily fix the puppets' feet onto the surface with pins.

O. C.: What was the main difficulty when filming?

C. & W. L.: Balance was our first totally animated film. For the previous ones, we made the puppets move directly and used animated elements as well – but very few. As we were aware that the idea for this film required a quality animation, we worked hard to create the characters; it was necessary to create a sense of drama, yet at that time we still had very little experience.

O. C.: How much time did you spend on the actual animation?

The last man finds himself left alone with the box, but he will never be able to reach it without tipping himself over the edge. This shot shows his situation in an extremely effective way.

The action of casting the fishing rod is complex with characters that are so hieratic. For this reason, the angle has been lowered to create a more dynamic image with a better legibility.

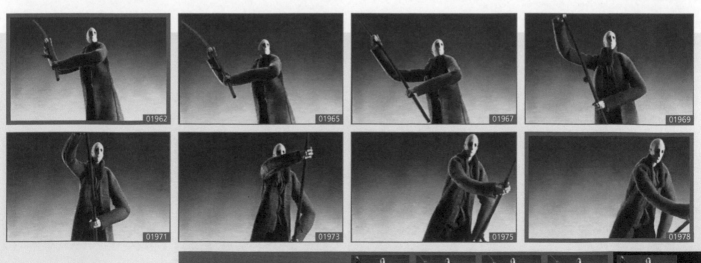

C.&W.L.: That was the longest part – we worked on it for five months.

O.C.: Did you have any method for testing?

C.&W.L.: We improvised a sort of line test. Today, it is a widely used procedure for stop-motion animation, but at the time it was very new. In 1989, there wasn't a computer to do it. We had to use an old video cassette recorder and record each image for one second. Then, by making the tape play fast enough, we were able to see what the animation would look like on film.

O.C.: How did you make the eyes move?

C.&W.L.: A common technique – they had a hole in the center of the pupil. We were able to move them in any direction by using a needle.

Soundtrack

The work on the soundtrack is very important in animation – it brings credibility to non-realistic visuals, but it can equally enrich a minimalist production by adding an extra dimension. In the case of *Balance*, the sound serves as much to establish the drama of the action, as it does to legitimize the characters' journey. Consequently, the soundtrack is used for both scripting and staging. Given the production conditions of this film, it was entirely home made…

O. C. The soundtrack is of great importance to this film, not only because the characters all want to own a music-box, but also because there are a whole load of other sounds that are always present in this space. What was your main intention?

The box is fussed over as if it were treasure or a living being. It is in fact the only element which seems to have a soul in this particular world.

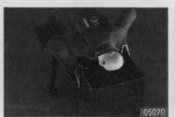

C. & W. L.: We wanted to create somewhere unreal.

O. C.: And why so much reverberation?

C. & W. L.: The atmosphere needed to appear really nightmarish to the audience.

O. C.: However, the box contains an apparatus that plays a classic jazz tune...

C. & W. L.: We love jazz. This tune in the box may seem strange, surrealist, but it is also lively; it 'grooves'! Apart from that, it contrasts with the stasis of the rest of the scene, particularly at the beginning, when the characters hardly move.

This film is a perfect example of what can be achieved by artists with few financial resources, if they have ideas and talent. The atmosphere that emerges is unique. The editing of the film is obviously very important; it is through meticulous planning that the desires of the characters are revealed. Merely using this simple platform inhabited by five people, Christoph and Wolfgang Lauenstein have developed an intense drama. The film is very theatrical. In contrast to those spectacular works that sometimes lose their soul by the importance of their production, *Balance* has a very particular intensity. The simple basic idea is worked to its very limits. It is a great and memorable lesson; the conditions of production do not matter when creative energy and the will to communicate a message are present.

Manipulation

A human hand draws a character, on a piece of paper, which then comes to life and asserts its independence. The artist's hand, refusing to cede power, manipulates the character, playing tricks on it and creating obstacles to its freedom. The drawn character tries to rebel and run away, but its attempts are in vain. In a last ditch effort, the character becomes a puppet made out of crumpled paper, before it is thrown indifferently into the wastepaper basket by its creator.

Oscar 1991

Credits

Title: *Manipulation*

Year: 1991

Country: United Kingdom

Director: Daniel Greaves

Production: Tandem Films Ltd

Screenplay, animation, artwork,

Layout, storyboard: Daniel Greaves

Technique used: Drawing on paper, cel, pixilation stop-motion

Camera: Frameline

Sound: Russell Pay

Editing: Rod Howick

Length: 6 minutes 20 seconds

The artwork used to create the main character is intentionally simple and direct. The more the audience can identify with a personage (and to achieve this, the character must be as neutral as possible), the more the audience can become emotionally involved.

Daniel Greaves was born in 1959. He studied animation at the Surrey College of Art between 1977 and 1980, before working for several studios as an independent animator. In 1986, he went into partnership with Nigel Pay to create Tandem Films, a company specializing in advertisements and television. *Manipulation* is his second personal film. Always on the lookout for new scripts, and using the money that *Manipulation* earned for winning the Cartoon, Daniel Greaves made *Flatworld* in 1997, a short film combining 3D sets and 2D characters, which takes the audience into the heart of trompe l'oeil. He has since co-directed Rockin' & Rollin' (2000), directed Little Things (2004), and Beginning, Middle and End (2004).

Screenplay

The history of art (among others) often teaches us that accidents are the source of many great ideas. Thus, it was during the filming of a line test for an advert that Daniel Greaves, short on time, put his hand in the camera's field of view while he was shooting the animated character on paper. The position of the character against the human hand made him wonder what would happen if it reacted.... against this interference, creating a relationship between the two. Daniel Greaves immediately understood that this idea could be developed much further and that a film based on this interaction could be fascinating.

From the outset, the film is made up of a series of events likely to interesting on the screen. The choice and organization of these scenes constitute the writing of the screenplay.

Manipulation proposes a simple but spectacular concept: the confrontation of two very different antagonists worlds. Given this, working on the screenplay was not as easy as it looks, because the specifications are simultaneously strict and very open. As can be expected, except for the moments of the birth of the character at the beginning of the story (creation) and his death at the end (when he is thrown in the wastepaper basket), the body of the film is made up entirely of minor incidents, of sketches laid end to end. The script development is not traditional as we are not, strictly speaking, following a story based on classical rules, such as a three-act structure; rather, we are working within a sequential continuity, a screenplay made up of episodes.

The film is mainly composed around visual and dynamic strokes of inspiration. Its length is not determined by the development of the story. Consequently, it could have been much longer, or shorter, if the film-maker had wanted. However, it must be remembered that the viewers are following a series of sketches: It's not always easy to guess how long this collection of sequences will last. A film like this, if it is too short, leaves the spectators hungering for more. If the film directors is too long, on the other hand, the lack of dramatic progression eventually bores them. This is the problem that classic cartoon film directors faced in their time, whereby the development of a script based on a situation implied a series of short scenes which generally developed into a chase.

Daniel Greaves used a checklist to make sure he did not forget any stage of the work.

Therefore, the writing is complicated; the only real dramatic progress that the film-maker can rely on lies in the organization of the sketches; this must give an evolutionary logic to the dramatic composition. For example, the volumetric view of the character should be worked on last (crumpled paper, puppet strings, etc.), after all the two-dimensional possibilities have been exhausted.

This sequential structure also requires the concept to be developed carefully during writing. The quality of the linkage of events has to be constantly monitored to ensure seamless transitions from event to event.

Below, the paper character, locked away in his paper prison; fitting the different levels together is one of the major components of this film.

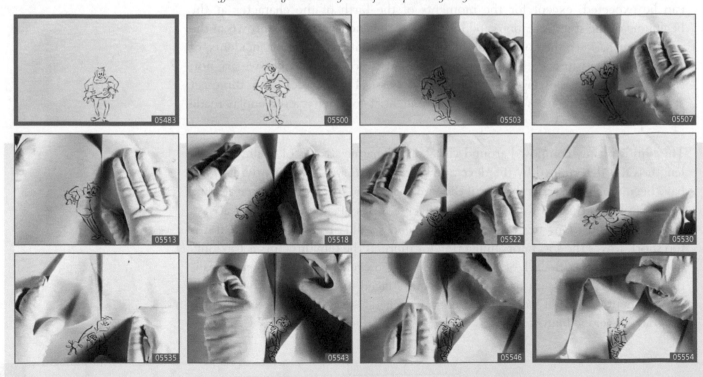

"

O. C.: What was your principal aim in this film?

D. G.: I wanted the audience to really believe in the relationship between the two protagonists, to accept that the paper character was as alive as the hand of the Creator.

O. C.: Did you want to communicate a specific message?

D. G.: I liked the idea that the Creator wasn't happy with his work and wanted to destroy it, whereas his creation wants to live and have its own life.

O. C.: Did you have another project in mind at the time?

D. G.: I always have loads of ideas and projects that are all more or less developed, but when I decide to make one, I devote myself to it completely. Otherwise I'd never finish my films.

O. C.: Is that difficult for you?

The character's fall (he has become volumetric) into the wastepaper basket. This scene is highly symbolic.

D. G.: As the process of developing and making animation is long, I'm always discovering new things that I really want to try out in other films. But I have to put the new ideas aside and concentrate wholly on what I'm doing, which requires a lot of discipline for me.

O. C.: Was the film perfectly clear in your mind from the beginning, or did you have to keep going over it while you were writing?

D. G.: The writing technique was special: I had quite a long list of possible visual actions and interactions between the hand and the character. The work mainly consisted of linking them together. I had a vague idea of it beforehand, but everything actually fell into place when I started animating: I felt that the ideas linked together organically.

O. C.: Did you spend a lot of time on the idea and writing?

D. G.: No, I was impatient to start animating! That has its advantages: the film seems spontaneous because it was instinctive and natural like a first sketch.

O. C.: Did you think about the audience's response when you wrote the story or when you were thinking about the final result?

D. G.: Yes, because they must be convinced that the character really interacts with the hand. It's very close to magic, to illusionism: everything is in the rhythm, the timing. I wanted the

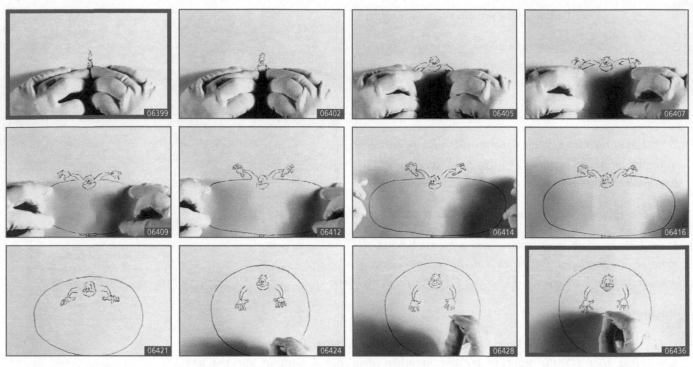

This scene is inspired by classic cartoons. It also shows the cruelty of the Creator.

audience to feel sorry for the character. The fact that he is drawn freehand helps because it makes him vulnerable.

O. C.: *Do you envisage the whole film before picking up your pencil and drawing the storyboard?*

D. G.: *I have an impression, but I can't see the details. I put down a combination of preparatory sketches and ideas on paper and then bring it all neatly together with the writing at the storyboard stage.*

Classic Tools

While the most spectacular aspect of *Manipulation*, from both a visual and technical viewpoint, is the use of real hands and an animated character, it should be borne in mind that the basis is still traditional. Animation, in the technical sense of the word, is the main component; Daniel Greaves is first and foremost an animator.

The role of animation in the film is all the greater as the image very simple. If the character appears as real as the human hands, that is truly down to the quality of the animation. It is interesting to note that this film is a real return to the roots of animation: the lack of sets and extensive coloring allude to the early days of animation. On the other hand, the interaction with a human subject recalls works from the beginning of the twentieth century, especially Max and Dave Fleischer's *Out of the Inkwell* and Walt Disney's *Alice in Cartoonland* – which already combined the two universes to show the magical side of the animation process – or the more recent *La Linea* by Osvaldo Cavandoli. While this work of animation on paper appears simple because of its minimalist visual approach, several small technical and artistic subtleties add to the image and its dynamic by playing on the effect created and the visual conventions of the genre.

O.C.: In the film, there are a number of scenes that are quite funny because they rely on the visual conventions of cartoons. In one scene, for example, the fully outlined character plays with his own color. He leaves it behind as he runs faster, but the colored shape follows reproducing his movements. On what background were the elements (colors, outlines) drawn?

D. G.: *The two elements were on cel. To keep the artwork, I mean the original outline of the character – which is normally on paper – we used a Chinagraph pencil, which creates this kind of look.*

The whole film is based on trompe l'oeil effects and playing with the codes of cartoon making. Nonetheless, even an uninformed audience would understand the underlying humor perfectly, without any specific knowledge of traditional techniques.

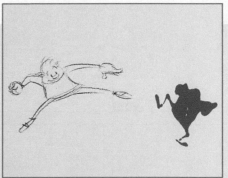
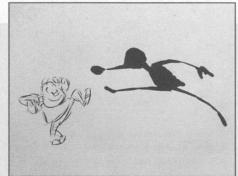

The animation of the colored layer is exactly the same as that of the outline character. Only the treatment differs which maintains the specificity of each material.

O.C.: *The paper character plays ball with the red paint through he remains transparent. The ball is just a small circle and is clearly behind his fingers when he catches it. There are only two ways of doing this: either the inside of the character is painted white to imitate the paper background or the red paint fits the contours of his fingers perfectly...*

The ball the character plays with is slightly fluid to highlight the fact that it is a paint ball.

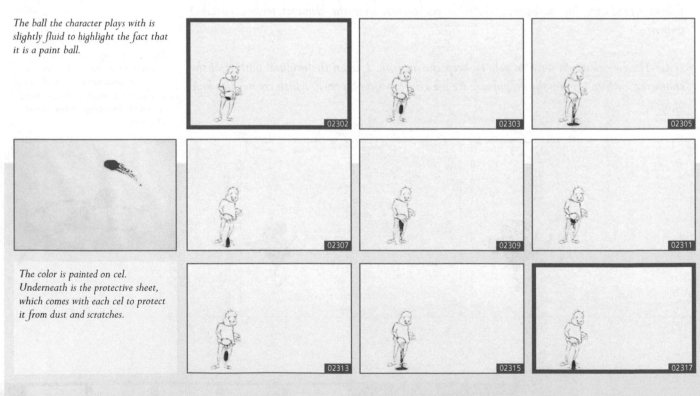

The color is painted on cel. Underneath is the protective sheet, which comes with each cel to protect it from dust and scratches.

D. G.: The second option: the paintwork had to be very carefully spread out so that it looks as though it is behind the character's fingers.

O. C.: Before becoming a volume, the character goes through a stage of being a ball of crumpled paper that bounces all over the screen. How did you think of that and animate it?

D. G.: I first did an animation pencil test of a drawn ball of crumpled paper and used this as a guide for the real ball of paper. In the shots, I quite simply placed the crumpled paper on a drawn guide and did this each time I had to take a shot; that was my reference point.

This highly minimalist image uses paper in two forms: flat and crumpled. Out of context, you might think that these are the frames of an experimental film.

O. C.: This ball of paper then becomes a volumetric character. It stands up and takes a vertical pose (the camera moves towards an almost horizontal axis to show this to advantage). Did you have to make a puppet with a skeleton and other devices?

D. G.: Yes, at the end there is a skeleton in the crumpled paper. The character was filmed frame-by-frame with the real hand. I should mention that no computers were used, not even in post-production. All the effects were created during the shoooting, including the mix of real and animated elements.

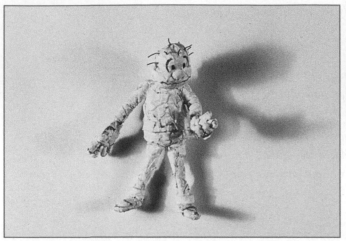

At last, the character is in volume. He lies on the paper where he was born.

Alas, the paint pot plays one last trick on the character as he slips on the paint and slides off the desk. A physical armature is required for this scene. The presence of the animator's desk is a tribute to the art of 2D animation.

The character stands up, then the camera comes back to its initial view, which allows the whole room to be seen.

The character, drawn in pencil on cel: the effect is the same as a normal pencil on paper.

Mixture of Animation and Reality

In some scenes in the film, you can see the two hands and the character in the same field. These are the most complicated sequences to make: this mixture of traditional animation/live action, which today can be made easily using digital compositing, was done directly under the camera: the drawn stages were filmed simultaneously with the positioning of the hands.

One of the main difficulties involved the hands coming into physical contact with the paper. So that their position changed as little as possible from one frame to the next while an assistant changed the animation drawings by carefully sliding them underneath, Daniel Greaves could only lift his hands a few centimeters (so as not to lose sight of their previous position) without changing the pose. He then laid them on the new sheet of paper and moved the position of his fingers and palms slightly to animate them. This is quite an astonishing mix of classic animation on paper and pixilation (animating human characters, as in *Neighbours*). Filming was demanding for Daniel Greaves, who was physically immobilized for hours with his hands tense, which gave him back pains that he still suffers from today.

In spite of all the care taken during filming, the hand shakes slightly on screen. It is effectively almost impossible to move them by just a millimeter in each frame, frame after frame, all the more so because they were shot in close-up: (the field is easy to guess because the presence of the real hand provides a scale). The trembling of the hands, however, fits in well with the fast pace. Ironically, this lack of stability inherent in the technique enhances the Creator's personality, as the paper character moves more smoothly.

Each of two protagonists have a movement that is their own, a personal dynamic, in the animation tradition. Coming from different universes, they cannot move in the same way. However, the technical challenges do not end there. Due to the screenplay's requirements, a large number of other difficulties had to be dealt with, sequence by sequence.

O. C.: *The film starts with the artist's hand drawing several versions of the character's head, very quickly, as he is looking for the right design and because you clearly want to spare us the natural slowness of the action and to get to the point. Did you draw a series of stages in the construction that were filmed one after the other, let's say 'a drawing construction animation', or are they accelerated shots of your hands drawing the character directly under the camera?*

D. G.: *I drew directly onto the same piece of paper, stopping at each important stage in the animation process so that the frame could be shot. I was helped by a complete drawing placed under the sheet, which was slightly visible against the light.*

O. C.: *When the hand pushes the head or the body of the character away from the paper, is it also drawn or did you use cutouts?*

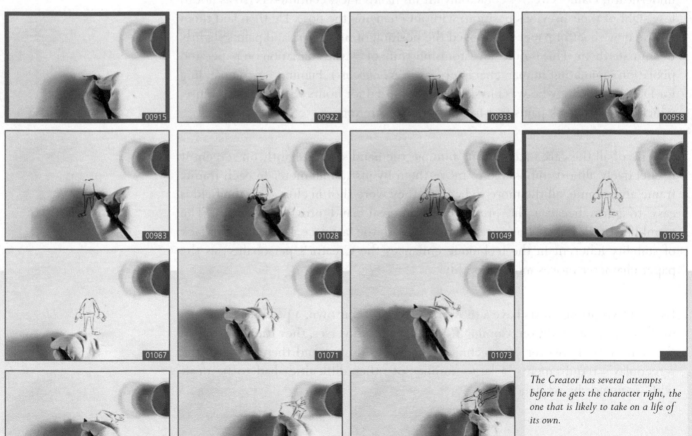

The Creator has several attempts before he gets the character right, the one that is likely to take on a life of its own.

D. G.: *Paper cutouts weren't used as you might think, and as might be used moreover it was completely animated because I wanted the head to change shape when it was pressed (squashed). The sheet was replaced for each frame. I had to raise my hand carefully for the next piece of paper to be put in place. The movement was fast, which created the illusion, as you don't really see the irregularities in the positioning of the hand.*

O. C.: *Then there is the episode with the overturned paint pot. How did you manage that?*

D. G.: *It's simple object animation. The paint, which spreads out on the paper, is animated frame by frame. We made quite a thick, viscous paint mixture to be able to handle it easily and to give it the desired shape frame by frame.*

O. C.: *How were the paint and the outline drawn when the real finger presses the character to make him squirt his color?*

D. G.: *The color and the outline were drawn and painted onto separate acetate sheets (with the same tools that were used when the character plays at outmaneouvering his color). Of course, everything is prepared in advance, in the traditional manner, and filming is carried out with the finger pixilated in the field.*

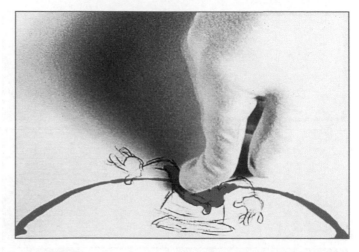

In this sequence, the timing must be perfect because the finger must give the impression that it is pressing on the drawing. We can see that, as it is in direct contact with the drawing and almost immobile, the repositioning and the joint deformation of the finger must be similar from one frame to the next.

The animation of the liquid gives the character a physical credibility, which is the irony of a scene that is particularly unrealistic.

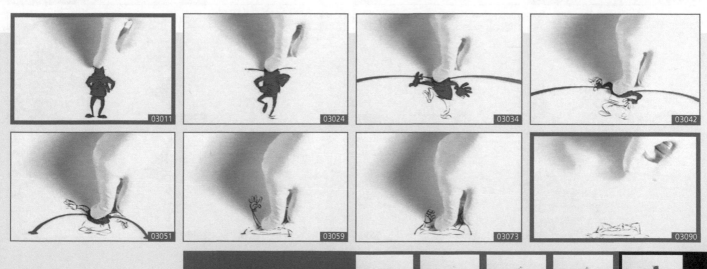

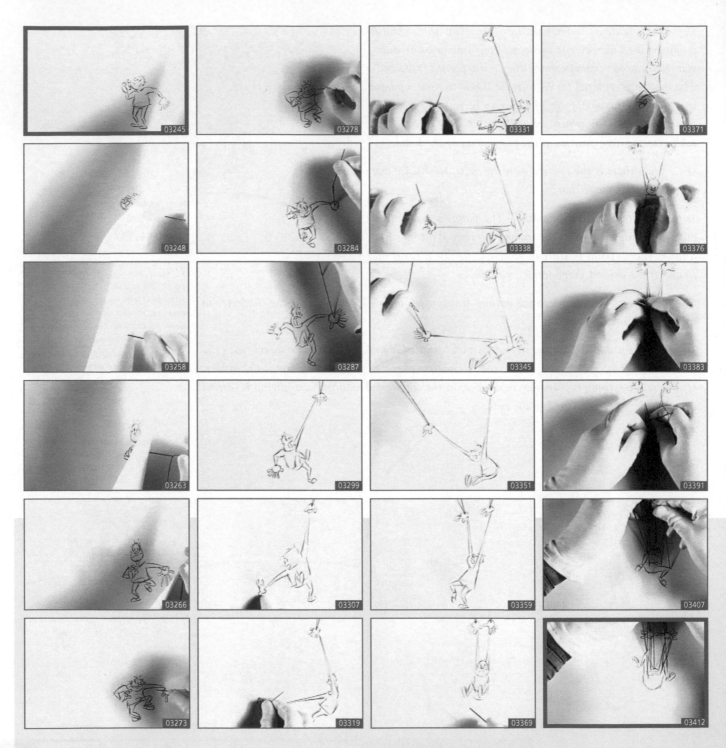

The Creator's cruel game is a 'mise en abyme': the character becomes a prisoner to the medium that gives him life.

> **O. C.:** Towards the end, the character's limbs are attached to threads (like a flat puppet on a string) as he is drawn on paper: a new demonstration, of the fact that the Creator refuses him even the vague desire of having his own life. How was this done?

The dance is sketched before being cleaned, conforming to the traditional animation method.

D. G.: With a real thread passed through the paper using a real needle! The animation was shot in stop-motion, with my hands constantly in the field while an assistant changed the drawings underneath. Then, the threads were replaced by cables painted red and repositioned frame by frame on the sequenced drawings. These cables are attached to a piece of wood placed above, out of the frame. As a result, it naturally creates a real shadow.

O. C.: Nevertheless, you still had to think up and draw the animation without having the threads as a visual aid, and their position is significant for the final composition of the frame. How did you plan this?

D. G.: When I animated the dance sequence, I thought of how the threads would pull the character's body in different directions. It was thought of from the start, and it was easy to lay the threads where the body was connected in the shots (in the end... this took a bit of time all the same!)

Opposite page: the process, of showing a thread for each joint is long. Also, the first two threads are attached in real time, whereas the others, showing the two hands are accelerated.

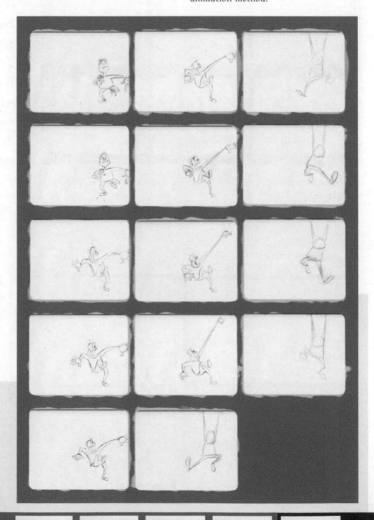

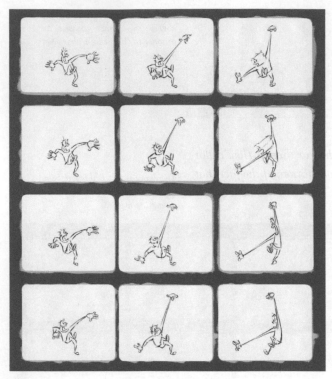

The original animation of the forced dance sequence, once the frames have been cleaned.

O. C.: The character escapes by taking out a (drawn) penknife and using it to cut the threads. In this very scene, you can see in two or three frames that the red thread which is becoming loose is absolutely slack before disappearing out of the frame.

D. G.: We used thread for the whole dance sequence in order to recreate the tension that exists naturally when it supports an object or a character. As we used real metallic thread, which can bend, we slightly curved it for a few frames to simulate its flexibility.

O. C.: There is another impressive effect; the character takes the knife again and cuts a door in the paper to escape. Was the paper actually cut frame by frame?

D. G.: Yes, it was really cut out. It was also slightly raised to create relief and shadow before the character dives into the slit. In this way, you get a real volumetric effect that gives the scene credibility. As it is white against a white background, this shadow allows you to see the gap more clearly; a slightly grey surface was essential.

This depth effect is possible because the audience accepts the character as being 2D.

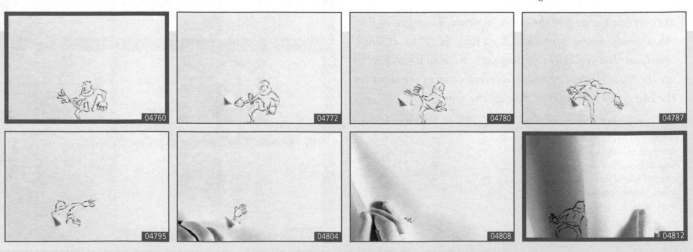

O.C.: The creator also amuses himself by rubbing out the artwork of the character's head with his finger, still trying to deny him any autonomy. Was this done on screen or was it prepared?

D. G.: It was prepared in advance. The characters face was smudged on the paper in each consecutive drawing. During the filming the finger makes a side to side movement to create the illlusion that it is rubbing out the face. Clearly, here as well, the paper is replaced frame by frame under the finger.

O. C.: There is another surprising scene where the character punches the paper, which crumples at the site of the impact. I can't really see how this texture could be drawn on paper. Well, you could do it, but it would take a long time...

D. G.: Effectively! The character is animated traditionally on paper. While filming, I took the sheets and manually crumpled them in the places that were going to be hit with punches, before putting them in front of the camera. The lighting is adjusted to highlight these irregularities: the lamps were placed lower down so that it would be more striking and create shadows.

Sometimes, the character has to be isolated from his paper background and for the above sequence paper cutouts are used. Here is a series of expressions, cut out separately. On the reverse is the numbering which is indispensable for the order during filming.

On the original animation papers, you can see how the character was textured. As the background is plain white, this research was necessary.

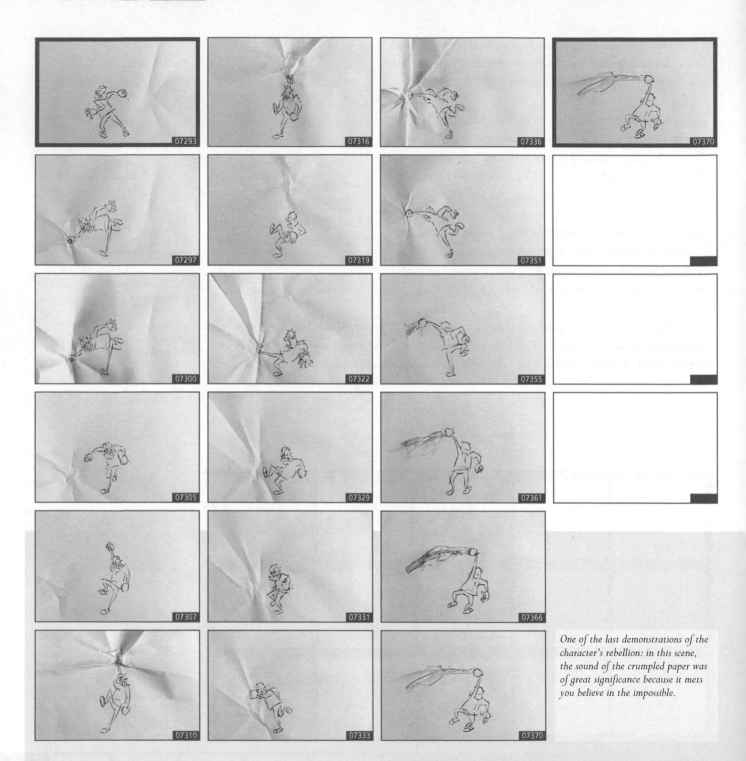

One of the last demonstrations of the character's rebellion: in this scene, the sound of the crumpled paper was of great significance because it mets you believe in the impossible.

O. C.: *Towards the end of the film, the character crumples and folds the paper over like a blanket, wrapping himself inside. Were there lots of levels to this?*

D. G.: *The character is animated and transferred using paper cutouts. Each stage is carefully cut out and then placed on the background paper. This is crumpled frame by frame and is timed with the animation of the character above. This method is used until the crumpled paper covers the character completely and he can no longer be seen.*

O. C.: *The credits match the general system and style of the film, where the letters appear behind shreds of papers that tear by themselves...*

D. G.: *The paper was torn frame by frame to show the names of the contributors. So, there was only one element that had to be animated on screen.*

,,

The paper is crumpled, frame by frame when the character punches it.

After the punches, the character tears the paper with his nails. The transparency of the animation sheet shows that it was really torn.

A quality film is often recognized by the care put into making the credits: in Manipulation, *the beginning, like the end of the film, uses the main material in the story: paper of varying thicknesses.*

Soundtrack

In order to make this mixture of pixilation and animation believable, the two elements must be linked by the soundtrack. The soundtrack must also draw the viewer into a universe in which events are often only suggested visually, the film being largely made up of a stylized outline drawing.

Russell Pay dealt with this task and like Daniel Greaves he was, at that time in his career, still quite new to cinema. [Moreover, as a musician in a rock group, he had to work with quite basic technical means (a microphone and a portable DAT recorder).] Today, after fifteen years, he is still Daniel Greaves' regular musician.

The sound was recorded after the animation; the visual aspect thus preceded the sound. However, there are two exceptions: firstly, when the character is animated by being pulled out of shape like an accordion, because the visual rhythm has to follow a preexisting sound; secondly in the Charleston scene, in which the character is forced to dance while attached to strings. For this latter sequence, the music was analyzed frame by frame (sound breakdown) so that the animation could be perfectly timed with each note. The Charleston tune came from Daniel Greaves' collection: an LP recorded on DAT for the final edit. This music, due to its length, ends with an artificially added loop, made with a sampler.

Daniel Greaves and Russell Pay wanted the music to be as simple as possible, as realistic as possible and, preferably, based on the film's main material: paper. The priority was to give credibility and importance to the character.

O. C.: How did you organize the recording sessions?

R. P.: Daniel came to my house with paper, card, washing up liquid bottles and other items and accessories. He also put a microphone in the bathroom and we threw balls full of water around almost everywhere. In fact, we took everything we could get our hands on and played with it – it was an organic process!

O. C.: All the same, wasn't it a complete risk?

R. P.: No, Daniel knew his film inside out. He knew what he was looking for and he knew when he found it. So we actually recorded it all quite quickly. It all took around three morning sessions.

O. C.: With all the sounds collected, there must have been a great deal of editing to do...

R. P.: Daniel took it all to Rod Howick (the editor) and they worked on it to synchronize it with the image.

Manipulation is a stunning film that succeeds in being experimental in its techniques and entertaining at the same time. Moreover, it is a funny film that nonetheless has a very strong philosophical theme. All these ingredients are combined without irritating the audience on the contrary, rarely does an entertainment film fill the viewer with wonder at the unrelenting development of the screenplay concept, the technical brilliance and the depth of the story. It is a unique film that should be watched again and again as each viewing presenting the film from a new angle.

Mona Lisa

descending a staircase

Through the transformation of famous pieces of art, the film offers a panorama of painting from the end of the nineteenth century to the present day. Using incomparable technical and artistic skill, it creates a explosive display of colors, textures and clues, for the amateur to decipher, as to the indentify of the work. The screenplay relies on the pleasure experienced upon seeing the chosen works, and the intelligence of the associations as well as the way they are linked in the film.

Oscar 1992

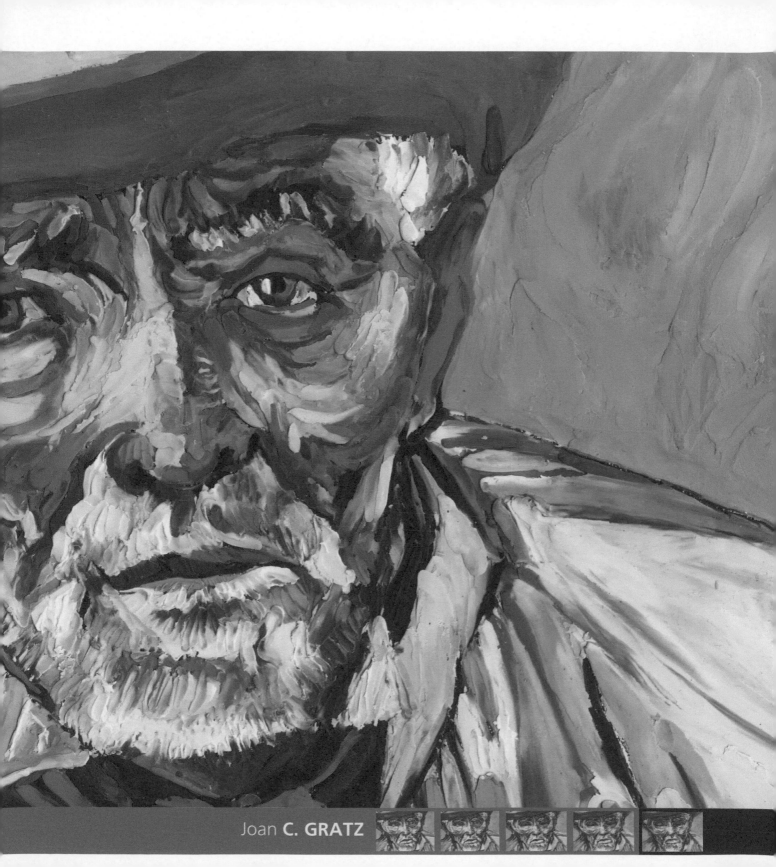

Joan **C. GRATZ**

Credits

descriptive

Title: *Mona Lisa descending a staircase*

Year: 1991

Country: United States

Director: Joan C. Gratz

Production: Gratzfilm

Screenplay, animation, artwork, layout, storyboard: Joan C. Gratz

Technique used: Clay painting

Music: Jamie Haggerty

Sound: Chel White

Voice and didgeridoo: Jean G. Poulot

Sound mix: Lance Limbocker

Optical printing: Fred Pack

Length: 7 minutes

The transformation is applied to the film's symbol (Mona Lisa) to create the title sequence.

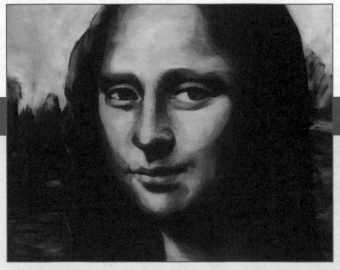

Joan C. Gratz received degrees in painting from the University of California at Los Angeles and in architecture at the University of Oregon. She developed her technique of animated painting when she was an architecture student, then shifted to clay while working with Will Vinton Studios from 1976 to 1987. During that time, her work included design and animation for the Academy Award nominated film Return to Oz by Disney. Short film nominees Rip Van winkle and The Creation, which was the first film to feature Joan's clay painting. She established her own studio Gratzfilm in 1987.

Her independently produced and directed films include: The Dowager's Feast, which explores the unconscious through abstract imagery. The Dowager's Idyll, commissioned to be screened at a live concert performance and Pro and Con (with Joanna Priestly), an animated documentary about life in prison. In addition to her personal films, Joan C. Gratz has made many commercials. Her clients include Microsoft, United Airlines, Coca Cola and Knorr.

Screenplay

While experimentation and formal artistic research are not always used in commercial pieces of work, they are often the source of more personal films. The animator's approach comes closer to that of the artist wanting to give complete freedom to an individual expression that knows neither external nor narrative constraints: the only rule is aesthetic pleasure.

The majority of animation film-makers have been at least partly trained at fine arts colleges and graphic art schools. Thus, they normally draw their sources of inspiration from the traditional visual arts. This influence assumes great importance and promotes the use of many well-known cultural references in their films, including allusions and tributes to classic paintings and sculptures. Joan C. Gratz's film *Mona Lisa descending a staircase* is an especially eloquent example of this. The title is a combined reference to Leonardo Da Vinci's famous painting, the *Mona Lisa*, and Marcel Duchamp's *Nude Descending a Staircase*, giving the audience an insight into the type of visual display they are about to watch. It is worth mentioning that Marcel Duchamp was also interested in *Mona Lisa*, and painted a rather personal version in which he added a moustache – *Mona Lisa with a Moustache* (L.H.O.O.Q.).

The seven minutes of Joan C. Gratz's film present a panorama of contemporary painting, introducing the works of 35 famous artists with images of their most representative work. An outstanding stylistic work of art, it takes the viewer on a journey through modernism at the end of the nineteenth century to the present day; behind this list of works floats the timeless figure of the *Mona Lisa* as the archetype of pictorial work.

04950 04969 04977 04986
04992 05001 05009 05023
05029 05035 05043 05052

A difficult transition between two canvases with very different styles: note that the first one by Fernand Léger is animated slightly (the lines decorating the woman's hair).

O.C.: *How did you get the idea for this film?*

J.C.G.: *My original idea was to create an animated history of painting in the twentieth century by using morphing images.*

O.C.: *How much time did you spend on the idea?*

J.C.G.: *Although the project was conceived in 1981, it wasn't completed until 1992. I spent nearly eight years researching and planning... and putting everything off until tomorrow. The animation as you see it took two and a half years.*

O.C.: *That's quite a lot of time in production. How was it organized? I guess you were unable to work exclusively on the film...*

J.C.G.: *While I was working on* Mona Lisa, *I was the set designer and special effects animator on Will Vinton's feature film* The Adventures of Mark Twain, *and on the Disney feature film* Return to Oz. *I also made several commercials. There were a lot of interruptions.*

O.C.: *And financially?*

J. C. G.: Mona Lisa was made with different subsidies, including grants from the Oregon Arts Commission, the Western Regional Media Arts Commission and the American Film Institute. I also used the money I made from advertisements. The fact that the American Film Institute imposed a two year deadline within which to make the film was motivation enough for me to get a move on.

O. C.: What is your relationship with the audience when you are preparing a film?

J. C. G.: I don't think about the audience when the work I am doing is solely for my own pleasure; it's quite the opposite to doing commercial work, adverts in particular, in which client satisfaction is paramount. Mona Lisa is an entirely personal film.

O. C.: Do you envisage the film in its entirety before starting?

J. C. G.: No, not at the beginning; it's exactly this discovery process that interests me. If I were aware of how the whole film would develop before I started working, I don't think I'd be interested in making it anymore...

O. C.: You had to devise an 'order' for presenting the paintings, a chronology that allows fluidity. Was that difficult?

J. C. G.: Yes, determining a chronology to introduce the artists was complicated, as was showing the way in which the images change and providing information about the style and technique used in each painting. That's the visual side of it. The soundtrack provides indications about the cultural and environmental context for example the sounds of war during the German expressionists and Picasso's Guernica.

O. C.: Was the soundtrack made before or after the film?

J. C. G.: After, to match the images more closely.

The storyboard in this particular film catalogues the different paintings that constitute the film's continuity.

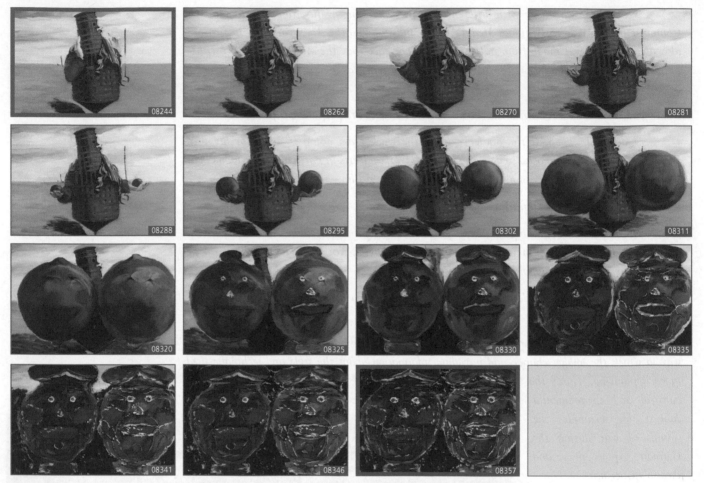

In the middle of the film, surrealism gives way to art brut during the transition from Ernst to Dubuffet. The painting style is completely different in the two paintings; the second painting gradually arrives at its definitive style. In this case, it is the very subject of the first painting that provides the idea for the transition.

Francis Bacon is a painter whose style is most compatible with Joan C. Gratz' own and therefore a pleasure for her to replicate.

Technique

Joan C. Gratz is a specialist in clay animation. Her work at the Will Vinton studio, a pioneer in this field[1], led her to research the techniques and visual effects she has used since then in her commissioned work and in personal films made at her own studio.

When one thinks of animation techniques based on modeling clay, one normally thinks of stop motion puppet films (for example, *Wallace and Gromit* by Aardman Animations): animated films that are similar to stop-motion cinema and use techniques that involve the use of puppets or other solid figures. The originality of Joan C. Gratz's work is the fact that the base material is not used three-dimensionally, but two-dimensionally to create paintings. She uses modeling clay in the same way that others use oil paints; it is a material that can easily be retouched, and its long drying time makes it easier for it to be modified and reworked frame by frame.

The saucepan is an essential tool in painting with modeling clay, along with a hot plate! The material needs to be malleable in order to mix the colors.

[1] Will Vinton won an Oscar in 1975 with *Closed Monday*, his first film. With very few exceptions, it was the first time in that era that the possibilities of using modeling clay in animation were shown at the cinema.

Modeling clay is a fragile material. It must be stored in a way that prevents it from picking up impurities and dryint out. The use of small plastic bags to protect it is ideal.

It was by adding a little here, scraping off a little there and substituting small quantities of clay that the paintings were modified frame by frame. The work has to be done with small pieces of clay for it to be precise.

The modeling clay is spread out on a solid background, which it sticks to naturally due to its consistency. This background is placed on an easel; the work is carried out vertically, and not horizontally as is often the case in animation (working on the animation stand with the drawing or painting laid flat). This style of work is indicative of the artist's influences.

On the contrary to what one might expect the clay is viscous enough to hold throughout the several days of animation and filming. However, it must be said that the clay used by Joan C. Gratz is most definitely not the variety that is available commercially. It's her own special secret mixture. To reproduce the textures and aspect of the different paintings she has some wire tools, but mainly uses her hands to recreate the brush-strokes.

Looking closely at the clay that constitutes the painting, you realize that this material allows it to closely resemble the original painting.

O. C.: *How were the animation sessions organized? How do you work?*

J. C. G.: *My painting technique is based on oil-based modeling clay, which allows me to reproduce the textures and colors of the paintings. I work at an easel with the camera placed behind me. The animation is live: I work the material, then shoot the frame, I change the painting again, shoot another frame, and so on. Each time, you have to add a little clay, remove a little, and change either everything or some details. I use my hands and also a small wire to make holes in the clay. It obviously takes a long time...*

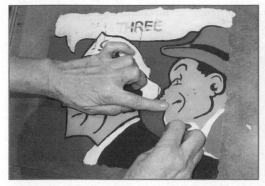

Working with her fingers or a wire tool add or remove modeling clay on Andy Warhol's pop art painting inspired by Chester Gould's Dick Tracy cartoon strip.

The final result: a transition between two very different pop art paintings.

O. C.: To be able to distinguish clearly between the different textures and impastos in some of the reproductions, the lighting must have been very important.

J. C. G.: I filmed with two lights at 45° to the painted surface. This is the classic method of lighting under an upright animation stand. In this aspect my work is similar to classic animation.

The setup is quite simple. The camera is perpendicular to the easel with two lights at a 45° angle to the painting surface. Each second of film produced in this manner required two days. The exact replication of the key paintings was more time consuming.

O. C.: There is something very surprising in the quality of the different textures. The material is always the same, but the result really looks like oil painting, with all the variations that this presupposes about the style from one painting to another... was this difficult to do?

J. C. G.: Oil based clay is a remarkable material. The thickness can be changed and colours blended to replicate the varied consistencies and textures of oil paint. For example, German expressionism uses quite thick brushstrokes, whereas American pop art has little surface texture.

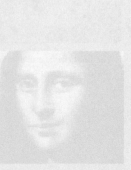

A typical example of a painting showing the characteristic thick impasto of the German expressionist school.

O.C.: You work at an easel. Does the clay never run?

J.C.G.: My easel is very stable and even though it's almost upright, I have never had any problems. The clay being oil-based has good adhesive qualities and wouldn't run unless exposed to heat.

O.C.: We have both seen that work on this film was spread out over quite a long period of time. There are a few transitions in Mona Lisa but they are quite spaced out. There is some fade to black, which separates the major periods in the history of painting. As your work is filmed directly and you have to remember the stage you were at when you stopped, didn't you have any problems when you started working on the film again after a long interval?

J.C.G.: I was able to give Mona Lisa a feeling of uninterrupted flow. I planned cut-points which allowed me to down-load and develop sections of the film without loosing the fluidity of the imagery. Occasionally I would animate to a solid color and cross-dissolve to hide a cut-point. But in one scene, the sequence showing Picasso's cubist period, I had to interrupt the work to film an advert. Suddenly, there is a jump... apart from this there was no problem stopping between each animation session.

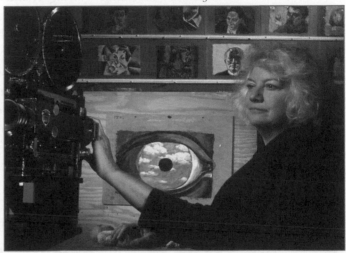

A 35 mm camera was used for filming (held here by Joan C. Gratz). Generally, the cost of production for the film and development is quite low in animation, as less footage is shot, compared to live action films.

In the course of the transformation from one painting to another, we can see that the change in the viewpoint between the transition painting and the final painting is completely animated; there is no camera movement or change of focus – animation has changed the geometric organization of the scene.

Animation

In watching *Mona Lisa descending a staircase*, we might assume that the animated part of the film is quite basic, as it is limited to creating the links between one painting and another. It is true to say that we are definitely not considering a film that shows living characters who display behavior patterns or feelings. In this respect, the general work ethic of *Mona Lisa* is far removed from the traditional one, the Disney ethic, which consists of giving a soul to each protagonist. Using the paintings in a realistic or cartoon-like way would have been possible, but this would have over-ruled the film's creativity in a direction that Joan C. Gratz would not have liked. The paintings would have been set up in a narrative framework and would have had to abandon, or at least relegate to the background, the idea of a panorama of the history of twentieth century art, which was her main inspiration.

A simple transformation linking two very different paintings: it is the small elements that make up the first and second paintings that shape the play on their similarities to create a harmony between them.

Nevertheless, the animation in *Mona Lisa* is far from a series of skillfully executed transformations linking the paintings. Firstly, the paintings are not always easy to transform; problems are posed by the theme, background or colors. Consequently, Joan C. Gratz had to create a spatial and dynamic arrangement flexible enough to build up a particular elegance, a natural effect, in the transition from one painting to the next. It must be borne in mind that each pair of paintings is unique and the transitions between them are always different.

Secondly, as these transitions are works of art in themselves (this can be seen when there is a pause at a particular image during viewing, or simply if the viewer pays attention during screening), it quickly occurred to Joan C. Gratz that these new paintings could in turn create a show within a show. Thus, certain new elements, independent of both paintings, were introduced into the background, and others simultaneously, or otherwise, are simply born of preexisting colors and textures. It is also in this way that parts of the metamorphosing paintings achieve an existence for a few frames and play an ephemeral role in the film.

The cloud backdrop in Magritte's painting provides a semantic element for the transition.

173

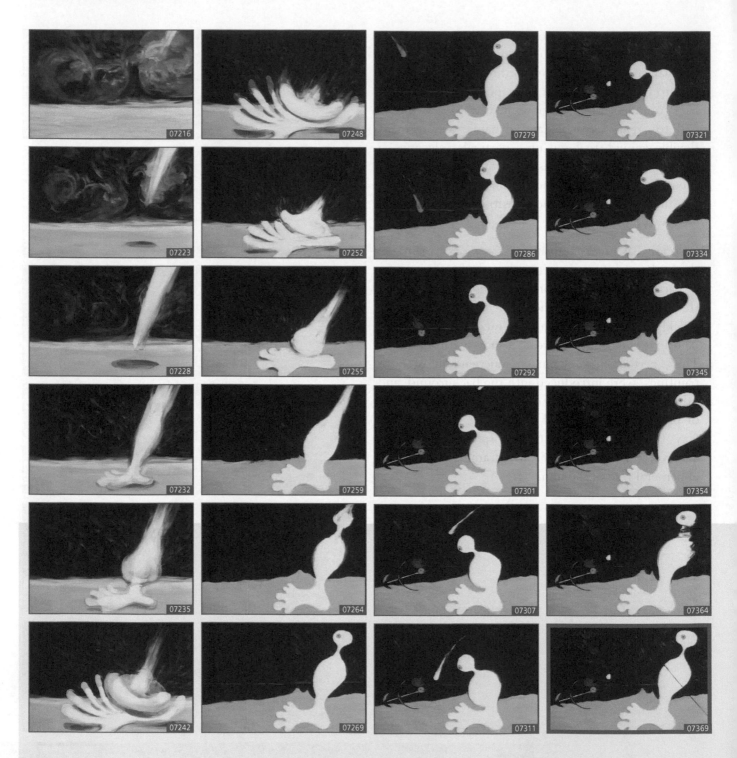

Some examples of the results obtained by playing with the basic material. Many types of classic painting techniques can be reproduced using modeling clay.

O.C.: Do you think in terms of geometric arrangements to pass from one painting to the next?

J.C.G.: The transitions were the most interesting aspect of the work. A great deal of what they show consists of providing information about the style of the paintings. As there is constant transformation, the images between each painting are a mixture of the two paintings, of the work of the two artists. The relationship between the images depends on the era, the artistic movement and the interconnection between the artists.

O.C.: Technically, did the timing have to be carefully thought out in advance to reach a suitable rhythm for the introduction of each painting?

J.C.G.: No, I didn't prepare the general timing too accurately. I didn't know how long each image would stand still on the screen before the next transformation. Once the animation was complete, I changed the rythm of the film through optical printing in the lab. This allowed me to refine the pacing and flow of the final film.

O.C.: So there were no prior animatics that allowed you to determine the rhythm?

J.C.G.: I never make animatics. I am a great believer in spontaneity. Once again, if I know in advance how the film is going to look, I have no reason to make it.

O.C.: Some scenes must have been particularly difficult to animate.

J.C.G.: A great deal of time went into planning which painters and paintings to include in this film. Certain painting styles are more sympathetic to my own work, but I tried to represent the major art movements. Naturally the painters chosen reflect my own bias. In terms of animation the most difficult paintings are those with no texture or small realistic details.

Facing page: the second painting is introduced by animating successively a series of frames of its components. The character in the second painting is animated to create a theatrical entrance.

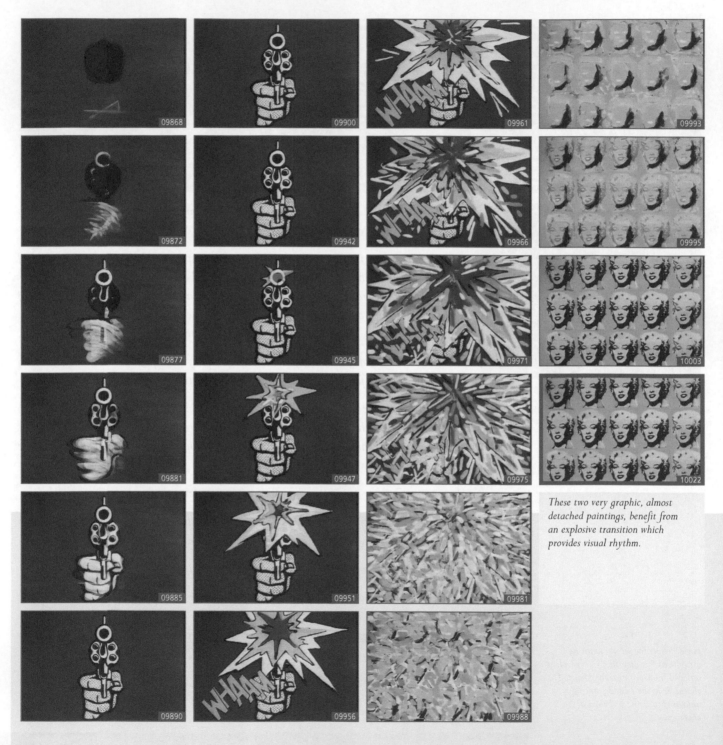

These two very graphic, almost detached paintings, benefit from an explosive transition which provides visual rhythm.

Watching *Mona Lisa descending a staircase* always provokes a kind of euphoria in the audience; laughter can even be heard from the theater when certain transformations take place. Such reactions may be surprising, because if part of the festival-going audience has the same cultural references as the artists, these transitions are not necessarily comic. This film certainly has a playful dimension; following the treasure hunt, recognizing the paintings and references, having fun in trying to guess which painting will be next and how it will make its appearance on screen. Above all, in this film, the audience relives its discovery of painting. In this animated gallery its a part of our souvenirs that stream past.

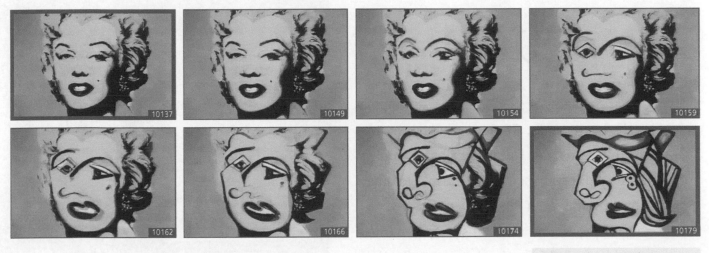

A play on the mise en abyme technique: Warhol's Marilyn Monroe (Gold Marilyn Monroe) becomes a 'fake' Picasso redrawn by Lichtenstein (Woman with Flowered Hat).

Quest

A creature made of sand awakens, an empty bottle by its side. It must find water to ensure its survival. Following what it thinks to be a dripping sound, it travels to one strange world after another, going from a world of paper, to a world of stone, then into a world of machines, in the search for the precious fluid that will quench its thirst and prevent it from disintegrating. However, just when it is close to success, it meets its death. It crumbles into a pile of sand that drifts to the bottom of the sea and forms a new creature that comes to life, an empty bottle by its side...

Oscar 1996

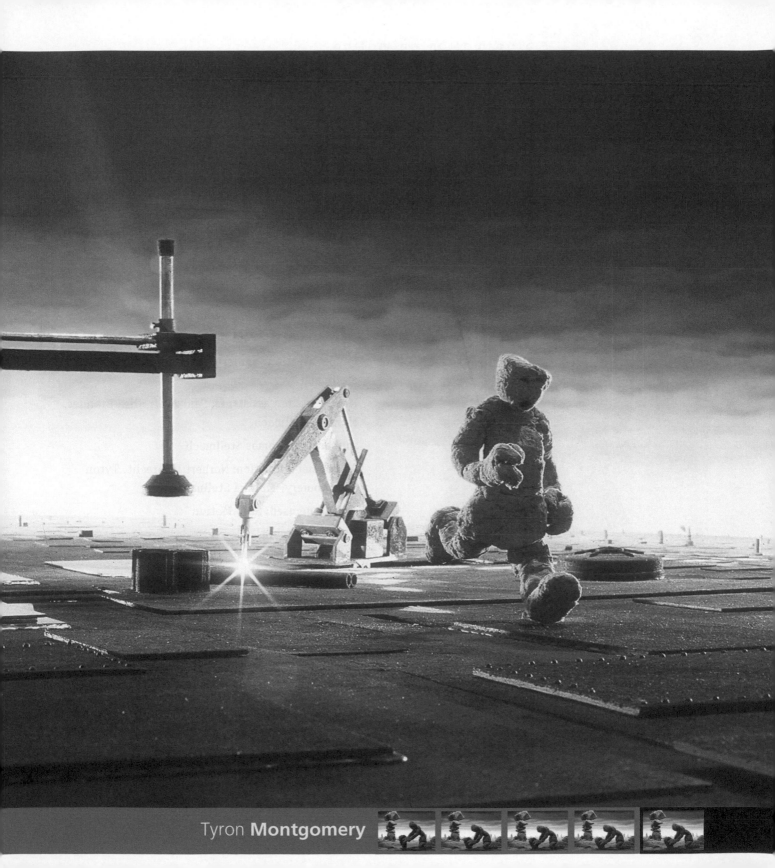

Tyron **Montgomery**

Credits

Title: *Quest*

Year: 1996

Country: Germany

Director, photographer: Tyron Montgomery

Producer: Thomas Stellmach

Story: Thomas Stellmach

Screenplay: Tyron Montgomery

Story consultant: Paul Driessen

Puppet creation: Norbert Hobrecht and Thomas Stellmach

Model creation assistants: Said Arefi, Gisa Brandes, Monika Stellmach

Animation: Thomas Stellmach

Additional animation: Norbert Hobrecht, Tyron Montgomery, Monika Stellmach

Technique used: Stop Motion

Music: Der Spyra

Length: 11 minutes 33 seconds

Tyron Montgomery, born in 1967, was originally a director of special effects and photography for many films (including *Small Talk*, 1994, by Thomas Stellmach, the future scriptwriter and producer of *Quest*). The success of *Quest* made Tyron Montgomery's work known and enabled him to develop other projects with very different techniques. He then started a web conception and design company whilst still continuing his work in cinema (*Die Gruene Wolke*, 2001), always as director, visual effects supervisor or director of photography. Today, he still manages to fulfill several different roles working on commissioned films.

Screenplay

This film is both an allegory on survival in a hostile world (symbolized here by the search for water, which the character needs to stay alive) and a variation on the theme of moving from one world to another by the completion of a 'test'; reminiscent of the dramatic format of computer games.

The main difficulty this first work faces is that of retaining audience attention for this unique character's story throughout its eleven minute duration. Thanks to the changes of scene, which are as important to the plot as the character, the story manages to keep us hooked all the way through. Even though the purpose of the character's quest is soon guessed, the audience still wonders why he really needs the water; which, moreover, is symbolically the only living element in the film. This short film has its foundation in metaphysics.

The basic plot structure for the film was first developed by Thomas Stellmach, the producer. At the time, he was a student at Kassel (Germany) under the tuition of Paul Driessen (one of the best animation film-makers in the world). He wanted to develop a simple short film screenplay as a writing exercise. This work, which took him a year, was further enhanced by contributions from other students on the course. In March 1992, Tyron Montgomery arrived on the project. He reviewed the script and slightly modified the ending. The origins of this film could therefore be seen as quite unusual; it is a truly collaborative work, with contributions from its future producer, a class of animation students and its director, who arrived later.

O. C.: How was the work organized?

T. M.: When I arrived, Thomas and Paul had already spent a year on the concept, but obviously not full-time. Thomas had also been discussing it with the other students and had built in some of their ideas. At the beginning, everyone was working on other projects. When I began to be involved, Thomas had just finished his previous film, so we were able to dedicate ourselves completely to Quest. I rewrote the script and Thomas designed the storyboard.

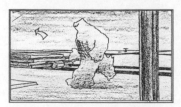

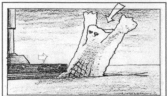

At the same time, we had begun the technical preparations and the construction of the stop-motion props. It was all mixed up – we didn't really do things in the normal order.

O.C.: Let's talk a bit about the development of the story through the film.

T.M.: It's a very linear film and the story is extremely simple, right up until the last 20 seconds, when suddenly something is revealed that makes the rest of the film clear.

O.C.: Yes, the ending is what really makes the film. At the same time, the story goes full circle. It's a never-ending quest.

T.M.: Without those last 20 seconds, the film has nothing to say. It all rests on a very simple idea, but one that changes everything.

O.C.: You're talking about the story, but what is your relationship with the audience?

T.M.: When I used to make my little 8 mm films, which I did for several years, people quite liked them, even though I made them for my own pleasure. My approach therefore seems to be of pleasing them, without asking myself too many questions... Maybe that's because I'm a person who develops a balance between rationality and emotion, rather than an eccentric artist. I don't know.

O.C.: In practical terms, how does your creative process happen?

T.M.: I trust my intuition and I imagine the effect upon the audience. I discuss the project with the team members and organize screenings, if necessary, to test reactions. For Quest, I used this type of test screening and afterwards added a scene at the end.

O.C.: You do these screenings to test audience reactions, but do you see the film clearly in your mind before that?

T.M.: Usually, yes. I have quite a clear vision and don't need drawings to develop my ideas. Nevertheless, I like storyboards, even right at the beginning of a project, because they allow me to think quickly, to concentrate on the details and, above all, to communicate with the others on the team. For Quest, the main part of the film was initially shot directly according to the story.

The film's storyboard. The directions are sufficiently clear to show the narrative continuity. The drawing is simple, as this stage of the job is above all about communicating with the other team members.

Production

This film needed a lot of technical resources because creating the background sets was a complex task. The production was therefore difficult to mount and manage. Furthermore, the school did not own the necessary equipment; there was no film set, no recording studio for the sound, no 35 mm equipment, and no mechanism for installing the lighting.

The two associates therefore started with nothing. The film's budget was 57,000 Marks at the beginning of the 1990s (roughly 40,000 USD).

This lack of professional equipment led Tyron Montgomery and Thomas Stellmach to buy an old 35 mm camera (an Arriflex II BV) with a hand-made motorized attachment to guide and drive the film, image by image. There was also a special base for animation. This equipment is quite standard. This lenses chosen covered a wide focal range, even if they were the old Arriflex models. To this was added a zoom lens, used for one single sequence. Despite having quite colorful visuals, no special filters were used during filming.

The team was made up entirely of students. To begin with, six people worked on the construction of the models, backgrounds and stop-motion elements, which were numerous. Then four of them were involved in filming the paper world (three animators and Tyron Montgomery). The rest of the film was made solely by Tyron Montgomery and Thomas Stellmach.

The old Arriflex that was customized by hand to adapt it for animation. This camera is a classic model.

Because of the lack of experience and technical difficulties imposed by the shooting script, many scenes had to be refilmed. It is difficult today for the authors to assess exactly how much work they did twice. According to Tyron Montgomery, nearly half the shots were re-filmed several times. The problems encountered were not solely of a technical nature – half the time it was the puppet that did not provide the desired result on screen.

The production began in the spring of 1992, and was finished in 1995. As always, this is an 'official' time span; the creators did not work full-time on it.

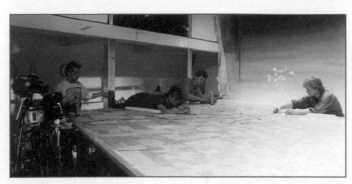

Working on the set. Animating the flying papers, as seen from the ground. You hardly notice the strings that support them.

"

O. C.: *There are a certain number of shots that could have been created more easily today, using digital post production. This new technology was just possible at the time when you made the film. Was there any contribution from computer technology?*

T. M.: *No, we didn't have the budget for it. Everything that you see in the film was filmed directly, in front of a camera. Notably, there is no digital overlay. Later, I worked on advertisements, and in the majority of cases I also filmed them directly. To me, the result seemed more authentic like that. I only used the green background when something couldn't be done any other way.*

O. C.: *Did the project seem difficult to direct from a technical point of view?*

T. M.: *I'm quite at ease when I have to sort out technical problems. And besides, we had already experimented with puppet animation and stop-motion filming on our previous films. But Quest was nevertheless difficult, because there were many tricky scenes that needed lots of preparation. However, we didn't get any nasty surprises – everything was always quite well planned.*

O. C.: *All the same, it was an ambitious project for students.*

T. M.: *No-one imagined the total production time. At the beginning, Thomas wanted to film Quest as a simple exercise, in less than three months! I thought that it was a shame to waste a good story on a student project. As a result, the project became important. It didn't stop us from hoping to finish the film in less than a year... We were wrong, because at the end we had worked for 24 or 30 months.*

"

Making the Puppets and Sets

The skies figure largely in this film, and are typically painted on big vertical surfaces that go with the set. The background was curved to create a cyclorama, allowing a diversity of camera positions. A clever principle was used, which consisted of placing a very definite horizon line in each world. This totally separated the sky from the ground; the image is thus composed of a horizontal surface and a vertical surface. This aesthetic decision enabled economies to be made in the total number of backgrounds needed. However, it requires the

sky, which can occupy a large part of the frame, to be of sufficient visual quality to suggest a rich and authentic world, and that the earth gives the impression of being vast.

In this film, we follow the wanderings of a puppet. However, he is the only 'living' element in the worlds that he traverses. He must consequently captivate the audience. Many props are animated around him.

" *O. C.: The film studio is rather large. How did you find the location?*

T. S.: At university, we had two rooms for filming. The first, quite a big room, was reserved for classes. The other was a low cellar with hardly any room to film. So we asked the teachers if we could use the big room during the holidays.

In reality, we had totally underestimated the production time… We took three months to make the set. Afterwards, we had to have discussions with the teaching staff about keeping the room – they finally agreed.

O. C.: That was very kind…

T. S.: Yes, except when we finished filming the worlds of paper, stone and the over-ground metal world; we had to move into the cellar to finish filming the underground metal world. This room was small, humid, cold and full of dust. One day, we even found ten centimeters of water in there, and we lost a lens. It took a year to finish the filming.

O. C.: The puppet is very different to the one on the storyboard. What happened to him?

T. S.: At the beginning, we had imagined the creature as a pile of sand. In the end, to simplify the animation, we created a humanoid puppet – that's to say, one with arms and legs and an internal skeleton.

O. C.: How did you make the main puppet?

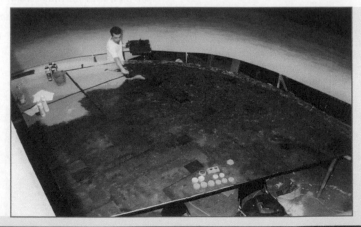

The construction of the sets took a lot of time. The curved structure – the cyclorama system – is used by film studios. It enables many different camera positions to be used.

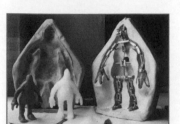

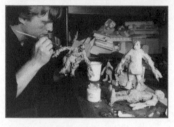

The fabrication method is quite a classic one. The use of a mold enables replacement puppets to be made.

T. M.: We made it as all animation puppets are made; we made a clay sculpture that was molded. A home-made armature was made and inserted into the mold. Then we filled around it with latex foam and baked it. The final texture was created by tearing off little pieces of latex, adding more pieces of latex foam and then sticking a layer of sand on the top.

O. C.: Did the sand adhere successfully?

T. M.: The sand came off during the animation, because of the endless movements. Before each take, we added a new layer of sand and repaired him. The problem was that only the sand came off and not the glue! As the production went on, the puppet grew bigger, layer after layer... If you know in which order the sequences were filmed, and if you look closely, you can see it.

T. S.: We repaired the puppet at least 150 times during filming!

O. C.: How was the puppet fixed to the ground?

T. M.: It was screwed to the set, image by image.

O. C.: It's the classic procedure used more or less everywhere, and which Trnka used a lot...

T. S.: I didn't know that. But in fact, if you look closely at the set, you can see the little holes in the ground.

O. C.: You could also see that with Trnka's work sometimes! Even though the puppet's face was quite rough, did you have any problems filming his face in close-up and animating his facial expressions?

T. S.: Yes, and for that reason we made another version of the puppet, without legs, but larger, measuring 30 cm. As this model was used for close-up shots of the face, we didn't need to make another background on the same scale, because the original one was distant and often blurred.

The creature gradually becomes more and more dried out. A little sand was added to each of his footsteps, and the position of the camera emphasized his disintegration.

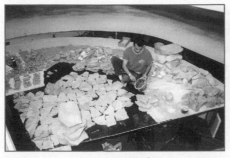

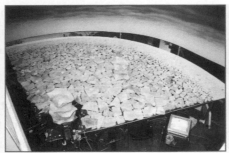

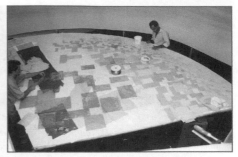

The main difficulty with the world of stone lay in sculpting and painting a large quantity of rocks to create the illusion of an authentic world.

The world of paper was completely flat. Unlike the world of stone, it required the animation to take place in the upper part of the picture, with papers being blown around in the wind.

Inside the world of metal. This could not just be a film set; all the gears had to actually work, so that the imaginary underground machine plant could be animated.

The set of the hydraulic presses that will finally crush the creature. The materials used are simple and inexpensive, but the paint techniques and lighting give authenticity to the construction.

Final result on screen. Animating the figure in such a cramped space is tricky, because access is so difficult.

Filming and Special Effects

To minimize the risk of errors, a video line test was used to control the continuity of recorded sequences. The equipment was a rather old fashioned Amiga belonging to the school, which originally filmed 2D line tests and only recorded images in gray on 4 bits (16 levels 2^4). At the beginning of the production, the animators were afraid that the use of computer technology in their work would intrude upon their freedom. But Tyron Montgomery insisted, and the team finally accepted this way of working. They admitted that they did get a taste for it. A few months later Thomas Stellmach even refused to animate a scene with the excuse that the software was broken!

Stop motion animation

For practical reasons, some shots can be filmed from an angle that is not the one you will see in the final film. Note the video line test system on the screen on the left.

Camera movements were done in the traditional way; dolly rails were fixed to the floor and the camera apparatus fixed to a dolly, which glides along the rails.

The quantity and complex nature of the puppet movements in this film used most of the traditional methods of stop-motion animation. The sheets of paper that flew around in the world of paper, for example, were created in the classic way, by using glue to sandwich a sheet of aluminium foil in-between two sheets of paper, thus enabling the paper to keep its animated shape, frame after frame.

As so many sheets of flying paper were needed for the scene, a large sheet of aluminium foil was sandwiched between two sheets of paper and then cut into small rectangles, ready for animation.

O. C.: The animation of the special effects can't have always been simple. What problems did you encounter?

T. S.: We had plenty. Several of the animated elements had to be held in the air without visible support, so we had to be crafty. We mainly used strings.

O. C.: Is that what held the creature in the air with the flying sheets of paper in the world of paper scene?

T. M.: The smallest sheet was held with tungsten wires, which are practically invisible on screen. The puppet was too heavy to be supported by these, so we suspended him on nylon strings. When they became visible on camera, we painted them the same color as the background. Sometimes we had to change their color, shot by shot, to follow his movements across the set. In the finished film, you can see them on certain shots, but not unless you're looking for them. The problem wasn't the strings, but the mechanics of holding everything up, making the sheets fly and making the puppet run.

T. S.: Also, this type of filming takes a long time. Tyron often had to stand on top of the set, changing the position of the wires. These wires were connected to a movable frame similar to those that are used to support string puppets. We filmed at 24 images per second, and not at 12, as most film-makers do. So, for each image, we had to move the support frame, change the length of the strings, and change the shape of the sheets of paper, down on the set.

O. C.: The world of stone sequence was also very impressive, with the vertical movement of the stones as they fall from the rocks.

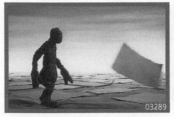

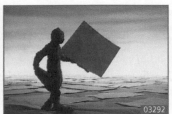

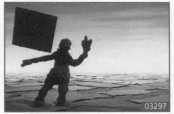

Having just arrived in the world of paper, the creature narrowly escapes a sheet of paper that is blown along by the wind. This element is held and animated by several wires.

To give added authenticity to the creature, the ground is made to look as though it sinks under his weight. This is done by making the base of the set flexible.

T. S.: *The small stones caused the most problems. There were so many of them and they weren't easy to attach to the wires.*

O. C.: *Didn't they tend to roll over?*

T. S.: *Yes, especially the little ones. That's why we used two wires for each one when we could. It was tedious.*

O. C.: *What about the big stones; what method did you use to make them grow larger?*

T. S.: *Each stone was made of styrofoam and stuck in place. The stone tower, which the creature climbs down, is the only one that was screwed into the base. For the animation, each stone that pushes up through the ground was fixed on a tripod that used a track to lift the piece of set.*

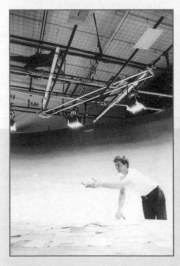

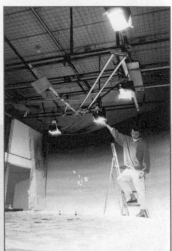

For greater efficiency, the operation needed two people – one to pull the wire, the other to make sure that the animated element was precisely positioned.

Here, the framework and the papers can clearly be seen hanging over the set. The vertical spotlights create the effect of sunlight.

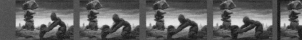

O.C.: We have seen that computers didn't play a great part in the creation of special effects.

T.S.: No, we only used old-style camera tricks. For example, with the sparks in the world of metal, we used the classic method of placing a mirror at 45°. The camera faces the set and a semi-reflective mirror is placed in front of the lens; this simultaneously captures the animation of the character and reflects the mask with the sparks from a light table.

The effects of the spray of sparks are achieved by using a mask, lit from behind. It is important to animate the character in relation to the movement of the sparks.

O.C.: In the world of metal, part of the creature's foot gets cut off. Was it really cut during the filming?

T.S.: Yes. As he was made of foam, it wasn't difficult. Afterwards, the cross section of the foot was covered in sand.

O.C.: Was it the same trick that you used for the head, when he fell on the floor and squashed the back of his skull?

T.S.: We cut that off as well! The problem was, of course, the filming wasn't done in chronological order. Sometimes we had to rebuild his head for certain scenes that came 'before'.

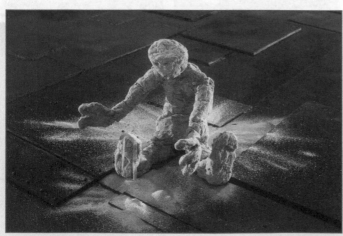

O.C.: When the welding machines go into action, a bright light creates the effect of an electric arc with loads of molten sparks. How did you do that?

T.S.: In a very simple way, with a little sliver of mirror which we put on the set. We repositioned it frame by frame, so that it always flashed a blue light straight into the lens of the

The creature has just lost a piece of his foot. To give the illusion that sand is running out of his cut foot, transparent stalactites covered with sand were animated and changed frame by frame.

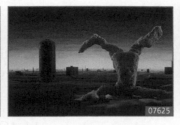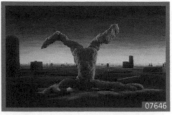

The beginning of a sequence in a new world, using a lateral traveling shot to reveal the place where the creature has fallen into.

camera. We 'overcooked' the film, so it was overexposed and exactly the effect we were looking for.

O. C.: At the end, the creature falls into the water and disintegrates. The filming for this was more standard than for the rest of the film, I imagine?

T. M.: Yes, we used a tank two meters square. But we doubled the number of images at the optical printing stage (rather than when filming) to obtain a better effect for the water. It was a bit 'stroboscopic'. This trick also allowed us to maintain the 'stop motion' feel, rather than resorting to 'live action'.

The sand creature is crushed and disperses into the water, with a slow motion effect that conveys the solemnity of death. The water that he coveted so much has become his tomb, but also the route to resurrection.

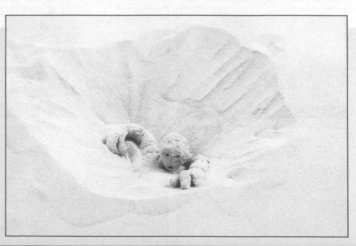

The first time the creature passes from one world into another. As with Le Château de Sable, *animation using sand is always an intricate process.*

Lighting

One of the main difficulties of filming in stop-motion consists of appropriately lighting a surface that is often too small to allow for subtlety. Fortunately, the dimensions of the studio allowed the natural placing of the light sources. The flatness of all the different sets also helped, as this made it easier to control shadows and general lighting balance. However, it was important to note down the specifications of each world.

O.C.: What equipment did you use?

T.S.: The main lighting consisted of two sources of 1,000 and 2,000 watts.

O.C.: I imagine that, as the worlds were so very different from one another, you had to use very different methods...

T.S.: Yes. For the world of metal, the lighting was situated behind the camera. For the worlds of sand and paper, the light was directed onto styrofoam panels, one meter square, situated

At the beginning of the film, the creature awakens and realizes that his bottle is empty. The lighting is delicate; the sandy texture of the character, the misty background and the transparency of the empty bottle are all tangible.

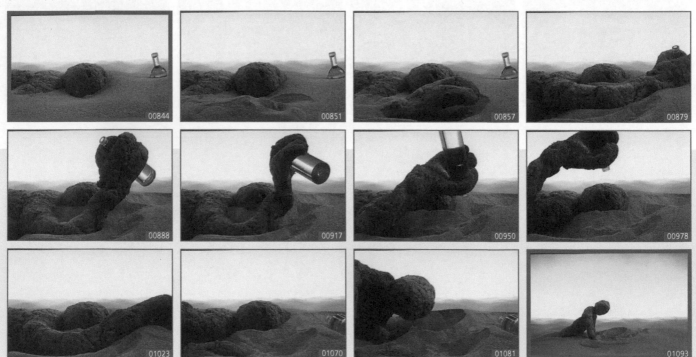

both to the right and left of the frame. This gave a soft, very diffused light. For the world of stone, we fixed the lights and the styrofoam panels above the set to reproduce the effect of natural sunlight. The sky backgrounds were lit with traditional TV Janebeam spots. There were eight spots, each at 800 W. The major problem was changing the bulbs when they blew during filming.

O. C.: When the creature goes into the underground part of the world of metal, the ambience is distinctly more gloomy...

T. S.: For this sequence, there were only four Dedo-Weigert spots at 100 W each and eight little halogen lights at 50 W each.

O. C.: When the creature finds the water, you play a great deal with the light; there is a reflection of the liquid surface that dances on his body. How did you do that?

T. M.: After many tests, I used two sheets of glass, with waves molded onto their surface. They were mounted on poles and reflected a beam of light onto the creature's face. Obviously this was animated frame by frame, so that the light reflections moved like the surface of an expanse of water.

The underground set for the world of metal. The light/shade ambience renders the space both mysterious and scanay. It is here that the creature will die...

The creature digs a hole in the ground to find water. The light that shines from the opening illuminates his face. The all-pervading green light symbolizes life, and contrasts with the world of metal's atmosphere, with its hot, rusty colors.

In the mechanical world, the water is suggested by a lighting effect. Beyond the clever visuals there is an obvious symbolism; the face of the creature is illuminated by the object of his quest.

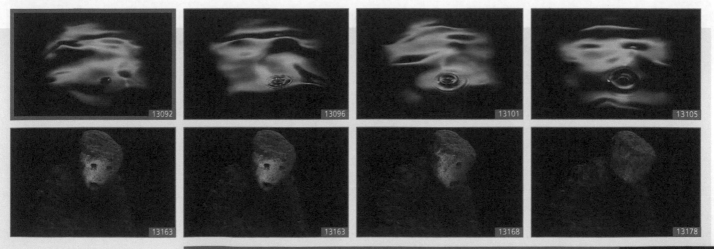

Animation

O.C.: *What difficulties did you and Tyron face with the animation?*

T.S.: *From the beginning, we had problems that forced us to redo shots. We began by animating the world of paper; at the moment when the creature sinks into the ground, there are sheets of paper that are flying around in the background, and others that blow along the floor. The whirlwind engulfs the creature, who tries to hold on.*

O.C.: *Yes, that shot lasts eight seconds. How long did it take to animate?*

T.S.: *18 hours.*

O.C.: *That's quite fast, actually...*

T.S.: *I was up on the overhead dolly, seeing to the flying papers. Monika Stellmach and Norbert Hobrecht animated the creature and papers that were blowing along the ground. When we watched it, we were disappointed by the rendering of the papers that blew along the ground. As a result we re-shot the scene. We didn't feel very good about it, as there were still about 150 shots to retake...*

O.C.: *What influences are you aware of, in terms of animation?*

T.S.: *Nick Park's work* Wallace and Gromit *and other short films by the Aardman studio, Tim Burton's* Nightmare Before Christmas, *Paul Berry's* Sandman *and Christoph and Wolfgang Lauenstein's* Balance. *Paul Driessen also inspired us a lot and showed us many other works of animation.*

The creature finds water and starts to dig for it. His digging will lead to him falling through the hole. The animation must authentically convey the effects of gravity.

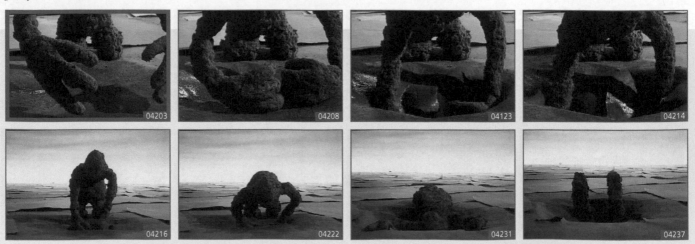

06053 · 06070 · 06140 · 06197

The creature's fall was difficult to create, as the sensation of weight must be perceptible. The upper part of the creature had to be well secured so that only his body and legs moved.

O.C.: The camera is often at the creature's height. How did you manage its positioning?

T.S.: We used lenses with 40 mm, 28 mm and very occasionally 14 mm focal lengths.

Soundtrack

The story of *Quest* not only evolves on the screen, but also off camera; the soundtrack warns the audience of what is to occur before it happens on screen. Furthermore, each fantastic world has its own particular characteristics to reveal.

O.C.: The different worlds each required specific sound-scapes. Did this take much time to arrange?

T.S.: Once again, because of a lack of funds we decided to record and mix it ourselves. For this, we bought a digital system that worked on a PC and we spent a year up in the school attic, recording, cutting, editing and mixing all the different elements in stereo.

The lighting must show the texture of the stone, bring out the shadows created by the creature, and sufficiently light the background to visually separate them. The position of the camera must also give the impression that the creature is up high, and therefore in danger.

Stop motion animation

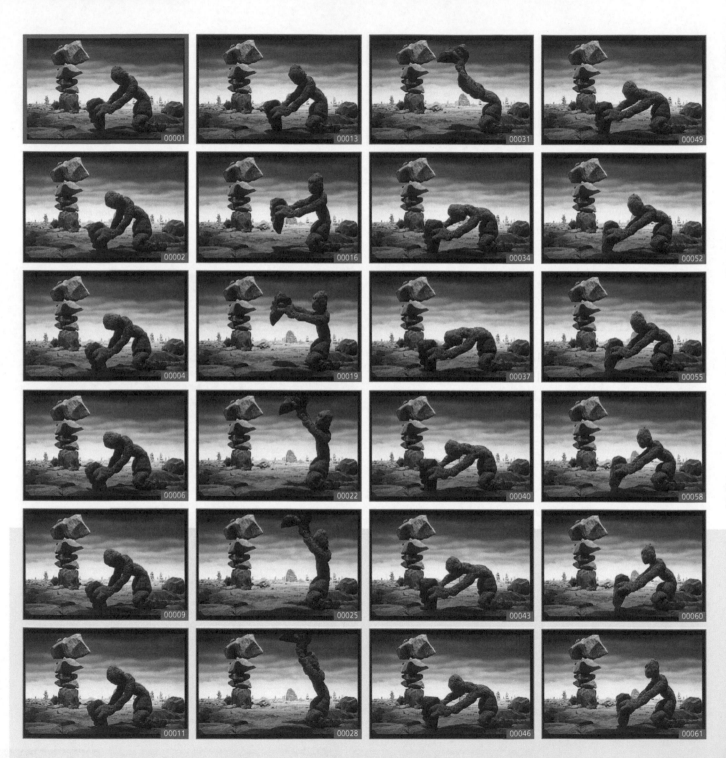

196

O. C.: Practically speaking, how was the work organized?

T. S.: After the filming, we recorded hundreds of sounds, separately and without watching the film. We found ourselves with thousands of sounds to assemble, edit, stretch, remove and synchronize with the scenes.

O. C.: All using the PC set-up?

T. S.: And with the help of a 35 mm editing suite. The computer was indispensable, as there were 60 tracks to mix. Moreover, it wasn't just in stereo, but also in surround.

O. C.: Why did you choose surround sound?

T. S.: To convey the richness of the natural phenomena (the wind, the cracking of the stones, the flapping of the papers) and the human sounds of the puppet (his voice and breathing, and the crunching of his sand body), but also for the machines and the music.

O. C.: At what point did the music appear?

T. S.: Right at the end, just like the dripping water sound that we added.

Der Syra working on the soundtrack.

Creating an animated film is a long and laborious task. That a student production stretching over nearly four years had the drive to create such meticulous sets, and to create animation of such quality that any flaws were constantly corrected, is testimony to the dedication of these craftsmen. This collective work (the film owes as much to Thomas Stellmach as to Tyron Montgomery) is a model for all students who wish to get involved in an ambitious project. The intelligence of the story, which plays with the logic and drama of a video game whilst incorporating an existential dimension, contributes to the unique theatricality of this work, which was justly rewarded by an Oscar. The fact that the award was given to honor the work of two German students bears witness to the quality of animated film education in that country.

Facing page: Animating the creature in profile shows the fullness of his movements to the best advantage.

The Old Man and the Sea

As the title indicates, this film is an adaptation of Ernest Hemingway's famous short story. A fisherman from Havana is disappointed that he has not caught anything for a long time. He decides to take to the sea again, alone on his small fishing boat. A few days later, he comes upon an enormous swordfish, which he manages to capture. However, on his way back the sharks, which have been attracted by his catch, devour it and, in the end, the fisherman returns to his village with just a skeleton.

Oscar 1999

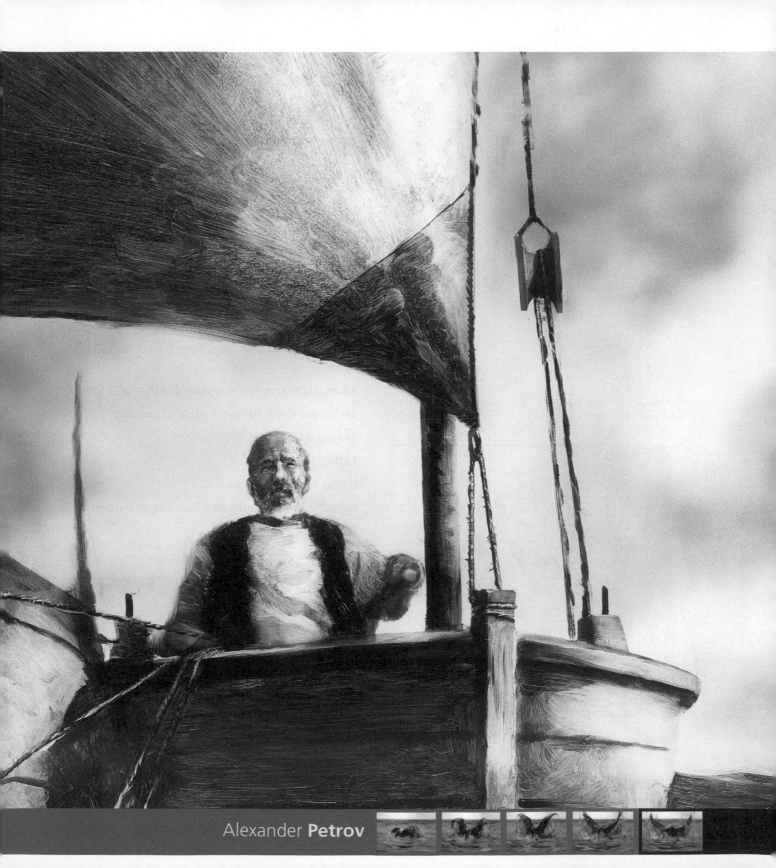

Alexander **Petrov**

Credits

Title: *The Old Man and the Sea (Le vieil homme et la mer)*

Year: 1999

Country: Canada, Japan, France

Director: Alexander Petrov

Production: Bernard Lajoie (Pascal Blais Productions), Tatsuo Shimamura (Imagica Corp.) and Animation Film Studio of Yaroslavl

Executive producers: Jean-Yves Martel and Shizuo Ohashi

Adaptation, artwork, storyboard: Alexander Petrov

Technique used: Paint-on-glass animation

Cameraman: Sergei Rechetnikov

Editor: Denis Papillon

Music: Normand Roger

Sound: Antoine Morin and Dominique Delguste

Length: 22 minutes

A symbolic image of the film: gazing into infinity. Is it the challenge of fishing that makes men take to the sea, or rather the desire to lose themselves in the never-ending ocean?

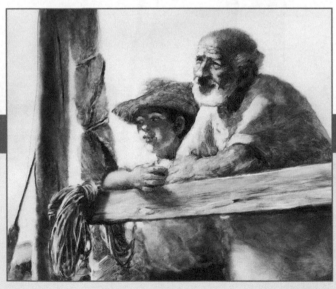

 Alexander Petrov was born in 1957. He started in animation in 1981. The first techniques that he used included puppets, sand and cels; however, paint-on-glass animation was to become his favourite media. *The Cow* (1987–88) won the Grand Prix at the Hiroshima Festival, and *The Dream of a Ridiculous Man* (1990–1992) won the best short film award at the Annecy Festival, as well as the Grand Prix at the Stuttgart and Kiev festivals. *The Mermaid* (1994–1996) won the Grand Prix at the Espinho Festival, the Zagreb Festival, the special jury prize at the Annecy Festival, in addition to an Oscar nomination. Amongst other international prizes, *The Old Man and the Sea* (1996–1999) won him an Oscar.

Screenplay

The subject of the film is an ideal story for any film-maker who loves existential stories. The tragedy of the story, the seafaring context and the link between its elements provide material for the creation of spectacular images and Alexander Petrov, as a master of animated illusion, is one of the most capable film-makers to produce them. Nonetheless, this kind of subject matter is difficult to treat in animation, as it does not favor the creation of realistic images. (It is worth mentioning that Petrov worked on poetic images in *The Dream of a Ridiculous Man*.)

Some frames from the storyboard posted on the wall throughout the production.

This challenging use of animation to create realistic or natural images (backgrounds, as well as characters) is difficult to develop in dramatic composition, because the viewer may quite legitimately wonder why the film was not made in live action. The proof of this is that filmed versions of *The Old Man and the Sea* already exist. To divert attention from the issue of justifying the technique, Petrov uses metamorphoses at the beginning of the film and his extraordinary painting skills to intensify the scene in the tradition of classic paintings depicting realistic scenes.

With its dramatic strength, the film was developed to last just under half an hour and above all it makes full use of the possibilities available on the large screen – in this case, IMAX. While this kind of giant projection adds an undeniable dimension to the film, it also creates a whole set of technical complications in terms of production. Moreover, the scale ratio between the viewer's vision and the dimensions of the projected image requires extra thought to be given to how the frames are edited and visualized; this is not classic film-making. The writing must be adapted to take advantage of the IMAX system.

Original drawings of a part of the storyboard at the first stage.

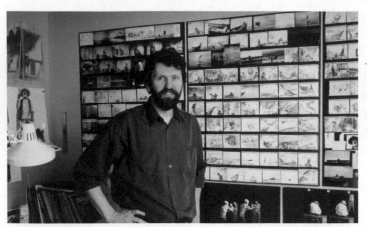

Alexander Petrov and the storyboard of The Old Man and the Sea *as usual, the images are there to help keep the film's continuity in mind. On the wall to the left, you can see some rough sketches and initial paintings that would determine the style of the film.*

Production

The story started at the Ottawa Festival in 1990 when Pascal Blais saw the film *The Cow* by Alexander Petrov, which was competing in the festival and had also been Oscar nominated. The producer was deeply struck by the film and felt that he was watching a 'living painting' by a Rembrandt.

For her part, Martine Chartrand, a film-maker at the National Film Board in Montreal, discovered during a visit to Russia (where she learned the technique of animating on glass from Alexander Petrov) that he was interested in making an adaptation of Ernest Hemingway's short story. She succeeded in convincing him to put together a pitch, with a storyboard, and set out to look for a producer in Canada.

Strangely, the initial attempts were not well received; even the NFB rejected the project. Pascal Blais took on the role of producer. At that time, his company, which specialized in commercials employing film-makers such as Caroline Leaf and Cordell Barker, had started to produce a few more artistic films; among the company's collaborations was Sylvain Chomet's *The Old Lady and the Pigeons*. Bernard Lajoie, vice president at Blais Pascal Productions, immediately started looking for funding for Petrov's project. A producer at the NFB advised him to propose the project in Japan, where Imagica Corporation, Dentsu Tec and NHK Enterprise agreed to co-produce it. The last two co-producers requested that the film be made in IMAX.

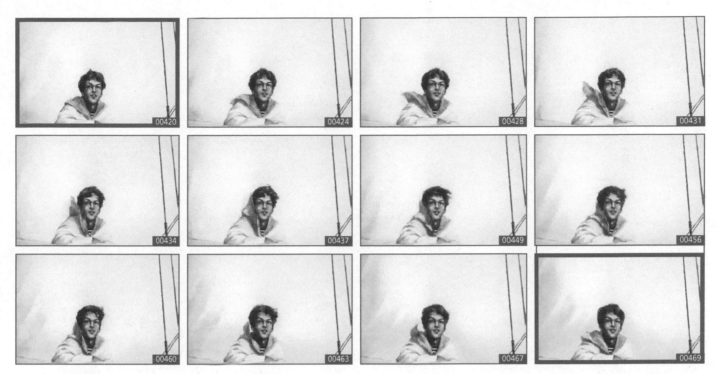

The simple movement of an item of clothing is sometimes enough to bring an image to life by evoking the wind blowing over the ocean.

> *O. C.: How did the film end up in Canada?*
>
> *A. P.: For financial and political reasons, the economic situation in Russia would not have allowed such a film to be produced. Fortunately, Martine Chartrand had taken the project with her when she went back to Canada.*
>
> *O. C.: And the choice of IMAX?*
>
> *A. P.: That was a production choice. The cost of making it was of course far higher, but Hemingway's short story is so well known that the potential audience was very large. And, of course, the wide open sea goes well with large formats.*

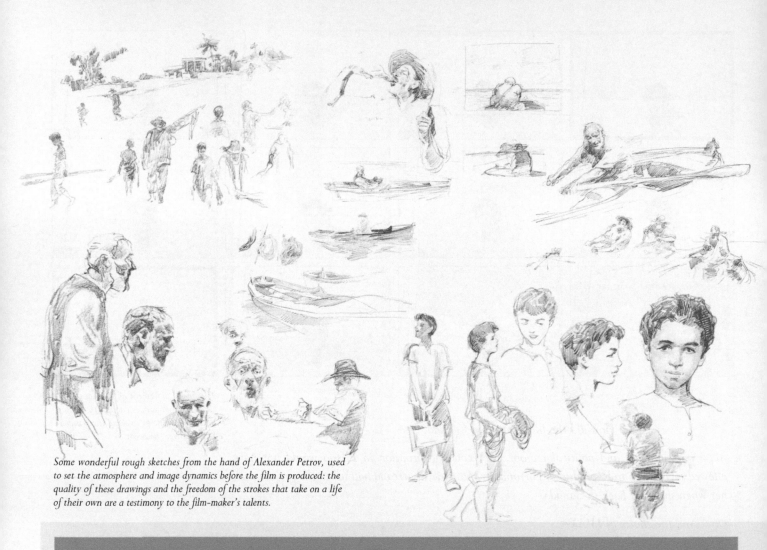

Some wonderful rough sketches from the hand of Alexander Petrov, used to set the atmosphere and image dynamics before the film is produced: the quality of these drawings and the freedom of the strokes that take on a life of their own are a testimony to the film-maker's talents.

21,95mm X 18,6mm

35mm
(Format académique)

70mm X 48,5mm

70mm
Format IMAX

IMAX is the largest current film format. It is shot on film that is 70 mm wide with 15 perforations per frame; thus, the film does not scroll vertically, but horizontally. The surface area of the exposed film is enormous: ten times larger than 35 mm film projected in theaters. The result on the screen is impressive, because the absence of emulsion grain allows a maximum enlargement of the image in the theater. In the case of live action footage the process produces a perfect illusion: the screen becomes a window to the world.

Working on the Image

Alexander Petrov's style is inimitable; the film-maker has been working at his painting and animating on glass plates technique for more than 15 years. He is without a doubt the most important creator of realist animation using this media.

 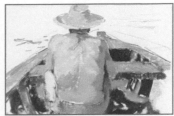

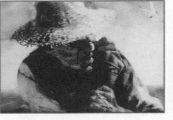 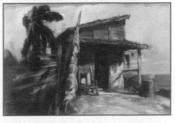

After the stage of black and white sketches, color studies are necessary to establish the lighting and dominant colours. These images are not yet like those of the future film as they will be in a different technique, but they serve to submerge the artist progressively into the world that he will create.

" *O.C.: How do you work on glass?*

A.P.: I mainly use my fingers to spread out the oil paint, a paintbrush for the finer details and an eraser to rub things out. Working directly like this with my fingers is faster; it's the shortest route from my mind to the image I am making.

O.C.: The character of the old man, who we follow throughout, seems very life-like. Were you inspired by someone?

A.P.: Yes, by my father-in-law. My son Dmitri read him the story and he really wanted to have the role! Dmitri took lots of photos of him and that's how the character gets his face.

O.C.: Did you have other sources of inspiration?

A.P.: I went to Cuba, where the story takes place. I accompanied a 99-year-old fisherman, Grigorio. Which allowed me to become familiar with sea fishing on a small boat and how it feels to be alone against the elements.

O.C.: The IMAX format was new to you. How did you approach it?

Alexander Petrov working at an ordinary animation stand: the paint tubes form a large palette along the sides of the image. This work of composition is carried out using backlighting.

A. P.: It was a little difficult for me to imagine what more a large screen could offer, but once I saw the film in the IMAX theater during testing, I discovered a classic fresco, like a Michelangelo (even if I don't have the pretension of comparing myself to him). I was really impressed.

O. C.: While your previous films The Dream of a Ridiculous Man *or* Mermaid *present a dreamlike vision, the adaptation of Hemingway's short story, must have required strict realism...*

A. P.: Yes, otherwise the audience would have been unable to identify with the hero of the story. Moreover, the action takes place at sea: the mechanisms for creating the waves and the movement of animals (birds, fish, etc.) meant that I had to be extremely accurate in analyzing the movements.

Light is one of Alexander Petrov's priorities when painting: the reflections that you can see on the hull are a good example of this.

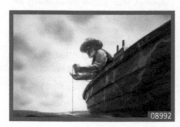

Technique

From the beginning of his career in animated films, Alexander Petrov has used a personal technique of painting on backlit glass. This method is found in the work of some painters. As soon as movement is added, it is technically impossible to repaint the whole background, frame by frame, on cels that would be filmed on a backlit table; the work would be immense and, moreover, useless, as all the elements that constitute the frame are not animated. The best method is to animate the film directly under the camera by only changing the moving parts of the scene.

Generally, the background, the characters and the other moving elements are on the same piece of glass, but Alexander Petrov had to be able to reconstitute the background after it had been obscured by the moving foreground elements. For *The Old Man and the Sea*, the producers looked for a way to overcome this difficulty.

Portraying the depth of the ocean is never easy, as there is always the risk of fish seeming to be suspended in the emptiness: Alexander Petrov decided to make this place mysterious by transforming it into liquid fog.

Moreover, as this medium-length film was designed to be produced on IMAX 70 mm film (which is rare in animation), the production was faced with other problems, starting with building an animation stand from scratch that would be compatible with the format and which would allow Alexander Petrov to work using his technique. A format on such a grand scale, which is projected onto such a large screen, does not allow any errors; the smallest detail is enlarged so much that it must be absolutely precise.

Interview with Bernard Lajoie, the film's technical director

O. C.: Bernard, how was the technical research organized?

B. L.: Everything was based on the contractual obligation to use the IMAX format. The giant screen, which can be compared to a seven storey building, first forced us to reconsider Alexander Petrov's working format. Instead of a field of 9 or 12 inches maximum, he had to use a 30 or 40 inch field format, and sometimes more, because there was a risk when broadening the field that you could see his enlarged fingerprints on the screen. The format was determined by carrying out photographic and cinematic tests to judge the level of detail that could be obtained with different basic drawing sizes.

This type of background is specifically intended for screenings in the movie theater: while the movement of the sea engulfs the viewer, the tiny fishing boat remains visible. Its small size adds to the dramatization of the man against the elements.

10517

10570

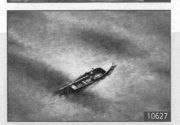

10627

10713

O. C.: It was from this mandatory work surface that the animation stand could be designed?

B. L.: Yes. But as with a traditional animation stand, you needed to be able to move the glass plates east to west, north to south and to rotate them. Once again, because the enlargement is so important when screening, our error margin was minimal, between 1/1,000 and 1/10,000 inch (from 0.0024 to 0.000254 cm); the ratio of the film's format to the screen size is 1/400. That's roughly the same as for 35 mm film, but the surface of the screen covers a greater field of vision for the spectator.

O. C.: Talking about moving the glass plates, it is clear when watching the film that some backgrounds were painted on one plate, whereas other elements were animated on one or several distinct plates. Is this a kind of multiplane effect?

B. L.: Again because of IMAX, the lens we had to use was 25 or 35 mm, but the depth of the field was half an inch, almost 1.25 cm. There was nothing we could do to counter the problem, even by closing the aperture as much as possible. We discussed it with IMAX engineers and ended up using a photographic enlarger lens.

O. C.: You could close the aperture sufficiently using an enlarger lens? I don't see why...

B. L.: It's quite strange... in fact, it has to do with the rather particular optical qualities of this type of lens. In any case, we were able to attain a depth of field of up to 8 inches (20 cm) and, as we had four layers of glass (which were quite thick), we were saved.

O. C.: This means that the distance separating each of the plates must have been ridiculously small. How was it possible to work in these conditions?

B. L.: Alexander couldn't slide his hands between the plates. We needed to find a way of removing the glass and replacing them for each frame, in exactly the same position, of course. For this, the plates slid on frames, like drawers and we set up a pegging system which entered a housing and as soon as the plates were back in place: they made electrical contact to show that they are in the right position; it was a sensor system.

The horizontal ocean is in opposition to the verticality of the swordfish as it surges from the water.

O. C.: Was there a video control to check the animation?

B. L.: Yes, not only so that Alexander could judge his work while he was doing it, but also for the focus and the frame, as we couldn't easily get to the camera. The image was shown on an enormous 36 inch diagonal cathode screen.

O. C.: As we are talking about electronics, I suppose that the animation stand was computer assisted for the background and camera movements...

B. L.: Absolutely. First we made the first and last frames; Alexander then had nothing more to worry about. Obviously, he had to paint the background beforehand to serve as a guide for the frames. It is also worth noting that the painting was never done directly on the glass plates, but on large cels that were taken away and changed after each scene was filmed.

O. C.: To integrate all these mechanisms, the animation stand must have been huge...

B. L.: We had to dig into the ground for the foundations: the whole animation stand weighed nearly a ton and a half!

The animation stand and the considerable size of the glass plates permits this kind of camera movement at the beginning of the film.

The area to be painted is extensive, as the film will be enormously enlarged during projection. The size of the glass also tolerates camera movements, as you can zoom in and out on an image without becoming too close to the texture of the painting.

Interview with Alexander

O. C.: What were the main changes required by the IMAX format?

A. P.: I could no longer apply the oil paint (which dries very slowly) with my fingers to the glass plate as I did in The Cow, The Dream of a Ridiculous Man *or* Mermaid; *the change in*

the scale of the painting surface made the painting much longer, so I needed to find a new approach.

O. C.: Did technology help?

A. P.: Yes, the video control allowed each painted stage to be recorded, so that we could view the sequence at anytime. The length of the recordings was also quite long compared to how I usually do them, so I needed to put a little more effort into remembering the movements.

O. C.: Also, because some sequences are really very long and complex: simultaneously working on animating the rocking of the boat and the characters inside it is quite incredible. Do you work with assistants?

A. P.: I had my son Dmitri with me and my assistant cameraman Sergei Rechetnikov. There was also, of course, the Pascal Blais production team.

O. C.: Your cameraman cannot have been used to working with this technology.

A. P.: No, not really. He would check each movement along seven axes and the calculations for the acceleration and deceleration curves. In fact, the computer wasn't accurate enough for a format like Imax, so he often had to redo his calculations over and over; he was more accurate than the machine! His greatest fear was making a mistake that would have meant that I would have to redo a sequence.

His role was indispensable. It's not easy to shoot this type of film. You need to calibrate the lighting of the glass plates: because with backlighting, the amount of light that is going to expose the film depends on the thickness of the paint – its opacity; if this varies during a scene, it is critical because, it is animated, you need to be able to adjust the lighting in consequence.

O. C.: What type of lamp did you use?

The enormous animation stand meets the requirements of the filming format. Its complex design and build help the film-maker forget technical problems.

The backlighting is difficult to set up because it must simultaneously light the outside and retain the details and textures inside the hut.

Alexander Petrov in front of the monitors that allow him to check the continuity.

A. P.: *Neon to high-frequency. Neon is neutral and high-frequency lets you avoid the vibration caused by faulty synchronization with the camera shutter.*

O. C.: *In the end, what did all these technical ideas do for you?*

A. P.: *If* The Old Man and the Sea *had been made under the same conditions I used to work in, it would have taken me five or ten years to finish...*

O. C.: *How long did filming last?*

A. P.: *Two and a half years. We started in March 1997. We had a house outside Montreal which we used as a film studio and living quarters for my family and me. Before that, it took me six months to resolve the problems linked to making the animation stand.*

O. C.: *How many frames were drawn for this film?*

A. P.: *29,000.*

O. C.: *On average, how much did you film?*

A. P.: *Almost 500 feet a month. We were aiming for a minute, but we were only able to do 50 seconds a month.*

O. C.: *That's huge! Even with puppets, where all the elements are ready and only need to be animated, filming falls short of that. You must not have been working without counting the hours...*

A. P.: *The working week was six days, and working days were Ten or Twelve hours... The problem was that you always had to wait a few days to see the final result. During that time, I was obviously worried that I'd made a mistake, wasted time and the production was quite expensive...*

O. C.: *Were there errors?*

A. P.: *The system was so well organized that 85% of what I animated was good on the first take. In the 250 scenes that make up the film, only three had serious problems. Thank you Bernard Lajoie!*

O. C.: *I have always felt that there are two types of animated films: those in which talent, professionalism and patience count, which in a way is no mystery, and those which, for all my efforts, I cannot see how such a wonderful creation is humanly possible. The Old Man and the*

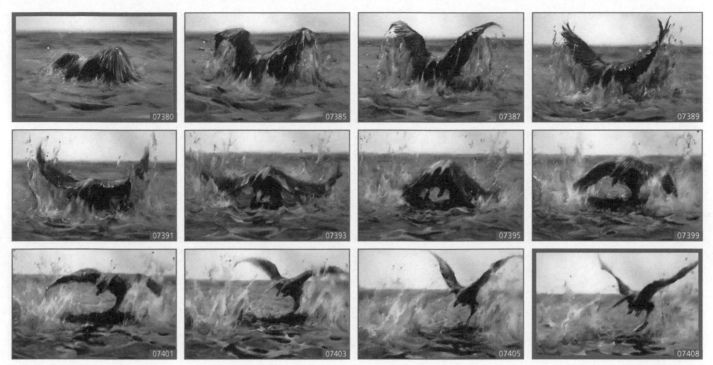

07380 07385 07387 07389

07391 07393 07395 07399

07401 07403 07405 07408

The bird has just caught a fish and flies back up into the sky: the paint-on-glass animation technique works wonderfully in this particular case, showing the depths of color.

Sea, of course, falls into the second category. To manage such an animation of the light with concurrent movements that look perfectly natural, I can only think of one solution: you must to have an incredible photographic and dynamic memory of everything you see in the real world, and to know precisely what you are going to do before you animate.

A. P.: *I sometimes use small-scale models, like the one of the boat, which help me to feel the dimensions. For really difficult animations, I make a sort of pre-animation on paper that I slide under the glass plate as a guide (which of course I remove when I shoot the frame). It doesn't need to be copied out again, but is simply an aid for rotating movements and animation in three dimensional space. Once more, on such a large screen, you cannot make any errors in the perspectives. Dmitri also made some of the animations.*

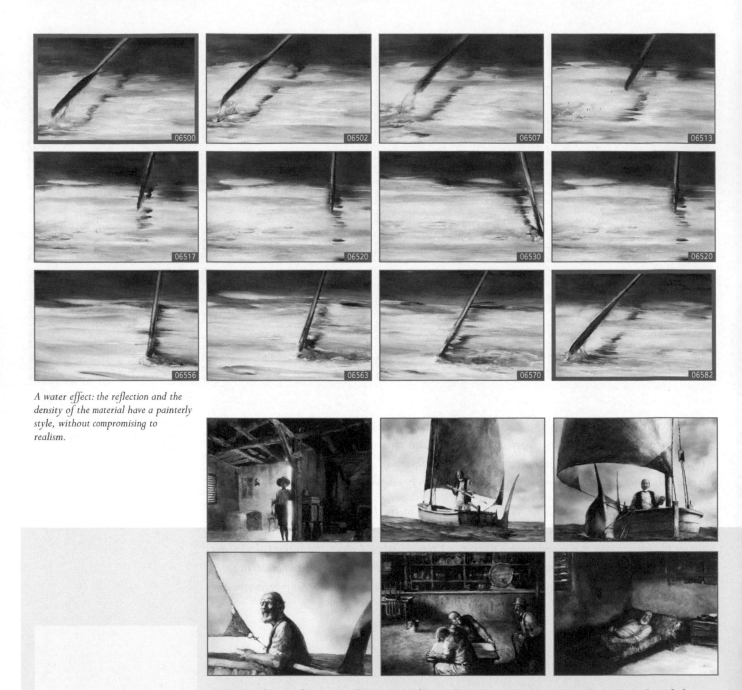

A water effect: the reflection and the density of the material have a painterly style, without compromising to realism.

Some images from the film: one can feel the clear influence of classical painting in the chiaroscuro. Additional proof, if any is needed, that classical art and quality animation are inextricably linked. This is also Alexander Petrov's specialty; he has perfectly understood the lighting effects used by painters like Rembrandt. Note that the backgrounds can be blurred: the paint textures blend together, giving extra depth to the frame.

Soundtrack

For a film of this scale, which requires a musical lyricism that reflects the subject matter, the soundtrack assumes major importance; all the more so in this particular case, as IMAX's sound reproduction quality is one of the best.

The composition of the soundtrack was entrusted to Normand Roger. This task was not easy either, as similar to Frédéric Back's *The Man who Planted Trees* the narration is present throughout the film and the music must allow the voice to be heard. The sound effects are also essential, the ocean effectively being one of the main 'actors' in the film. These difficulties formed a schedule of conditions that the composer had to take into account.

" O. C.: *Normand, how did you get in touch with Alexander? It was your first collaboration with him.*

N. R.: *I met him for the first time at a symposium in Urbino, Italy. We met again at a festival, where he expressed his desire to work with me on his next film, The Old Man and the Sea. As the work moved to Montreal, it was the perfect opportunity for me, but the producers had another composer in mind; we had to present a demo sequence to convince them, as well as for the project's presale which was already being financed.*

O. C.: *How did you have the idea for the musical soundtrack?*

N. R.: *In any project, there are always several contributors: the film-maker, the producers and the specific needs of the film also come into play. Each puts forward their ideas which are approved and accepted through tests. That was what happened here.*

O. C.: *What were your aims for the composition?*

N. R.: *In each scene, there are a large number of details that need to be*

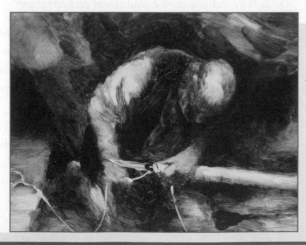

Given the perspective, this animation is very difficult to do. All the diagonals in the frame converge on the spear the fisherman is attaching to the end of the oar.

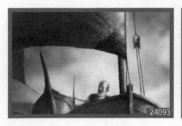 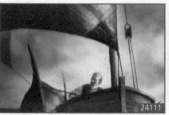

This angle is the most appropriate to illustrate the relationship of mutual respect that unites the fisherman and his catch.

clarified or emphasized through the music and the sound. In The Old Man and the Sea, *I wanted to bring out the poetic side of Alexander's artistic interpretation, without neglecting the narrative. I am convinced that the music would have been different if the film had been in live action.*

O. C.: *How did you link up the live music/sound relationship with the voiceover?*

N. R.: *Quite easily. It's a predominant element in the soundtrack, which is part of the film's overall concept; lots of animated films have a narrative, so I am used to this type of work. On the other hand,* The Old Man and the Sea *is characterized by a sort of realism (Petrov's animated painting), which is less common. It must be understood that this sound processing is very different from that developed for films in which the visual form is caricatured or largely stylized. But because of the soundtracks that I composed for Frédéric Back, I already had experience with realistic images.*

For a film integrating voiceover, the whole sound and musical idea is structured around this. It's the central element, on both the dramatic and sound levels. Consequently, there are no mixing problems: everything has been thought of to link it to the voice. So, I compose with the narration, and everything falls into place naturally.

O. C.: *Why did you choose traditional orchestration?*

N. R.: *IMAX is the format that can best handle an intricate sound framework. Moreover, the more an image is projected onto a large screen, the greater sonority and detail it requires in its soundtrack. This sound reproduction system has more sound channels than 35 mm Dolby Stereo, and provides a greater distinction between them; this allows you to push the saturation threshold further.*

Orchestral music keeps its dynamism when it is played quietly behind a voice. It has the wonderful ability to lend itself to many genres and allows subtleties that remain noticeable in the background. I don't have an idea in mind when I start working and, therefore, I eliminate the different approaches that don't work with the narration; in the end, the orchestra was the choice that proved to be the best.

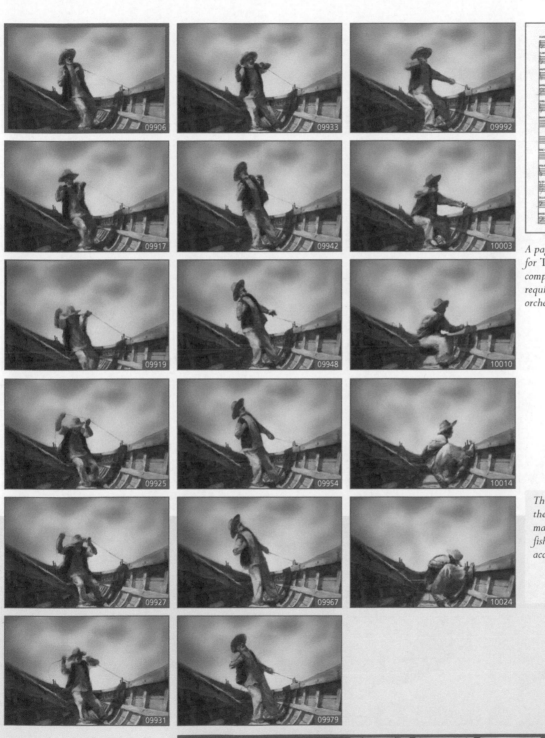

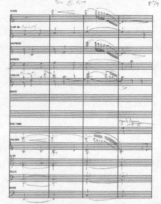

A page from Normand Roger's score for The Old Man and the Sea: *composing a symphonic work always requires accurate knowledge of the orchestral possibilities.*

The rolling rhythm of the boat and the very physical movement of the man draw the viewer into the fisherman's story: the profile view accentuates the scene's legibility.

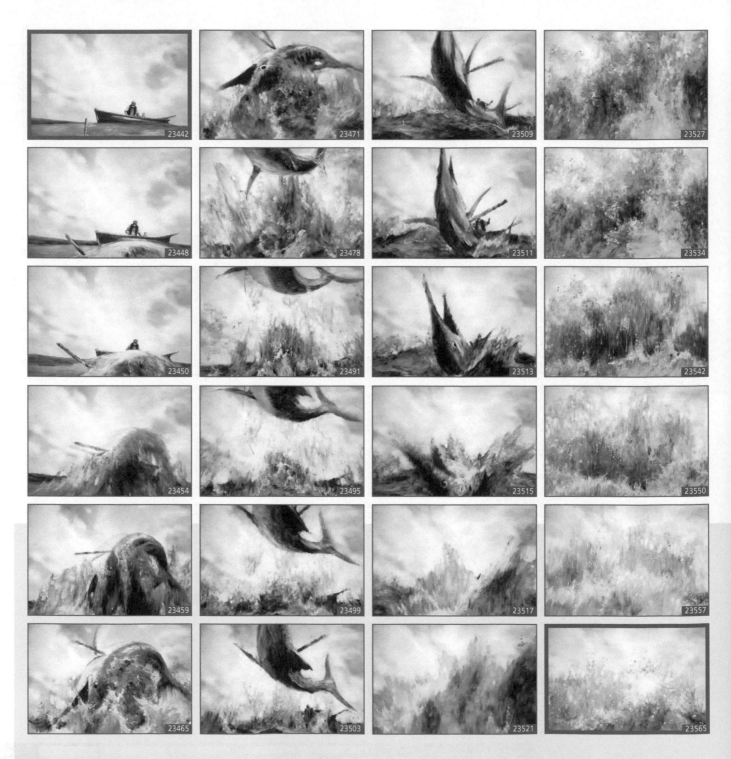

O.C.: Did you work with an assistant on the orchestration?

N.R.: Yes. As always, with Denis Chartrand, who prepared the musical guide. He plays the keyboards well and so, I can easily try out many orchestral and instrumental options with him. He also helps me produce the score, especially when there is little time for planning.

O.C.: How much time did you spend on the composition?

N.R.: Nearly two months, but I had already found the two main musical themes for the demo track a year earlier. There were of course minor incidents... for example, we had a sound recording that was too close for the bass, which made the bow on the strings sound too dominant. I liked this latter effect and so did the producers, but Alexander asked us, 'what's that helicopter sound?' He couldn't see how that sound could come from the orchestra. So we had to mix the bass to make the 'helicopter' disappear...

Everyone knows Ernest Hemingway's short story. The adaptation of a well-known piece is often difficult, as viewers look for what they felt when reading the story. However, in this medium-length film, readers do not feel betrayed by either the narrative choices or Alexander Petrov's visual treatment; they have not made any particular criticism of either aspect. Furthermore, it is the visual treatment that fills the viewer with wonder, regardless of their knowledge of the art of animation or visual sensitivities. Effectively, one does not need to be an expert to recognize the technical achievement and the artistic originality of the film-maker.

A rare feat, especially for an animated film, this film succeeds in being a personal film, the vision of one man, in spite of the immense production with its financial and technical imperatives. This result is as much the fruit of Alexander Petrov's talent, as it is the determination and respect of the producers – a vital alliance in the creation of such a film.

Opposite page: here is a particularly extraordinary example of the animation of the natural elements. It is a real tour de force.

Father and Daughter

A child accompanies her father to where he leaves alone on a boat. He never returns from his journey. Throughout her life, interrupted by childhood games, adolescent loves, her role as a mother and finally old age, the little girl who has become a woman returns incessantly to the place of departure, hoping to find her beloved, missing father. In the twilight of her life, she finds him again.

Oscar 2000

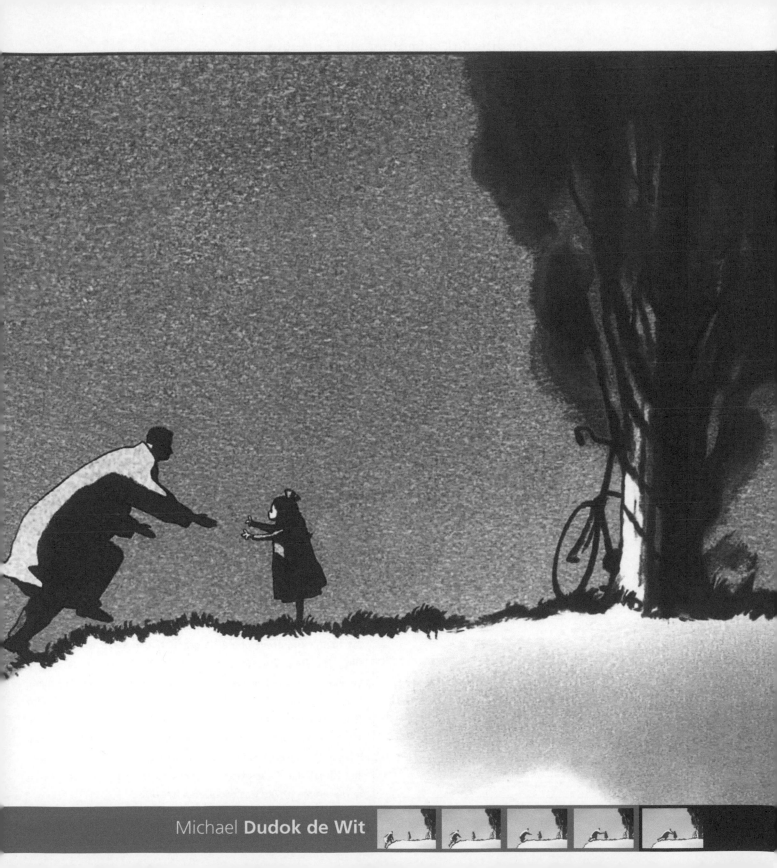

Michael **Dudok de Wit**

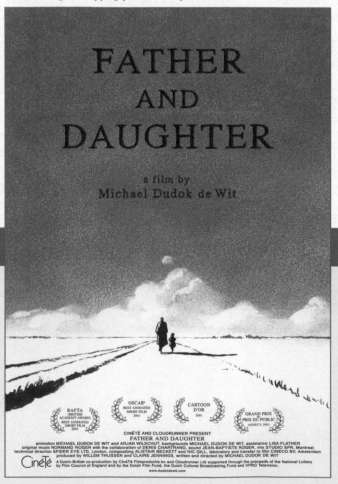

A beautiful exception: short films rarely have their own posters, as the market for this type of production is quite small.

Credits

descriptive

Title: *Father and Daughter*

Year: 2000

Country: United Kingdom/Netherlands

Director: Michael Dudok de Wit

Production: Cloudrunner Ltd, UK (Claire Jennings), and CineTe Filmproductie Bv, Holland (Willem Thijssen)

Story, design, layouts, storyboard and background: Michael Dudok de Wit

Animation: Michael Dudok de Wit and Arjan Wilschut

Technique used: Traditional animation and computer

Music: Normand Roger (in collaboration with Denis Chartrand)

Sound: Jean-Baptiste Roger

Technical direction: Spider Eye, Alistair Becket and Nic Gill

Length: 8 minutes 30 seconds

Michael Dudok de Wit was born in Holland in 1953. He studied engraving in Switzerland and animation at the Surrey Institute of Art in the UK, from where he graduated in 1978 with his first film, *The Interview*. After working in Barcelona, he settled in London, employed mainly in the advertising market. He made *Tom Sweep* (a series pilot) in 1992 and *The Monk and the Fish* (Cartoon d'Or, César for best short film, Oscar nomination) in 1994. *Father and Daughter*, won an Oscar in 2000 and the Grand Prix at the international animation festivals in Annecy, Zagreb and Hiroshima, in addition to other awards. His most recent film is *The Aroma of Tea* was completed in 2006.

Story

Quite extraordinarily, an artist just over 50, with only three earlier personal films under his belt, including a graduation film and a pilot, won all the international prizes for a short animated film. His work has thus far shown remarkable logic in its continuity; if his three independent films are considered – *The Monk and the Fish, Father and Daughter* and *The Aroma of Tea* – the similarity is clear.

To begin with the first two works are based on existential stories. The earliest shows a monk chasing a fish; at first he is taken with the idea of catching it (which he does not succeed in doing). In the end, he understands the true purpose of his pursuit and, becoming one with his prey, he finds inner peace. The film is similar to the traditional story of the oxherd who tries to catch an ox. The second film shows the quest of a girl who sees her father leave on a boat, never to return. In her endless comings and goings on her bicycle, she returns tirelessly to the place of departure until, at the end of her life, she meets her beloved father again; the fact that she must lie down and let go to reach her goal (she abandons the bicycle that accompanied her throughout her life to go down towards the remains of the boat) has a resonance with the final scene of *The Monk and the Fish*. The other common ground between these two films, which we will come back to later, concerns the calligraphy-influenced artwork.

O.C.: How did you come upon this rather minimalist and original idea?

M.D.W.: I was working on a new film involving a small blind Greek philosopher. I liked the story and the artwork, but I was struggling with the depth of the story. One day, while driving, I asked myself the good question – 'what do I want to communicate more than anything else in a film?' A moment later, the project about the Greek philosopher was abandoned and I had found Father and Daughter *instead.*

These five rough landscape sketches were based on photographs and memories. They are part of the preparatory artistic research, which helps to select backgrounds and ambiances.

This is one of the first drawings of the heroine: you can see that this work is highly influenced by Sempé.

A rough sketch searching the mood for the windy scenes.

This sketch is the first charcoal drawing made for the film. Still overly dramatic, it nonetheless reinforced the use of this technique in the film.

The light always comes from the water: at this angle the people are in silhouette. Every time the main character is seen in profile, she travels to the left to reach the place where she last saw her father and to the right to return home.

Rough sketch of sequence 1: it is this drawing that made Michael Dudok de Wit realize the extent to which he wanted to use shadows to maintain the dramatic atmosphere.

O. C.: *What was this desire?*

M. D. W.: *I wanted to express a kind of deep yearning, a longing. It is a painful yet very beautiful feeling, even if you don't quite know exactly what you want or miss. I have always felt this throughout my life and I think many people feel the same way. As for the film's main theme, it is separation followed by reunion. I believe it's a universal theme that can be found everywhere.*

O. C.: *What writing method did you use to develop the story?*

M. D. W.: *I gave myself a few weeks to digest the idea. If the story had not been good enough, I would have lost interest quite soon. I didn't put anything on paper until I was sure about the idea.*

O. C.: *The film is very existential. It looks like you believe in life after death...*

M. D. W.: *I believe that we don't entirely disappear after we die. This confidence is not linked to an idea or an image; it's simply a reassuring feeling.*

O. C.: What relationship do you have with the audience? Do you think about the spectators when you write?

M. D. W.: Yes, always. I often think about an imaginary audience. At each stage, for each idea, I wonder if the viewers will understand this or that thing, notice this or that mistake, are they going to look for too much symbolism in particular details, etc. I always strive for my work to be highly valued and appreciated by my colleagues as much as by an audience watching this type of independent animation film for the first time.

O. C.: Are your expectations mostly correct concerning the kind of response that you'll get?

M. D. W.: I remember that when I started production, I told my wife that Father and Daughter *would probably have less audience and success than* The Monk and the Fish, *because it was less entertaining. Well, quite clearly I was wrong! In fact, I try to make the kind of film I would like to see at the theater, a film that I enjoy and which leaves a lasting impression on me.*

The Idea

The film's outline is surprisingly simple. The linearity of time and the repeated journeys of the characters could make the viewer tire of the narrative. However, this is where one of the most important aspects of the story, after the idea, comes in: scripting. All the little anecdotal ideas developed in the film could have been replaced by others, thus the choice of which ones to keep was both subjective and difficult.

Each scene had to be made interesting in terms of the dramatic composition, as the scenes were so ordinary there was a real danger of them failing to captivative the viewer. This danger was even greater given that the film does not show close-ups of any of the characters, and the emotional aspect of the film is developed at a distance.

O. C.: Do you spend a lot of time on the idea?

M. D. W.: Generally, I spend a lot of time on the storyboard. It's a particularly creative stage. I also want to build up a good base for the rest of the production. For Father and Daughter, *I worked for several months to find the perfect rhythm and the right transition from one sequence to another. In the story, you see her whole life unfold, in a highly condensed manner. In spite of that, I wanted to create a quiet atmosphere, so that the viewer can feel the serenity of the passing time. It was a challenge that I enjoyed.*

O. C.: How do you work on the rhythm?

M.D.W.: To find the right rhythm, I spread out about a dozen drawings from the story at a time, on the floor or on my desk. Looking at them, I see the virtual film projected in my mind; I imagine the sound effects and the main movements. Then, when the storyboard is complete, I do the same thing again with all the drawings, from start to finish. This is the method I use to devise the timing of the storyboard.

O. C.: Even with all these months of work, do you still need to change your storyboard a lot during production?

M.D.W.: In the end, there were very few changes. I stuck the final storyboard on the wall and it stayed there throughout the making of the film.

O. C.: Given what you've said, I suppose you 'see' the whole film as soon as you sit down to create the storyboard.

M.D.W.: Yes. Actually, I admire filmmakers who can start a story without knowing where it is going to lead them. I would love to have the talent to improvise, but I really need to know how it ends – the full story – before I sit down to start drawing. I also need to have an extremely precise idea of the atmosphere and even some notion of the music.

O. C.: Although it all looks quite natural when you watch it, you advance carefully, step-by-step, and seldom go over things again. This provides the technically solid base that you need.

M.D.W.: Absolutely.

O. C.: Which ideas did you have to go over again when you realized they could be replaced by better ones?

M.D.W.: At the beginning of the film, when the father lifts up his daughter and hugs her, they twirl around together. My initial idea was to make them do a little waltz. But I decided against it, as the simplicity of the rotating movement was far more powerful.

The storyboard already gives the film a luminous atmosphere. The design of the characters is almost final. This stage demands highly accurate work which creates a document that the director will refer to throughout production.

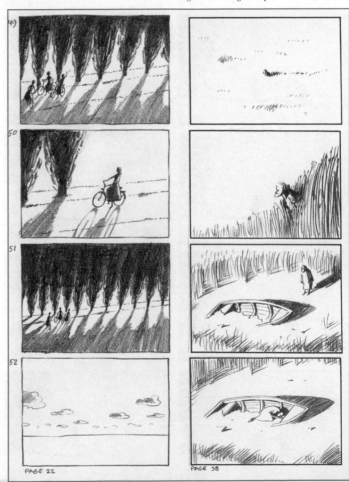

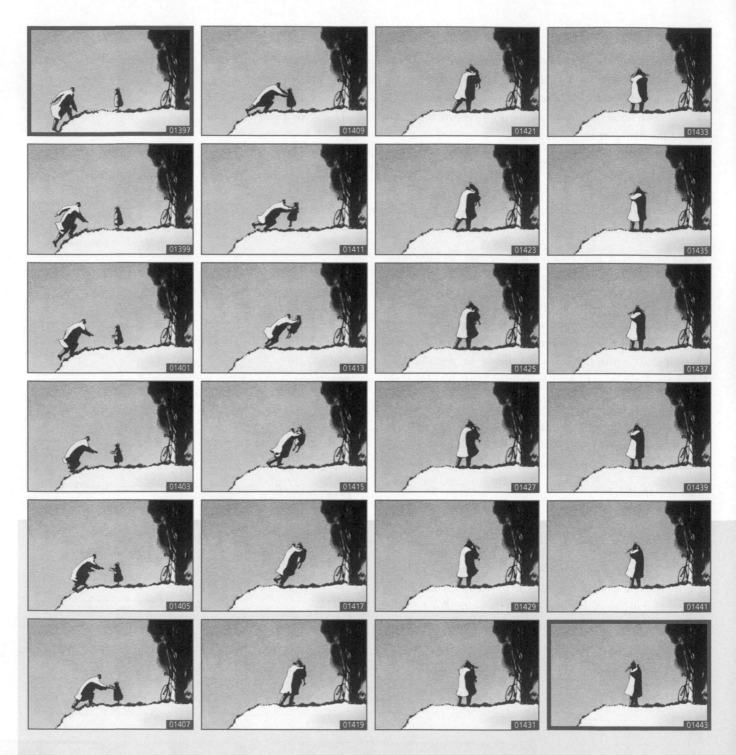

Opposite page: a perfectly timed simple animation – the little girl hugging her father as he is about to leave on the boat.

The same thing happened at the end: the father and daughter were supposed to do a little waltz (when they meet again), but I simply felt that a hug would be emotionally stronger. At the end of the film, there is also a scene with a seabird – an avocet. Initially, I had wanted to animate an amusing sequence with these birds – about twenty seconds long – before I realized that this could distract the audience from the main story. In fact, the essence of the creative process involved simplification: I started off with lots of ideas and I gradually clarified the story.

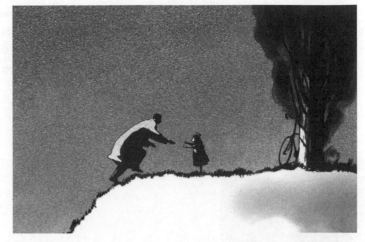

Final result of the compositing between the background and the characters in the farewell sequence.

The final drawing of the avocet: the image is incredibly simple and similar to traditional oriental calligraphic work.

O. C.: I really like one of the ideas at the end: the old woman, before lying down in the boat, tries to leave her bicycle upright on its stand, but it falls over several times. She tries two or three times more before giving up: you can feel that, for her, life has ended and she is detached from material things. She has passed a stage...

M. D. W.: *The idea just came to me. It's the kind of action that I love in Chaplin and Tati movies.*

O. C.: *The audience was particularly impressed by the backgrounds and the layouts you drew. How did you organize them?*

M. D. W.: *I see the layouts and visual compositions as movements. For example, when I draw a landscape, I visualize the lines and shapes that show directions or dynamics.*

O. C.: *These dynamics represent something important in your work. Could you tell me more about them?*

M. D. W.: *In an animated film you have all these interacting movements: the movements created by the dynamic lines in*

Background and color model for the first sequence in the film.

CRM 23

SKIN (FLAT)

The colors were prepared in advance to prevent inappropriate variations in a scene: we can see in the color scheme that few colors are used, but they are all textured to create a far richer visual effect.

each landscape, by the animation of the characters, by the transition from one landscape to another and by the transition from one animation to another; they provide the film's poetic quality and of course make the narrative clearer. There are other types of movement to consider, such as the timing, changes in the colors and contrast, changes in the mood, the rhythm of the sound effects, music, etc.

O. C.: Sometimes, contradictions exist between the narrative and the artwork: one can kill the other. How do you handle this?

M. D. W.: In Father and Daughter, they are equally important. I don't think I compare them.

A night scene: the camera is placed higher than usual because the background the character and the empty space before her must all be seen simultaneously.

Production

Michael Dudok de Wit is an international artist who speaks several languages fluently and has worked in many countries. His studio is currently in London. The production of *Father and Daughter* reflects the European culture that attracts him. The general setting of the film, which recreates the atmosphere of the Dutch landscape, helped to secure co-production for the film between a Dutch company and an English company. In spite of this, producing the film faced some problems.

Willem Thijssen, a Dutch producer, first obtained grants from the Dutch Film Fund (a government-run scheme that provides financial help to film productions) to finance the time needed to develop the idea for the film and to work on the storyboard. It is worth mentioning that the Netherlands has an important funding policy for film production, including animated films, of which the Dutch Film Fund is a part; this aid allows a large number of productions

to be made, and the overall quality of the films produced reflects the support given by these grants. Willem Thijssen then secured half the total budget from this organisation and VPRO (a Dutch television broadcaster). On the British side, the producer Claire Jennings provisionally obtained engagements from Channel Four (a British TV channel), which has always taken a considerable interest in animation, as well as a contribution from the National Lottery (in the UK, profits from the lottery fund various initiatives). Unfortunately, at the time financial aid for the film was being sought, these two British bodies were in the process of transformation, and the production of the film had to start without their definite backing. It was a bold step to take, and was even unadvisable, but Michael Dudok de Wit took the risk.

In the end, while the National Lottery provided 30% of the budget, Channel four desisted. New steps had to be taken to find other backing. Strangely, the BBC, a major producer of animated films (its funding of Aardman Animations, for example, is well-known), was not interested in the project. Finally, it was by deciding to cut back on salaries that the financial backing for the film was wrapped up. This limited budget forced some people to accept other jobs and to make the film in their spare time. Due to this splitting of the work schedule, production was stretched out over a relatively long period: four years (two years of actual work interrupted by commercial film-making and teaching in Kassel, Germany).

> *O. C.: Given the financing problems, how did work on the production go?*

M. D. W.: As normal. I mean, following the traditional chronology: first, the research for the style and the story, then the storyboard, the layouts, the backgrounds, the animation, the coloring of the characters, and finally, the music, sound effects and postproduction.

O. C.: Wasn't it difficult to interrupt the film-making in this way?

M. D. W.: The problem was that I didn't have a choice! When I had to get back to it after a week or more, I would start off with something simple to get back into the project which would allow me to move onto other more difficult sequences. Fortunately, however, the story was always in my mind and I referred to it all the time. The storyboard was in front of me and helped me to maintain the film's coherence.

Animation

We have already seen that making an eight minute film in which most of the movement consists of bicycles moving in profile, requires a good grasp of the timing, as well as imagination to make the scenes interesting. Here, too, the desire for simplicity, which permeates the whole film, affects the animation itself. Simplification demands absolute perfection, as the viewer's eyes are not swamped by visual details that could distract them; no tricks or mistakes are permitted.

This simplification does not deprive the animation of rhythm. The children's movements, for example, are successfully created: the traditional rules of deformation (squash and stretch) are strictly applied and even exaggerated, which makes them expressive. The animation of the woman whose life we are following gradually changes with her age, and this work is executed with similarly well observed sensitivity.

Animation on ones: 24 drawings per second (rather than the 12 normally shot) give vigor to the leaves shaken by the wind.

K. LEVEL
COLOUR 25

L. LEVEL
COLOUR 24

CRM. 27

M. LEVEL
COLOUR 25

A color chart of the leaves. As in the rest of the film, there are few tints: light is used to emphasize the movement.

> **O. C.:** *Did you make an animatic to check the editing?*
>
> **M. D. W.:** *Yes, but just for me and Normand, the musician.*
>
> **O. C.:** *How do you create the visual rhythm in the animation?*
>
> **M. D. W.:** *Intuitively and logically at the same time. I use a rational method, for example, when I know that a particular action requires a particular amount of time to be expressed. But most of the actions are organized intuitively, on feeling. It either feels right or it doesn't. It's as simple as that. When I have doubts, I make several versions of the animation that I film on the line-test recorder or I leave the scene aside and come back to it later.*
>
> **O. C.:** *Here as well, the storyboard must have helped you...*
>
> **M. D. W.:** *When I start a new sequence, I confirm its actual length and context by using the storyboard, so I can see what happened before and what should happen next. Then I put the storyboard aside to concentrate more on the animation.*

First rough sketches of the woman fighting the wind: the wind effect is mainly created by the dynamic pose of the body.

SC. 32 AND 34 ONLY

Color models for the final sequence of the girl fighting the wind.

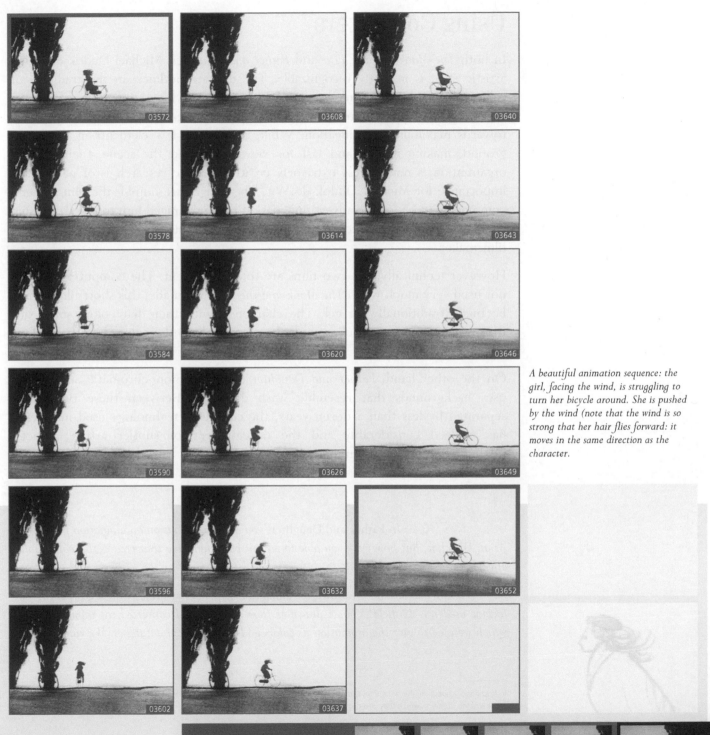

A beautiful animation sequence: the girl, facing the wind, is struggling to turn her bicycle around. She is pushed by the wind (note that the wind is so strong that her hair flies forward: it moves in the same direction as the character.

Using Computers

In both *The Monk and the Fish* and *Father and Daughter*, Michael Dudok de Wit's artistic style is instantly recognizable. The delicate outlines, in the tradition of calligraphic artistic design, emphasize the lighting with a minimum of effects. The image is stripped of ineffectual or disruptive elements, as the whole style leans towards maximum simplification. While there were few elements in the background, making it easy and fast for viewers to read the scene, their graphic organization is nonetheless extremely creative: artistic research is of paramount importance for Michael Dudok de Wit. The images are limpid: the film-maker's commercial work for the advertising market has encouraged him to research visual efficiency; perhaps this research is responsible for his success as a commercial film-maker.

However technically, the two films are totally different. The computer was still not used very much when *The Monk and the Fish* was made; this short film had to be made traditionally on cel. The characters with their flat colors stand out from the watercolor backgrounds, creating a brightly colored image full of contrasts.

On the other hand, *Father and Daughter* is almost monochromatic and mainly uses backgrounds that resemble wash drawings. Between these two films, separated by less than a dozen years, the computer technology used in cinema has evolved considerably and the development of subtler artistic effects: further evidence that animation is an art closely linked to the techniques available.

O. C.: In Father and Daughter, *you did the animation on animation paper with Arjan Wilschut. But how were you able to do this particular line that creates this calligraphic effect?*

M. D. W.: The animation was drawn on animation paper using quite a thick 3B pencil. The format used was 12 field[1]. These drawings were scanned and converted to Animo software, which we used to give the animation its colors and textures from databases. We employed this

[1] In traditional animation, the animation formats on paper are all organised using a system of charts and they are named according to the size of the frame on which they are drawn.

software to create the cleaned-up images and the final compositing. We clearly saved a lot of time this way.

O. C.: Did you use the same method for the backgrounds?

M.D.W.: The backgrounds were drawn on paper using charcoal and pencil. The charcoal was applied with my fingers and the palm of my hand. The result was then scanned and converted into Photoshop, so that contrasts could be adjusted, corrections could be made, the drawings could be cleaned up and black and white could be converted into color; all this was done with the help of a graphics tablet.

O. C.: You didn't use charcoal in your earlier film.

M. D. W.: No, it was the first time I used this medium. As I am accustomed to the watercolor technique, I adapted the charcoal by using it like I use watercolor, in layers. Sometimes I didn't like the result, but I could start again straight away, as it's quite fast. I like charcoal, but I have to admit that I would not have been able to get the final visual effect if I had not used computer graphics software.

O. C.: Did you work directly on Animo?

M. D. W.: No, I assigned this to a specialist. But for each scene, I myself prepared the color chart, as well as the textures that I made using charcoal and Photoshop.

Some final backgrounds: note that rather large areas of the backgrounds are darkly shaded, which is quite rare, especially in a production that is also intended for television.

Animo digital editing software allows all the elements that constitute a frame to be combined. It also allows each of the levels of the set, characters and other moving elements to be worked on individually, and for many adjustments to be made.

O. C.: *What are the advantages of moving onto working with digital software after the work on paper?*

M. D. W.: *You can save a lot of time. For example, I could animate a cyclist (and just one turn of the wheel) and adjust their size on the screen, reducing it to simulate distance. In this way, you can manipulate the base elements to accentuate them.*

O. C.: *Did you use safety frames for this?*

M. D. W: *Each landscape was drawn slightly larger (almost 10% larger on each side); this allowed me to later change the size of the field of work. This forethought turned out to be invaluable, as I had devised the film for a 1:33 format, which is for television. But just before postproduction, the Animo operator and I decided to change the format to 16:9, as British television had started to adapt to this new format.*

A rough sketch of her father's boat rediscovered. Translation of the Dutch text, 'she enters the boat and lies down on her side'.

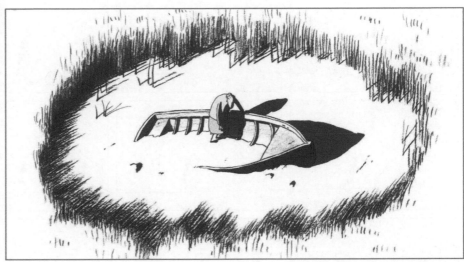

Final image of the sequence with the character: the overall lighting consistency is maintained even if we are seeing this scene for the first time from this angle.

The backgrounds are at different levels so that the final edit can be easily monitored on the computer.

Final sequence: the little girl has become an old woman. The figure changes but the clothes remain the same.

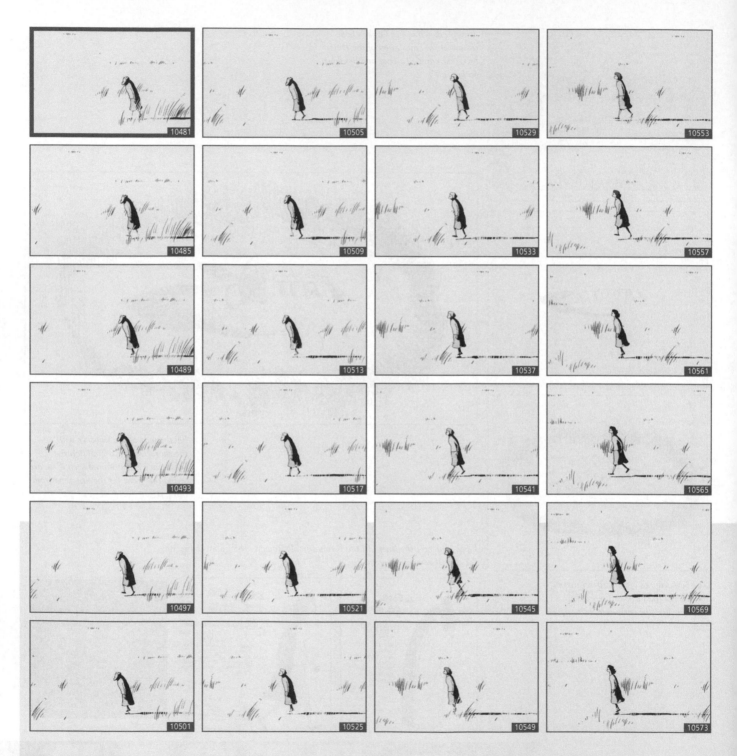

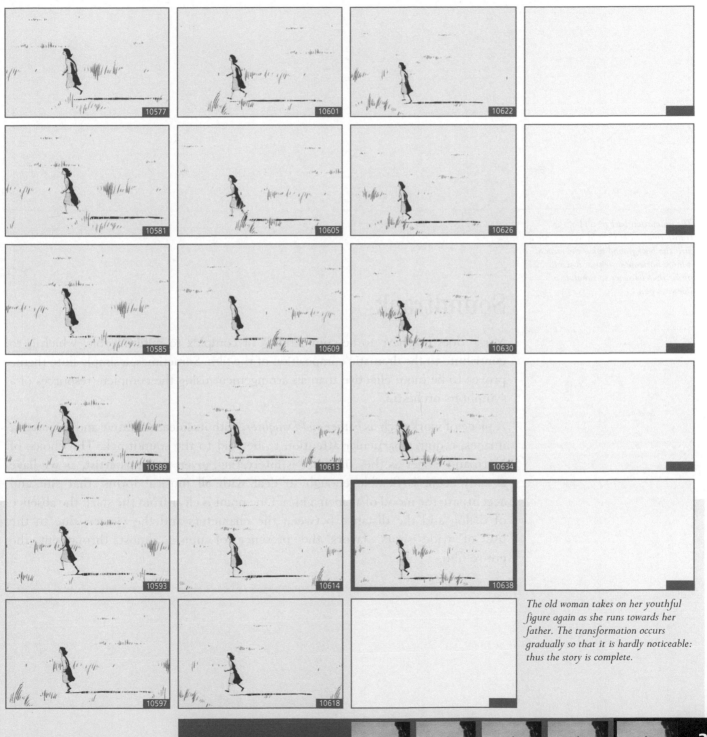

The old woman takes on her youthful figure again as she runs towards her father. The transformation occurs gradually so that it is hardly noticeable: thus the story is complete.

The animation background of the transformation of the old woman into a girl: the background takes the form of a large horizontal strip as it scrolls under the character to simulate a sideways pan.

Soundtrack

Music does not have to be commanding or complex to fulfill its role, which is to contribute to the dramatic composition of the film. Sometimes, a simple flute theme proves to be more effective than an arrangement using the complete resources of a symphony orchestra.

A piece of work such as *Father and Daughter*, with its linear narrative and minimalist images, requires particular attention to be paid to the soundtrack. The choice of Normand Roger as the composer is interesting, given that this artist, as we have already seen, is flexible enough to deal with all musical forms, that suit and accentuate the mood of a cinema idea. One point is clear from the start: the absence of dialog and the distance between the characters and the viewer, due to the use of wide shots, favors the presence of music almost throughout the entire film.

O.C.: Before working on Father and Daughter, *had you seen Michael Dudok de Wit's earlier films?*

N.R.: I wanted to work with him mainly because I loved The Monk and the Fish, *and also because I really liked the art quality and the originality of the screenplay for his new project.*

O.C.: He gave you the idea of using this recurring musical theme (Josif Ivanovici's Danube Waves). *Is this approach common in your work? What did you think of it?*

N.R.: I wasn't against using this melody in the first place. As the subject of the film deals strongly with nostalgia, having a well-known leitmotiv that is evocative of the past seemed like a good idea. It's not an unusual case, although most of the time, when I use an unoriginal theme, it's either because it's an integral part of the idea, such as Puccini's Madam Butterfly *in Pjotr Sapegin's film* Aria, *or because it seems unavoidable, such as Vivaldi's* Four Seasons *in Paul Driessen's short film* The End of the World in Four Seasons. *In* Father and Daughter, *it wasn't a requirement, but as the idea seemed reasonable to me and justified in one way, I didn't mind.*

O.C.: What were your first questions about the use of this musical theme?

N.R.: It was a starting point. It only features in the first and last scenes and, apart from a secondary theme by Ivanovici, all the other themes are original.

O.C.: At what stage was the film when you started working on the music?

N.R.: As in most projects, I started working when the animation and the editing were almost finished. You can still replace the scenes with new versions that are colored and polished, but as long as the timing stays the same, this doesn't create any problems.

O.C.: How did you manage the approach to the different orchestrations?

N. R.: *First, you have to start each sequence – or chapter as I call them – with a different orchestration from the previous one, which, when combined with the introduction of another theme, can help to suggest the idea that time is passing. Michael first suggested the mechanical organ to me, which is quite popular in the Netherlands. I did a few tests, but it didn't work very well in the middle where the action unfolds; these organs are mostly associated with town and village squares, but we are in the countryside. Moreover, it didn't lend itself very well to orchestral variations, so I abandoned this option.*

O. C.: *How did you manage to time the music with the action?*

N. R.: *The film's music is structured to accentuate the passing of time between the different chapters in the life of the main character. Thus, each chapter starts with a new theme and an instrumental arrangement that differs from the previous scene, but which ends with a musical motif associated with the departure (or the absence) of the father.*

O. C.: *What background sounds were added and why did you choose them?*

N. R.: *The realistic sounds of the track help the nostalgic effect and reinforce the reality of the characters. The sounds of the bicycles and the bells are particularly evocative. In fact, the ringing of the bicycle bells is very important and is firmly incorporated into the structure of the film. My son, Jean-Baptiste, did the sound editing under my supervision, but with a good dose of his own creative input. Michael came to Montreal to contribute to the final changes and finally we mixed the soundtrack at a local studio where the mixer's fresh input was very welcome.*

O. C.: *How did you organize the recordings with so many different orchestrations?*

N. R.: *I used an accordion, piano, bassoon, guitar, clarinet and strings, held or pizzicato. The strings and the piano were played on the sampler and the other instruments were acoustic. Denis Chartrand, with whom I've collaborated for a long time, played the piano and the accordion, and two other musicians recorded the bassoon and clarinet arrangements. In all of this, I was looking for simplicity. In each of the musical sequences, I only used two or three instruments, apart from the part with the strings, which are quite discreet anyway. Forcing or driving the emotion in the film could have had a diastrous effect.*

O. C.: *Did you make a lot of changes to the soundtrack?*

N. R.: *After sending him the first outline, Michael asked me to redo two scenes, which I did. This was a normal job that had to be spread out over several months, but with periods where I was working on other projects as well. It normally takes me six to eight weeks to produce the music*

and sound effects for a film of this length. This film didn't seem to be an exception, even if sometimes it was difficult to count precisely how long it would take when it was spread out over a longer period of time. The sound mix was finished less than a day before the deadline for the film to be submitted for selection at the Ottawa Festival, Michael and I drove two hours from Montreal to Ottawa so that the film could be included five minutes before the deadline! The film was chosen, awarded a prize and the rest is history.

It has now become quite normal to see films that triumph gloriously and that, in their life (within a year or two), are awarded not only an Oscar, but also nearly all the major prizes at the international animation festivals. This phenomenon is growing and is sometimes unwelcome, as it leaves very few opportunities for other films to gain public recognition; all the more so as the number of films produced annually is constantly growing.

Father and Daughter, with its dazzling array of prizes, however, is a case apart. Compared to a number of other short films shown on the festival circuit and in film libraries, this film creates a rather rare emotional response; the film deals with people, a personal voyage, and is full of moving details filmed with a discernment that shows the film-maker's sensibility. Without using spectacular techniques or colorful tricks, Michael Dudok de Wit gently invites the viewer to enter the hearts of the characters and their lives.

After spending the best part of two years compiling a work on the production of animated films, watching *Father and Daughter* was still a moving experience; the emotion pours forth from the screen and touches you deeply. This is the key quality of this magnificent film, which I strongly encourage you to discover.

Harvie Krumpet

This film tells the tragi-comic story of Harvie Krumpetski, who is born in Poland, then emigrates to Spottswood, Australia, where he does various jobs and changes his name to Harvie Krumpet. His difficulties in integrating lead to frequent trips to hospital, where he has a steel plate put on his head. When he is struck by lightning one day, the plate becomes magnetic. He later marries his nurse and they adopt a little thalidomide girl they name Ruby. Eventually, Harvie finds himself in an nursing home, where he lives out the remainder of his days.

Oscar 2003

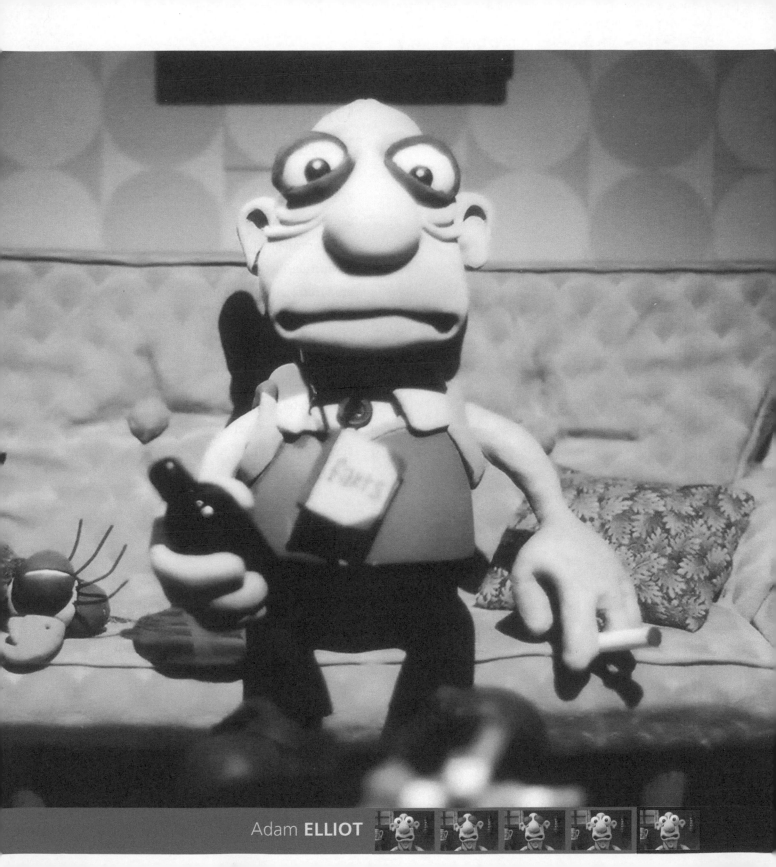

Adam **ELLIOT**

Credits

descriptive

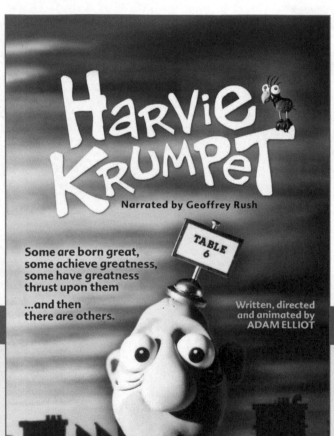

Title: *Harvie Krumpet*

Year: 2003

Country: Australia

Director: Adam Elliot

Production/distribution: Melodrama Pictures Pty Ltd

Producer: Melanie Coombs

Screenplay, artwork, storyboard, layout, sets, animation, camera: Adam Elliot

Technique used: clay animation

Music: Adam Elliot

Sound: Peter Walker

Voice: Geoffrey Rush

Editor: Bill Murphy

Length: 23 minutes

From as far back as he can remember, **Adam Elliot** always loved to draw, although he initially wanted to become a veterinarian. Somewhat restless, he deferred his studies and spent five years selling hand painted t-shirts at The St. Kilda Craft Market. He later went on to study at the Victorian College of the Arts in 1996. It was then that he conceived the idea for *Uncle*, his first animated short film. Although Sarah Watt (director and lecturer) had a strong influence on his education, especially on his writing, Adam Elliot principally learnt his craft and methods by himself, which enabled him to develop a very individual style.

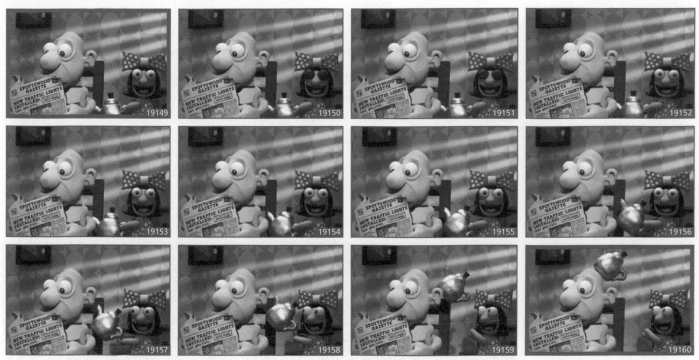

Ruby plays a joke on her father (whose skull has become magnetic).

Screenplay

This 23-minute film is the fourth work in a series of animated portraits. The three previous films – *Uncle* (1996), *Cousin* (1998) and *Brother* (1999) – were also created in clay animation. This family trilogy was seen at more than 300 festivals across the world and won more than 50 prizes, including four Film Institute awards (the Australian equivalent of the French *César*). Other prizes were awarded not only for its specificities as an animated film, but also for the screenplay and direction that is to say the particular quality of the perspective developed by the author. This quite exceptional achievement reveals that, in a certain way, the animated films of Adam Elliot are regarded as live action films by the public. The reason for this is simple; everything is centered on a main character whose biography is told in a human and tragic-comic way. Animated cinema rarely recounts the life story of one human being.

As a film, Harvie Krumpet is far more sophisticated in terms of lighting and ambience than its predecessors.

So what are the writing techniques that led to this special experience on the part of the viewer, and which give such importance to the characters? (All Adam Elliot's short films are named after their main characters.)

Practically speaking, the direction of Adam Elliot's films is based on a type of stop-motion plasticine animation. In some clay animation films, other materials, less malleable than plasticine, are often used.

Screenplay

It is noticeable from a first glance at the story outline (which is extremely concise!) that the film has a very linear construction and is rich in seemingly trivial events. Adam Elliot's screenplays invariably convey an astonishing association of drama and humor. Maybe this is the reason for their great success: the traditional cocktail of classic comedy.

A screenplay, especially one of this length, must always be mulled over. Adam Elliot had the character of Harvie Krumpet 'in his head' for a decade before bringing him to the screen. Chronologically speaking, the idea had come to him whilst he was directing his first films. The character around which the story revolves is a very personal creation, a combination of different people that the film-maker had carefully observed and studied. The name Harvie comes from the family dog, which Adam Elliot's mother had accidentally run over in the car... This anecdote illustrates the general idea of destiny, which runs throughout the film. As for the name 'Krumpet', Adam Elliot explains that 'A crumpet is a type of English griddle cake which has lots of little holes all over its surface. For some unknown reason, I found that the two words went well together'.

Quite apart from the methodologies and other basic principles of dramatic creation, he is definitely guided to a large extent by his intuition; this is indeed what brings a unique aspect to his writing technique. To use his own words, his main aim is to offer something to his audience that makes them laugh.

One of life's magic little moments; a nurse, wearing subtle make-up, brings her patient his cancerous testicle in a glass jar after his operation. It is love at first sight...

A. E.: I challenge myself to create and tell stories that are engaging and enriching. I want my audience to leave the cinema feeling happier; in some ways more human! Isn't that what all directors aim for?

O. C.: Did you want to convey a particular message in this film?

A. E.: I try and stay clear of messages that are too overt. People who know me well can see a lot of my personal beliefs in all my films. I have been called many things; atheist, mysoginist, depressionist, fatalist. All I try to do is tell a person's biography in a simple and concise manner; a good story, well told. If there is a message in Harvie, then I suppose it is that life is not completely what you make it, nor is it all fate. You can try and steer your own ship, but it is impossible to avoid the storms!

O. C.: Do you work on several projects at once?

A. E.: No, I have only written four scripts which have all been turned into films.

O. C.: You had ten years to think about this film. How long did the screenplay take to write?

A. E.: Four to five months... but there were 17 versions!

O. C.: How did you organize the written sequences?

The film's original storyboard.

CLOSEUP OF HARVIE (DISSOLVED IN)

AND BACK TO FRONT AGAIN.

(CLOSE UP OF PORTHOLES, HARVIE AND OTHER IMMIGRANTS PEERING OUT. (DISSOLVE IN)

TO A PLACE CALLED AUSTRALIA. HIS WORLD HAD BEEN TURNED UPSIDE DOWN ...

A SHIP AT NIGHT.

HE FLED AND MANAGED TO GET ON A SHIP...

A. E.: Once the script was written, I memorised it and would recite it in the car to and from the studio each day. Harvie became a very real person. That is what took me ten years...

He began as a small pencil drawing in 1993. In 1999 I decided to start writing the script. I have very detailed notebooks and journals and when I write I begin with the detail and work backwards. I am a very intuitive writer; the characters have to be believable and their situations must ring true.

O.C.: Do you spend much time writing? Do you ever get writer's block?

A.E.: No, I don't really get writer's block. I get up at 6am every day, but I can't work after five in the afternoon. I also read a lot.

O.C.: What about the three-act structure and all the traditional methods of writing?

A.E.: I'm not really concerned with all that. If there is a structure at the end of it, that's just a bonus! I don't apply any kind of formula. On the other hand, I am a perfectionist and each phrase has to be exactly right. For me, the script is THE most important part of the film and has my fullest attention and respect.

O.C.: Where do you concentrate most of your efforts?

A.E.: On simplicity. It's my favorite word, my mantra.

The first rough sketch, done in 1993.

A sketch done a little later, that looks more like the finished character.

Financing

Adam Elliot thought that the international prizes won by his previous films would facilitate the financing of *Harvie Krumpet*. He was sure that a producer would spontaneously arrive at his door, check in hand, to produce his new film. But *Harvie Krumpet* was financed in full by Australian government subsidies. The financial set-up required two years of effort and contributions from several separate organizations – The Australian Film Commission, Film Victoria and SBS Independent. The total budget was close to 400,000 Australian dollars (equivalent to 230,000 Euros/300,000 USD in 2005).

Adam Elliot was lucky to have an ideal relationship with his producer, Melanie Coombs. Being a true enthusiast for animated films, she not only knew how to accurately estimate the final budget of a film... she was also at the director's side at every stage of production. She had approached Adam Elliot after seeing *Cousin* a few years earlier, and told him that she wanted to work with him.

Adam Elliot with Melanie Coombs, his producer.

Making the Puppets

It is generally agreed that incorporating an armature (a jointed skeleton) is essential for the animation of a stop-motion character. This is especially the case with plasticine, as it has an annoying tendency to soften under the heat of studio lights. Adam Elliot, however, creates his figures in a totally different way.

A full length photo of the main character.

The arms were the only body part made entirely of plasticine, which covered a core made from 3 mm iron aluminum wire. The rest of the puppet contained neither armature nor plasticine, as discussed below.

This shortcut technique is possible because the characters that Adam Elliot creates do not move about much – and when they do, their legs are generally out of frame, invisible on screen. In other words, it is never necessary to hold a character still on one foot, as in the case of a walk. It is the writing and the specific shooting script that allows this simplified technique.

Most of the puppet's body is made from car filler paste. Mixed with a catalyst, the product sets hard in 20 minutes and then becomes strong enough to be sanded, machined, pierced, cut, threaded and painted. This resin is very solid and has a good resistance to wear and tear. It was used to create the torso and the head. These parts were then colored to match the tint of the arms. The clothes were not, generally speaking, real; they were directly painted onto the characters' bodies.

The eyes were molded by pouring a plastic liquid into rubber molds that were originally used to make ball bearings. Once set, the spheres were painted with gloss car paint. Contrary to methods used in other studios, the eyes were not pierced in the center (to facilitate their movement by using a pin), as they were large and prominent enough to be moved directly with the fingers. They stayed in place by gravity alone, and were not fixed by the clips that are generally used in stop-motion animation, which are made of two thin pierced strips.

For the facial expressions, a series of mouths were sculpted in advance and stuck onto metal plates. They attached themselves to the bottom half of the puppet's face, which was covered in a magnetic layer. For the animation, all that was needed was to interchange these elements, to produce the effect of mouth movements.

The average size of the puppets was 30 cm (according to Adam Elliot, the same height as a wine bottle). For certain close-up shots, the characters' hands were made on a larger scale.

Harvie's mother...

... and his father.

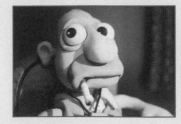

Clay animation

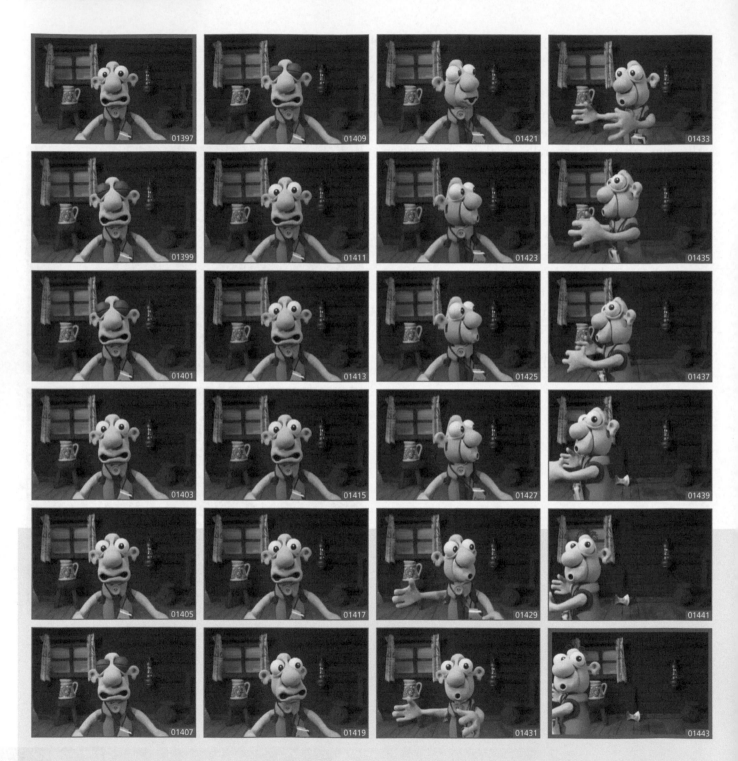

O.C.: Were you never interested in doing 2D animation?

A.E.: Since film school, I have worked with stop motion, although I did have all the equipment at my disposal to do cel animation, and even computers for 3D. Today, I can't see myself abandoning stop motion. I am definitely hooked. I like having dirty hands and making things with pipe cleaners and other such things. Being in front of a computer all day would bore me.

O.C: Your puppets are slightly bigger than most other models...

A.E.: I was born with an inherited physiological tremor, which affects my nervous system. When I move, I tremble a bit more than most other people, so my puppets had to be easy to handle. In fact, my characters are all a bit like me; they're not quite right.

Making the Sets

The sets comprise two very different types of elements; on one hand, there are the three dimensional props which are in the characters' immediate vicinity and which are part of their personal space; on the other, there are the objects that make up the periphery of the set, which determine perspective and are used for distance layers. This category includes the skies and objects that are supposed to be very big (mountains, buildings, etc.) in the background.

The skies were created very simply by means of an airbrushed painting on a 3 m × 5 m plywood support. As it was essential that this background appeared to be very large, Adam Elliot used lenses with very short focal lengths (wide angle), which cover a very large field.

There are also some components that are closer to the camera, but still part of the background. For example, there is an exterior scene at the beginning of the

Facing page: the lower half of the character's face is made up of detachable pieces, which are changed frame by frame.

The puppets are slightly bigger than those normally used.

The Polish scenery.

The immigrants destination...

... and their lodgings.

film, which is set in Poland. With Adam Elliot's techniques, it took four or five days to place all the scenery.

The stage was 2.5 meters wide. As the shot shows a hilly countryside scene, it would seem that the hills must have been quite large, but this is not the case at all. They were made on a smaller scale to give the impression of distance. The trick was to place them nearer to the camera than they should have been, which enabled their actual size to be reduced while matching the visual perspective. It is the same kind of trompe-l'oeil effect that is used in the theater.

This reduction in the general size of the sets was implemented to save on production time and space (a larger set takes longer to make) and the area that Adam Eliot had to stock the different components and to work in was roughly the size of a double bedroom. The hills were made of foam rubber, which could be sculpted to look like mountains. The shapes were then covered with synthetic fur (the same as is used on teddy bears) to simulate the grass. The trees were made from the branches of synthetic Christmas trees. The house was made from MDF, which was very easy to shape as required.

All these elements were arranged and stuck onto a balsa wood base. According to Adam Eliot, the amount of glue used to make the whole film was impressive… A very appetizing snowfall (icing sugar) was sprinkled on top of the whole scene.

O.C.: The first glimpse of Spottswood, the area of Melbourne where the immigrants arrive, is completely graphic; the buildings are two-dimensional and there is an obvious intention to make them appear unreal.

A.E.: Spottswood is a very flat and dull place, almost two dimensional. I wanted the three houses with windows to resemble the side of the ship with portholes and to express how the migrants were transported from one container to another.

Unlike what happens in other stop-motion animation studios, the set furniture was only made on one scale. In conjunction with this, Adam Elliot used macro lenses, which allowed him to focus up to 3 cm from the set. With this degree of enlargement, the textures have a greater impact, but that is all part of the director's aesthetic game.

Because the crew was small and the number of film sets was limited, it was not possible to save time by building subsequent scenery whilst current scenes were being filmed.

This trash dump was made up of hundreds of elements, all stuck on top of each other, to suggest that the trash is piling up.

The nursing home.

This set shows the bus stop, near to the nursing home, used by Harvie in his 'naturist' phase.

Filming

As we have already seen, the scenery was created as the film went along. The filming was therefore organized in long animation sessions linked to a particular set. This meant that the film, for obvious reasons, was not shot in chronological order. A method of filming that avoids repeating set-ups, but intersperses the shooting with long sessions of set building. Completing the filming took 14 months, because only five seconds of film were shot per day. Which is in fact a very good average.

Adam Elliote with his camera.

O.C.: *How was the filming organized?*

A.E.: *We only used one unit. That enabled us to stay sane! We worked for three months building and refining a set. We then filmed with it for three months, and so on...*

Considerable precision is a prerequisite. Ordinarily, there is very little safety footage actually shot in animation, unlike live action films. If filming is carefully prepared, the result is largely predictable, as image-by-image capture shooting enables precise control to be maintained. Furthermore, the considerable work that animation requires tends to preclude wasted effort; film sequences are shot according to the length of their use in the final edit. However, because this short film lasts for almost half an hour, adjustments were likely to be required at the editing stage to achieve the right rhythm, so safety footage was filmed – between five and ten seconds of footage both before and after each one of approximately 280 shots. It is worth noting that the editor, Bill Murphy, has a background in live action films and not in animation...

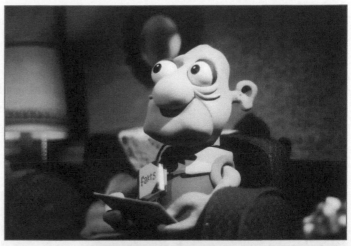

Warm lighting in a room lit by incandescent bulbs, to suggest the character's mood.

O.C.: *What sort of lighting do you use?*

A.E.: *I have never used the services of a key grip or a director of photography; I create my own lighting entirely. I have a lot to learn about lighting and I sometimes find that it is the most difficult part of filmmaking. It can become a very intuitive art form. I am always moving the lights around until I create a mood that 'feels' right. In my earlier films I used minimal and dull lighting set ups, but as I became more confident the set ups became more complicated and sophisticated. I am looking forward to working with a professional lighting technician on my new film.*

O.C.: *Technically speaking, what did you use?*

A.E.: *Low voltage globes via an adaptor to a powerpoint or torch globes to long life batteries for quick shots. Generally material of a strength between 5 and 15 watts.*

Diagonal lighting makes the atmosphere more dramatic.

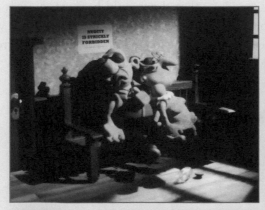

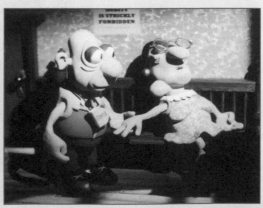

The morning after the night before for Harvie... and the morning after suicide for the other resident.

Special Effects

One way of simplifying the animator's work would be to write scenes that carefully avoided posing too many technical problems. Adam Elliot, however, increased the animation challenges in the screenplay with such things as lightning storms, rain streaming down windowpanes, and the animation of waves on the ocean. These are all things that would normally horrify an animator (rain, fire, water, smoke, etc).

Harvie is struck by lightning, which will make his skull magnetic. This scene offers a kind of phantasmagorical moment, rather than any sort of realism.

During the sequence set in Poland, we see Harvie Krumpet warming himself one night round a campfire, which is in fact made from small pieces of balsa wood, onto which pieces of red gel that have been cut up and painted are stuck. Many shapes were made, so that they could be continuously replaced for an animation 'on ones' (one 'flame' for each frame of film). The scene was long, so loop animation was used. Real twigs were arranged on the fire and lit from below by a tiny bulb to obtain a reddish glow (see illustrations on facing page).

A special effect to complement the narrative; a heart that beats between two souls. The heart is simply fixed onto the end of a metal rod and moved in each shot to suggest that it is beating.

06026 06028 0603 06032

The fire is made up of little colored cutouts.

Another special effect that was rather complex to set up was the rain streaming down the windows. It was created in the usual way, by placing little drops of glycerine on a pane of glass, with a toothpick. The droplets are then animated by blowing them gently down the glass, frame by frame.

A final example: Harvie is filled with wonder as he watches television to educate himself. Musical

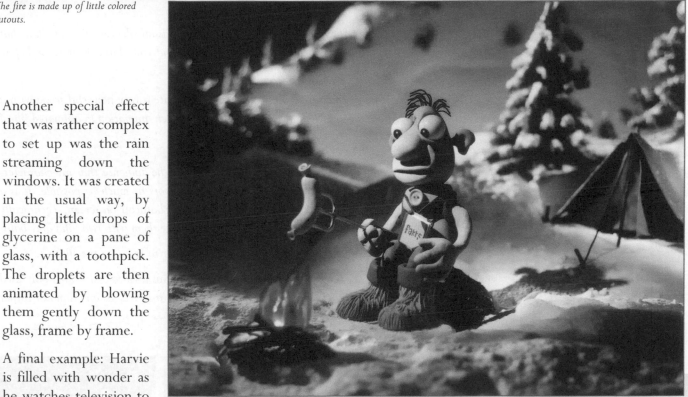

Polish landscape under the snow and the animated campfire.

comedies fascinate him. The television set is made from a rectangular box, into which stylized images of old black and white films are inserted. For this, a series of A4-size cards were painted with scenes copied from an animation that had previously been created using Flash software. This work was done by Warwick Bennet, and was integrated into the shots by placing the different cardboard 'cels' inside the television set, frame by frame. There was no digital compositing involved.

The TV program that Harvie watches pays homage to Busby Berkeley.

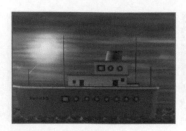

The sea is quite stylized.

Animation

> **O. C.:** *The voyage scene is surprising. The sea doesn't have any realistic characteristics. Was there a reason for this apart from an aestetic one?*
>
> **A. E.:** *The waves do indeed seem artificial, but it was not just because sea is difficult to animate. I really like the way they turned out.*
>
> **O. C.:** *Let's talk a bit about the animation. There are lots of 'visual silences' in your film, that is to say, moments during which the characters don't move. Did you plan this precisely before you began the animation?*
>
> **A. E.:** *Yes. I think silence is underused in cinema. You can create a very powerful scene with a very static image. I have always thought that there was too much animation in animated films!*
>
> **O. C.:** *Your characters blink a lot, don't they?*
>
> **A. E.:** *Because my animation is so static, blinking eyes remind the audience that my characters are definitely alive. I try and make them stare at the spectators as much as possible. It is a device to make the audience immediately 'engaged' with the character on screen. Technically speaking, I remove the white eyeballs for two frames and replace them with two solid grey balls.*
>
> **O. C.:** *Did you work with a video assist and a hard disk recorder to regulate the filming?*
>
> **A. E.:** *No, the filming was done with a really old Bolex. There was a video assist but I only used it to control the visuals on my Apple laptop. I prefer to use my 'instincts' as an animator rather than rely on digital technology.*

Harvie's oniric sequence with the wheelchairs and religious music in the background.

One of the most striking scenes in *Harvie Krumpet* (see p 270) depicts a wheelchair ballet against a background of ecstatic religious music:

'God is better than football, God is better than beer, God is better than cricket, 'cos God's there all the year…', written by Keith Binns. The editing of this scene, the flow of the action and the angles, which makes deliberate reference to musical comedy, was not conceived on the basis of a precise detection of the soundtrack and a synchronisation to the image. The song, which existed before the film, had to be re-recorded for technical reasons. The animation was freely developed, over one minute, and then cut to 30 seconds in the edit. This is the only scene of the film that was created without the help of a previously drawn storyboard… And probably the least likely scene imaginable to do without one!

Soundtrack

A film that contains so little movement relies a great deal on its soundtrack. The voice-over alone is so crucial that the film could not be conceived without it. Moreover, the voice of Geoffrey Rush is the only important sound element that was recorded before filming. It was nevertheless re-recorded after editing to match better the rhythm of the film. The recording took three hours (quite a session). Another element that had been recorded before filming was that of the two single words that Harvie says at the end of the film, in order to facilitate the lip-synch.

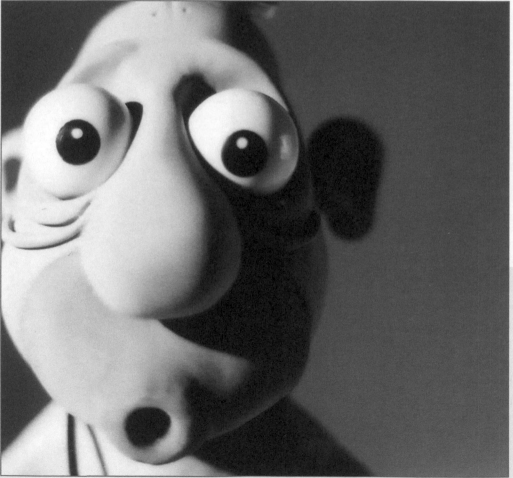

All the rest of the soundtrack was post-produced. The team took nearly two months to create and mix the different sound atmospheres. The work was considerable, there were more than 2,000 sound effects to be included in 23 minutes of film!

O.C.: How did you choose the musical extracts that accompany the film?

A.E.: They were among my favorite pieces of classical music.

*O.C.: The film begins with Pachelbel's **Canon**, which finishes differently to the original score in matching the brief length of the opening credits. Did you re-record it or was it a technical trick?*

A.E.: It was a cheat created by the sound engineer. All the music came from commercial disks, so we had paid for the rights to use it. The only music recorded especially was the song God is better than football, with a full chorus of children.

Words to *God is better than football*

A friend of Adam Elliot's was in the habit of humming this children's song, but didn't know all the words, let alone the name of the song's creator. It took a month of research to find it:

> 'God is better than football,
> God is better than beer,
> God is better than cricket,
> 'Cos God's there all the year.
>
> He isn't shut on Sundays,
> He isn't stopped by rain,
> He's better than a captain-coach,
> You can talk to him again and again,
> and again and again and again!
>
> God is better than football,
> God is better than beer,
> God is better than cricket,
> 'Cos God's there all the year.'

(Lyrics by Keith Binns, all rights reserved)

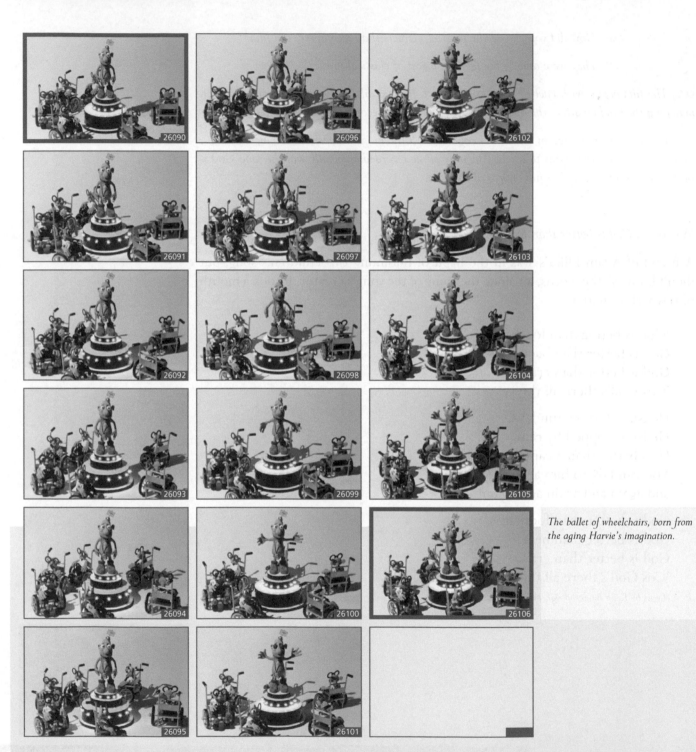

The ballet of wheelchairs, born from the aging Harvie's imagination.

The postproduction work lasted four months. The film's end credits were long, although few people were involved full time in the production. But everyone had to be thanked....

If there are (regrettably) arthouse films that sometimes suffer from a lack of narration, where the director's preoccupation with aesthetic considerations comes before the pleasure of telling a tale, then *Harvie Krumpet* constitutes a wonderful exception. The whole film is organized around the idea of the story; the shooting script, the animation and the entire dramatization was subjugated to the screenplay. *Harvie Krumpet* is a logical progression in the filmography of Adam Elliot. The voice-over that accompanies an image that is voluntarily undynamic, along with the mix of universal and intimate comedy and tragedy, act as an echo of his three previous films. This work touches a large audience, thanks to the methods developed and the ideal length of the film. If you dream of the pleasure of watching a story told like one from the time of oral tradition, then *Harvie Krumpet* was made for you!

Glossary

ACTING: animation in which the aim is to express through drawing the emotions of the character.

ANIMATIC: a video of the storyboard filmed with timing destined to check the rythm of the film.

ANIMATION STAND: a camera (with a frame by frame motor), fixed on a column allowing vertical movement in order to shoot the artwork placed on a movable table below. On today's animation stands, most of the movements, vertically, horizontally and rotational are controlled by a computer.

CARTOON: name given to a type of animated film often classically crafted on cel and with a comic screenplay. The term originates from the newspaper strip cartoons, which were often brought to the screen in the early twentieth century.

CEL: sheet of cellulose acetate onto which drawings first done on paper are transferred. The lines are drawn on the side of the cel that faces the camera, and the color (gouache or acrylic) is painted on the back. The transparency of the material enables the background around the character to show through. Cel animation has become synonymous with the term 'cartoon'.

CUT: that refers to the joining of two shots without any intermediate images.

DIRECT ANIMATION: animation that cannot be prepared in advance. The technique of stop-motion animation is direct animation in opposition to cel animation for example, where the work is entirely finished before filming.

SCRATCH ANIMATION: technique of animating, consisting of drawing directly onto blank film stock. The drawing is scratched onto a developed film (thereby removing the emulsion and revealing the clear acetate or even by painting the transparent film stock (without the emulsion) with colored inks.

EXPOSURE SHEET: or dopesheet: written frame by frame instructions for the cameraman indicating the order in which backgrounds, cels and effects are to be filmed.

CROSS: dissolve a progressive transition between two shots, by merging one into the other. Can be made in camera or optically in a laboratory.

KEY FRAME: drawing on paper or cel that shows an important phase of movement. Keys often show poses that are extreme or that have a strong visual or dramatic impact.

LAYOUT: precise drawing of a shot, which shows the main positions of the character, the background and props, and one or more framings or camera movements to be carried out during the shot.

LINE-TEST: recording the preliminary drawings usually in black and white, in order to evaluate the quality of the animation before it is actually cleaned or painted.

PAPER CUTOUT: a type of direct animation created by using cutout drawings on paper or card, positioned frame by frame on an animation stand.

PEGBAR: small slide rule with three pegs onto which the perforated cels or drawings are placed, so that each element is 'registered' precisely in relation to the others.

POSING: phase in an Animation pre-production that involves drawing the character in a very expressive and graphic pose.

ROTOSCOPE: projection of live action footage to be turned into animation, by tracing it frame by frame onto a paper.

SQUASH AND STRETCH: principle of classical animation that emphasizes the dynamic changes in shape of cartoon characters and other animated element.

STORYBOARD: sequence of drawings, at least one for each shot that contains specific instructions, this 'cartoon strip' is pinned to the wall or onto a table to serve as a guide for all the personnel working on the film.

Inbetweens: drawings created to build the continuity between the key frames.

Index

T - #0080 - 071024 - C294 - 230/210/16 - PB - 9780240520704 - Gloss Lamination